ecotopia

ecotopia

THE SECOND ICP
TRIENNIAL
OF PHOTOGRAPHY
AND VIDEO

Brian Wallis, Edward Earle, Christopher Phillips, Carol Squiers

Edited by Joanna Lehan

International Center of Photography

STEIDL

779
E192

Published in conjunction with the exhibition *Ecotopia: The Second ICP Triennial of Photography and Video* organized by the International Center of Photography.

Exhibition Dates: September 14, 2006 through January 7, 2007

 United Technologies

JPMorganChase ◗

Additional support provided by Etant donnés: The French-American Fund for Contemporary Art

First edition 2006

Copublished by the International Center of Photography, New York, and Steidl Publishers, Göttingen, Germany

Director of Publications: Karen Hansgen
Project editor: Joanna Lehan
Text editor: Philomena Mariani
Copyeditor: Eileen Willis
Design: Steidl Design / Claas Möller and Sarah Winter
Title logo: mgmt design
Separations: Steidl's digital darkroom
Production: Steidl, Göttingen

 International Center of Photography

STEIDL

1114 Avenue of the Americas
New York, NY 10036
www.icp.org

Düstere Str. 4 / D–37073 Göttingen
Phone +49 551-49 60 60 / Fax +49 551-49 60 649
E-mail: mail@steidl.de

ISBN: 3-86521-310-3
ISBN-13: 978-3-86521-310-5
Printed in Germany

cover: Mary Mattingly, *The New Mobility of Home (The Nobility of Mobility)*, 2004 (detail)
frontispiece: Simon Norfolk, *The North Gate of Baghdad (after Corot)*, 2003 (detail)

This book is printed on 100% recycled paper

Sponsor's Foreword

Environmental impact is on the minds of most thoughtful people of our generation. Mikhail Gorbachev, former President of the Soviet Union and the founder of Green Cross International, may have expressed this concern best when he said: "We are guests and not masters of nature."

The International Center of Photography's exhibition *Ecotopia,* appropriately showcases the work of artists who are examining in a broad sense the environment and humankind's relationship to it. With a solid environmental record in the past and equally strong commitments to the future, the employees and shareholders of United Technologies Corporation are pleased to sponsor this show.

UTC's philosophy starts with the premise of doing more with less. In business operations, this means cost-effectiveness and productivity. In terms of environmental impact, it means an eighteen percent reduction in kilowatts and BTUs consumed in our facilities worldwide since 1997, even while the size of our company has doubled. In product design, it translates into Otis elevators generating energy as they descend—offsetting the very energy they consumed on their ascent—and Carrier air conditioners in the United States that are thirty percent more efficient than those installed just one year ago. We often ask ourselves what the effects of comparable gains across companies and economies worldwide would be. The most reliable, easily achieved, and cost-effective alternative energy source is indeed conservation: doing more with less.

Artists capture and distill countless aspects of our lives. The works featured in *Ecotopia* approach head on a central theme and fact of this generation. We congratulate the artists and the International Center of Photography for this accomplishment.

Support for ICP by United Technologies began in 1981 with the sponsorship of *Eisenstadt: Germany* and included the donation of more than ninety historically significant Eisenstadt works in 2002. We are delighted to be partners once again.

George David, *Chairman and Chief Executive Officer*
United Technologies Corporation

Louis Chênevert, *President and Chief Operating Officer*
United Technologies Corporation

Director's Foreword

Three years ago, the International Center of Photography presented its first triennial exhibition of contemporary photography and video. We hoped that by launching a recurring exhibition of this kind, ICP would be able to bring to New York an adventurous selection of the most innovative work being done around the world by established artists as well as emerging or overlooked figures. That exhibition, *Strangers*, explored the complex issues of trust and fear in public spaces that had emerged in the wake of the 9/11 terrorist attacks. The show resonated with many viewers, as evidenced by the crowds who thronged to ICP's galleries during the fall of 2003.

The 2006 ICP Triennial, *Ecotopia,* takes as its starting point an equally timely theme: the response of today's artists and photojournalists to the challenges raised by rapid environmental change. Organized by ICP curators Brian Wallis, Carol Squiers, Edward Earle, and Christopher Phillips, with assistant curator Joanna Lehan, the exhibition examines human interaction with nature in the broadest sense. Featuring works by more than forty artists and photographers, from twenty different countries, *Ecotopia* encompasses an unusually wide visual territory, including dramatic photojournalistic accounts of recent environmental catastrophes, unusual glimpses of the animal realm, and imaginative visual evocations of future utopian states. Together, these works evoke the anxiety, hope, and urgency that characterize today's reflections on the global environment.

We wish to extend our deepest thanks to the exhibition's lead sponsor, United Technologies Corporation, whose extraordinary support helped make *Ecotopia* possible. UTC has played an important role in supporting ICP's exhibition program in the past, and we are pleased to acknowledge this renewal of our relationship. Crucial early support for *Ecotopia* was provided by JPMorgan Chase, a company that has long been one of ICP's leading corporate members.

We are grateful to Etant donnés: The French-American Fund for Contemporary Art, whose support made possible the participation of several of the artists included in the exhibition.

Many members of the ICP community deserve recognition for their extraordinary continuing efforts. The commitment of the ICP Board of Trustees, under the vigorous leadership of Chairperson Gayle Greenhill and President Jeffrey A. Rosen, has enabled ICP to present a program of unrivaled exhibitions. The members of the ICP Exhibitions Committee, co-chaired by Artur Walther and Meryl Meltzer, provided the encouragement and support that enabled ICP to launch its first Triennial, and demonstrated their sustained interest in this exhibition. The generosity of the ICP Acquisitions Committee, chaired by Anne Ehrenkranz, made it possible for ICP to purchase several key works in *Ecotopia* for its permanent collection.

We are grateful to ICP's Publications Committee, co-chaired by Andrew E. Lewin and Frank B. Arisman, for the enthusiasm and support that made this and all our publications possible. Thanks also to editor Phil Mariani and to Director of Publications Karen Hansgen for seeing the project through with our publishing partner, Gerhard Steidl.

Finally, I wish to express my sincere thanks to the members of the ICP curatorial team, who brought an extraordinary degree of visual sensitivity and intellectual rigor to the task of preparing *Ecotopia*.

Willis E. Hartshorn, *Ehrenkrantz Director*

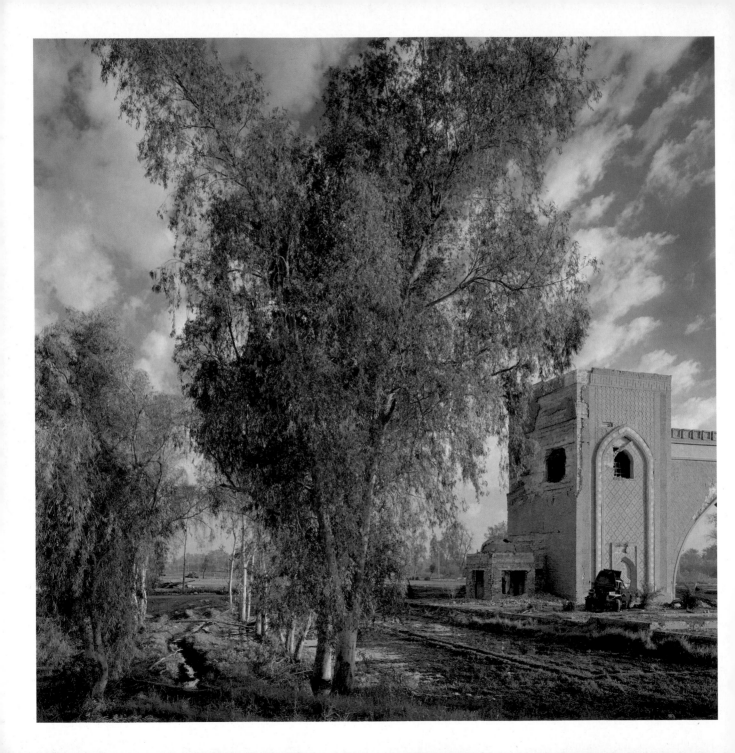

Ecotopia: A Virtual Roundtable

The following conversation among ICP curators and *Ecotopia* artists was woven from personal conversations, group discussions, telephone calls, faxes, and emails. The discussion transcended physical space to address contemporary notions of landscape, ecology, and imagery.

Landscape and History

christopher phillips: How do you see your work relating to historical conventions of landscape depiction?

simon norfolk: This is hugely important for me. The first photojournalists were "ruin" photographers and it tickles me pink to know that they were using cameras not dissimilar to mine. These photographers (Fenton, Brady, Beato, etc.) in turn drew upon many of the traditions that had been brought down from seventeenth-century Romantic landscape painting, in particular the work of Nicolas Poussin and Claude Lorrain. The ruins in these artworks were philosophical metaphors about the foolishness of pride; about awe and the sublime; about the power of God; and, most important to me, the vanity of empire. The work I'm showing is part of the project I've been making since 9/11/2001, and it's been a fascinating period in which to be thinking about the making of a new global empire; the brutality necessary for its construction; and what these new ruins might mean for all of us. I use the 4 x 5 because it gives me the tonal range of an oil painting, I use the morning light because it gives me the palette of Claude Lorrain, and I even employ a few of the motifs that these painters used—for example, shepherds or victory arches—since these were all part of a rich symbolic language that these artists deployed.

mitch epstein: History and politics are very present in my "American Power" pictures. I am interested in ambiguity in the play of hot and cold in a landscape, emotion and intellectual rigor. I admire both Andreas Gursky, who monumentalizes the landscape, and Robert Adams, who humanizes it. Gursky is making concept-driven renderings that play on the heroic aspect of landscape. Adams makes landscape pictures that are intimate, humane, yet intellectually rigorous. With "American Power," I am trying to integrate grandeur and humanity, along with formal rigor, into a single picture.

marine hugonnier: Since the nineteenth century, we have managed to create modes of analysis and perception—tools like photography and cinema—that echo the expansionist mission of the time and help to establish a particular ideological and perceptual "point of view." I see landscape as a form of cultural mediation, a social construction that informs the conventions of its representation. *Ariana, The Last Tour,*

and *Travelling Amazonia* form a trilogy that questions these conventions, these ideologies, and the tools that have helped to establish them.

an-my lê: I have been formally influenced by nineteenth-century European photographers like Atget, Fenton, and Le Gray, but philosophically I feel closer to the New Topographics photographers in my desire to create bodies of work based on social, cultural, and political incongruities in the contemporary landscape.

yannick demmerle: Most landscapes, whether they are photographed or painted, show open spaces. My landscapes, however, are closed spaces—they show something closed. One cannot escape from my landscapes or enter them; one is either trapped in them or shut out. . . . When I work in the gigantic forests of northern Germany or in Tasmania, I also lock myself in these forests for weeks, alone. . . . The Aborigines in Australia, a powerful thunderstorm in the forest, fishing for barracudas in the "Southern Ocean," or treading on a "tiger snake" in Tasmania—all of this has had more influence on my work than the last five hundred years of art history . . . these experiences and these dangers are the material with which I construct my life and my work. Libraries bore me, cinema as well . . . I do not need any entertainment anymore. For ten years now my only reference for my work has been my life.

mary mattingly: Some art historians believe that Edvard Munch painted the red sky in the background of *The Scream* because of the unusually intense sunsets seen throughout the world following the 1883 eruption of the Indonesian volcano Krakatoa. I love the contradiction of perceived beauty actually being evidence of disaster. I was and still am very attuned to the ideals of Ray Kurzweil [a pioneer in the development of artificial intelligence], because his studies and predictions line up with his sense of fantasy—it is his goal, like it is mine, to embrace the fantasy part of life and make it as real as possible. I believe that the two should be indistinguishable. I begin constructing images by sketching an idea of the space I want to create and imagining the story I want to convey. I almost always do something in post-production—whether it is heightening the intensity of the sky, combining negatives, or using a 3-D computer-imaging program. Computer programs like Maya and Bryce allow me to introduce fantastic elements, whether they are clouds, wave crests, or foliage, into the photograph. This I see as relational to our realities. We live in a world that seamlessly blends fantasy with image with physical reality. I may combine an image of an irrigation stream taken in Holland with a snow-covered mountain range in Iceland. The merger of these two places is a possible future, as our environment changes so rapidly right now. Within the history of photography, many artists have worked with composite images, and many artists have heightened qualities of landscape, through the use of filters or burning and dodging. I want the photographs to play with the line between plausible and implausible, seamless and irregular. Most of the time, the mood is a strong divide between the ominous and beautiful.

joan fontcuberta: I have done several projects on landscape and all of them have in common the question of translation—how to translate the experience of the place. The landscape is the expression of the

place and the place is the inhabited space, the space transformed in culture, the space appropriated by the conscience. The crisis of landscape as a genre in visual representation appears when we discuss under which parameters (political, economic, cultural, aesthetic) the environment becomes landscape. In my projects I try to underline the way contemporary landscape no longer depends on aesthetic factors but on conceptual and philosophical ones.

mark dion: My work relates not only to historical conventions of landscape depiction but also to those of wildlife art and illustration. Both traditions are pivotal to the history of American art. John James Audubon demonstrates so many aspects of American modern art—serial production, compositional innovation, conceptual fidelity, the production and maintenance of an artistic persona. From the Hudson River School of painters (many of whom were also remarkable photographers, like William Bradford), to Eliot Porter and Alexander Wilson [a nineteenth-century ornithologist and illustrator]. Depictions of nature embody the social conventions of their historical moment, although not always the dominant ideological positions. For me, reading the past of landscape and wildlife art is a bit like examining a road map; tracing the route to find out where you are now. The map depicts all the roads not taken, the detours, and dead ends. The history of the representation of nature is much richer than the mere history of painting. Mass media productions such as nature films, park service pamphlets, and, of course, natural history museums are all fascinating examples of what shapes our understanding of nature at a particular time for a distinct group of people. No single form or institution has a monopoly on the culture of nature.

diana thater: I think it is a given that any depiction of the landscape is a depiction of the culture that created it. So making a work, such as the one I did based on Mary Shelley's *Frankenstein*—which is a work about man and nature, or, more specifically, about the female and nature—would be addressing early eighteenth-century ideas about the natural world. The key issue there was the translation of nature from a place of the unknown, a place which induces fear, to a place that is becoming pastoral and controllable.

 All of my work is based on variant ideas of the landscape that I trace as a history from the early 1800s into the present. Another one of my works is based on John Ford's depictions of the American West. Each work is specifically involved with different ideas of the landscape, stemming from artistic depictions of it.

brian wallis: Diana, it sounds like what you're really talking about is a counter to traditional ideas about landscape—a sort of anti-landscape—derived in part from media stereotypes. After all, "landscape" is an outmoded genre. And I think what we're seeing in all of the works in this exhibition is a kind of reinvention, or at least a rethinking, of an aesthetic idea that had pretty much run out of steam. By looking at the natural world in a different way, through various means—the virtual capacity of the Internet, or Photoshop, or a rethinking of stereotypes—you are not really updating a historical genre but overturning it completely.

diana thater: I think you're right. Depictions of nature ran out the day Cézanne died. And that was in 1906. Even though one could cite the work of contemporary landscape painters, I don't think it's relevant at

all. And, at the same time, the actual physical landscape is also disappearing, if it has not already disappeared entirely. Harri [Kallio]'s images of the dodo revive a famous example of extinction. And I think the dodo is symbolic. Today, we're in a period of mass extinction. Hundreds of species are becoming extinct every single day. That's the condition in which we live. But this situation was not considered in the late nineteenth century alongside the development of landscape painting. That was about another kind of relationship to nature. So, we are bound to have—and we *need* to have—a different kind of idea about the landscape. And that would not be the landscape as an image, but the landscape as a significant territory for meaning production. This is not just a question of making images differently, it's more a question of ideas and politics.

david maisel: I would go further and say that when we're making landscape images now, they always function as a kind of double image. There is the optical and aesthetic aspect of the image, which carries a kind of value structure. But there is also the aspect that refers back to the cultural or historical context in which it's made, the time period in which it's made. So we have to ask: What are its references? Who and what is it speaking to?

christopher phillips: Has landscape as a place become so politicized that any depiction of a "landscape" will be read as a political or ideological statement? And, if so, how does this affect your working method or your choice of subjects?

mitch epstein: Politics, for me, is always about power. And the choices we make as artists give us power. Principally, this means the power of having a voice. And, of course, there is also then the consequence and the responsibility of that power. So, politics is inherent in the way in which we, as artists, reflect on the key choices we make.

allora & calzadilla: The classical Western understanding of landscape at its origins was bound up with ideological intentions and has since remained historically mediated and socially constructed. Defined precisely as that "portion of land which the eye can comprehend at a glance," the term *landscape* is always contingent upon the human gaze, and is therefore implicitly a representation of space in which human values and cultural meanings are encoded. The works that we have made are informed by a desire to unpack such representations, to critically disrupt totalizing and dominant narratives of space and place, and to allow for alternative interpretations to emerge.

broomberg and chanarin: In our "Forest" series, we document pine forests in Israel that, since 1948, have been systematically planted over the ruins of evacuated Arab towns. These forests look natural, as if they have been standing there forever. Our strategy here is to photograph the forests at the crack of dawn so the quality of light reinforces the feeling of harmless beauty, the myth of nature. Here we have appropriated conventions used in landscape painting, including the notion of the sublime and the picturesque. We wanted to show how the state of Israel has used these conventions, consciously or not, to stage or design

a landscape that feels timeless and innocent, a landscape that would not only physically erase a recent violent history but would also suggest a natural and legitimate space. The forest seems to say that if anything evil exists here, it must be in your imagination or subconscious.

All land and all landscape is political and our understanding of it and even our understanding of beauty is informed by various political agendas. What we are saying is that the way Israel presents and packages itself is a particularly potent example of this. Landscape is presented as innocent and natural, and this suits a particular political discourse. Settlers living in the illegal settlements in the West Bank are enticed by a combination of tax incentives and cheap housing with easy access to Jerusalem. But mostly they are offered a stunning view of a pastoral, unblemished Holy Land, devoid of an Arab population. These people are on the front line of a war, they overlook a landscape that bears scars of this war, of excavation and displacement, and yet it appears and is sold as this innocent and harmless landscape, a cartoon of the Holy Land that you can navigate with the Bible as a guidebook.

david maisel: Obviously, images can be interpreted in multiple ways. Any given image can be harnessed to one's own arguments, and I'm wary of wanting the work that I do to have a definitive meaning. Mitch used the word "ambiguity," so I'll start with that. I'm interested in terrains that have undergone some sort of upheaval, but I also see those as somehow symbolic of the interior world of the human psyche, perhaps even my own psyche. So, even in, say, the Owens Lake project, looking at the demise of this lake that was drained to bring water to Los Angeles, there is an unconscious motivation that frequently I don't understand until much later. At Owens Lake, I was very attracted to the blood-red water. And I was two years into that project before I realized that there was some sort of metaphorical process of considering my mother's death during heart surgery. As a result, I'm open to all possible interpretations.

Of course, that example is a very personal one—but there's something compelling about the areas that I am interested in working with. They're being dismantled—they're in a state of acute flux. And those kinds of dismantled sites work for me as metaphors for the human psyche, as much as anything. The political content is there, but I would hope that it's not the only possible reading of the work.

Politics of Animals

carol squiers: Catherine, we've seen a lot of work that incorporates animals and insects as we've been working on this exhibition. But none of the artists in the show are traditional wildlife photographers. How are you looking at animals differently? Are the creatures that you use in your work stand-ins for human beings? And if they're not stand-ins, what symbolic or literal function do they serve?

catherine chalmers: When you're using animals, the power to control more or less defines the relationship. Also, at this point in history, if you look at the use of animals, you have to consider that they are

going extinct. It's hard to use animals and not account for that aspect of power relations. And with the deciphering of the genome, we know that we have an uncomfortable number of genes in common with the mouse, for instance. That definitely changes how we relate to that animal and how we look at it.

So, I'm always aware that there's the specific context in which I use animals. But there is also the metaphysical intrigue of trying to understand what the nonhuman is. How do you know or understand an animal? How do you relate to it? What are ways that you interact with it? Do you go to a zoo? Do you have a dog? Do you go to Africa on a safari? What are the ways, at this point in history, that we interact with animals on a societal level?

These things play a part in how I make my work. And the political level is not so much something that I add to the work but an inevitable consequence of the historical context that I work in.

diana thater: I'm not using animals as stand-ins for humans—that's not what I do. I'm using animals as models for ways of seeing, or as question marks about subjectivity. And so the last thing I would ever want to do is use an animal as a stand-in for a human being. I'm not even trying to "use" them for anything. I'm trying to depict them in terms of a question about subjectivity and what other subjectivities would look like. So seeing animals as stand-ins for human beings is really antithetical to what I would ever want to make.

catherine chalmers: In my case, also, it's precisely the opposite of a stand-in; it's really the investigation of the other. My goal is to try to understand what it is *not* to be human. After all, at this point, most relationships to animals are as pets or pests. Is it possible to see animals outside of those two categories? Perhaps a third category would include those animals—either pest or pet—that become the subjects of science. But is it possible to bring animals into a larger cultural arena in a more meaningful way than through Disney productions, which basically do, as you say, make animals humans? And is it possible to have a relationship with animals that has greater meaning beyond the trite categories they are usually reduced to?

harri kallio: In my work, the dodos do not represent people, per se. But I do feel that the work shows the social relations of a whole species, like a culture of birds on the island, and that that has a parallel to what people do.

carol squiers: Harri, has your work always been about natural subjects?

harri kallio: It seems to be. I try to keep an open mind, but I'm more interested in natural subjects than people. Or, more accurately, I'm interested in the peculiar relationship between people and animals, and people and nature.

carol squiers: Here's a related question. What types of interactions between humans and animals are you depicting, if you are depicting any at all, and why?

diana thater: In my work, the depictions of animals are always directly related to the people depicting them. Alongside those people are specialists who I hire. In my work with free dolphins, for example, the

camera crew is depicted alongside a dolphin-rights activist who swims and films the dolphins, and knows a particular pod of dolphins. And then we depict him and his relationship to the dolphins while he films us. And all of us are interacting with this particular pod of dolphins. So the depiction of a human relationship to nature is very particular in my work. Those who depict and those who are depicted are viewed together, simultaneously.

sam easterson: The setup in my work is similar to Diana's. It's usually just me with the handlers and veterinarians who are out there with me. The scenario's the same in that way. But there's a distinct effort on my part—and I haven't quite figured out why—to try to stay off camera. And, after the camera is actually ly mounted to the animals, I try to have all those other people stay off camera, too. So, in the final version, there are no interactions between animals and humans. What I'm after is animals and other animals, other nonhuman animals.

carol squiers: On a more symbolic level, are you trying to show anything about animals and the wider society in your work?

sam easterson: I've been accused of Disneyfying what I do because I try to get as far out in the wild as possible, and cut out the wider society. There's definitely an effort on my part to erase telephone lines, houses, any built structure, and to get the animals in their "natural" habitat. But, of course, it takes a lot of editing to get rid of that stuff.

carol squiers: Harri, how about you? Since the dodo was driven to extinction by humans several centuries ago, perhaps the relationship you are implying exists between humans and animals is obvious.

harri kallio: I like to depict a kind of imaginary moment, in this case, the first encounter between dodos and people on the island. And what was the dodos' reaction to the people who first arrived on their island? Since they'd never seen people before, it was a very innocent encounter. But it ended very badly.

catherine chalmers: My interest derives more from a philosophical context, where those interactions between people and animals become problematic, where for some reason we have a difficulty in our relationship to the animal world. For example, the food chain is something that civilization has tried very hard to deny or suppress; that is, the idea that humans are a part of the chain. We may think of it as a large animal eating us, or perhaps as small animals eating us when we die, or perhaps even as parasites or other viruses and things that plague us. But it is those things that we are trying to deny—or separate ourselves from—in the animal world that I find most interesting.

alessandra sanguinetti: We don't realize how much a part of the cycle we are. I was thinking about how we call nature "mother nature," which is common in a lot of cultures—for instance, the Pacha Mama in South America, where they make a hole in the ground and feed mother earth, and say thank you to mother earth. It's pretty universal, the idea of the earth being our parent. And I was thinking about how we're dom-

inating nature now, in a way that has gone completely beyond our control, and comparing this situation to a mother-child relationship, when you don't have any limits. And when maybe—when you suddenly maybe don't respect the parent, or it loses its authority, I think you're lost.

edward earle: That's a very interesting point. When we lose our relationship to animals, by isolating ourselves, then we no longer have an appreciation for the life cycle that is associated not only with our food, but also with other creatures.

diana thater: I think we are in a moment in culture when it's essential, if we're going to do anything to preserve or to save the natural world, to admit that all of that is true. It's a critical point—particularly with something like, let's say, the Bush administration's position in denying global warming—that will have to be acknowledged.

david maisel: I would be very pleased if the Bush administration acknowledged global warming. But at this stage of the game, the problem goes much further than what even the United States government might be willing to do. Even if there were a broad and vigorous global response to the environmental crisis, my sense is that we are still approaching an abyss. And the possibility of applying the brakes now may be a case of too little too late. I don't want to sound too dystopian, but I'm curious whether the rest of you think that the work you are doing—individually or collectively—can actually stimulate political change, or, at least, changes in modes of thinking.

marine hugonnier: Literature, cinema *should* affect reality, put issues into crisis. But that doesn't mean they will have any actual effect in the political sphere.

alessandra sanguinetti: Artists can have a political role, but their work won't have a direct impact. Artists are not vehicles for change as a scientist or a politician or an environmentalist can be. Perhaps they can change people's way of looking at things over time, through more sensory or emotional means.

diana thater: Historically, art has been one of the things that leads culture. And artists and those who interpret art help to direct the culture toward seeing the world in a different way. And I think that there is the possibility to change people's notions about—let's say, from my perspective—the subjectivity of animals; that animals are not just objects for human transference and human use, but that they are in cultures, in and of themselves. If I could show people that, or lead people to believe that, or to notice that, then I would have done something that I want to do. And I believe that would change the world.

mark dion: If your primary goal is direct action for concrete political change, I suggest that the realm of contemporary art may not be your best staging platform. The art world with its highly skilled craftsmanship, rarified audience, and anachronistic economic structure is a frustrating arena for jump-starting a revolution. However, this does not mean that art doesn't have a place in constructing and perpetuating a culture of resistance. Perhaps art can be most effective as an ally to direct political action, community or-

ganizations, and other forms of protest. I imagine art can be a tool in the war of ideas. I see my own work as part of a broad discourse on the politics of nature, which functions philosophically in sympathy and support for movements in ecological activism, which includes social ecology, wildlife conservation, and global environmentalism. At the same time, I think part of my job is to produce a complex critique of some of the more bone-headed ideas embedded in those movements.

kim stringfellow: I want to return to an issue that Diana raised earlier: the exclusion of humans from nature. That was a premise or motivation of earlier landscape paintings, in which the very idea of wilderness excluded humans. And I think we have to start to see ourselves and our culture in the context of our environment. Only then will we begin to create more sustainable ways of relating with the natural world, and with the different species on the planet.

One of the issues I addressed in my film *Sea Pieces* is the idea of an artificial landscape versus a natural landscape. And what does that mean? Well, early on, environmentalists were not interested in the Salton Sea because they said: this is a manmade environment. But the birds of the Pacific Flyway didn't know that. The Salton Sea just sort of became a natural habitat because all the wetlands in California are gone. Birds began to use the space, and it became very viable for them. This raises the question: how can we think about other castoff landscapes? The Hanford Reservation, for example, has been terribly, terribly polluted, but, at the same time, it sustains one of the best areas for native salmon to spawn because it's not dammed. This kind of conversation—how we deal with the artificial versus natural—can be very constructive.

Fear of / for Nature

brian wallis: In the current context, artists are very politically aware but seem less inclined than previous generations of artists to address or take up specific political issues directly. Rather, they deal with them on a metaphorical or allegorical level. One thing we see, then, is images that provoke feelings of anxiety or fear or apprehension in relation to nature.

joanna lehan: Unlike traditional landscape photography, which often looks placid and benign.

mark dion: Nature is an arena of a great deal of cultural anxiety. One aspect of this seems related to the paradox that while nature has been ascribed with positive and even spiritual values since at least the nineteenth century, our culture, dominated by a notion of progress, is entirely based on a relentless destruction of nature. Our cultural guilt around this contradiction is so acute that almost any landscape photo or wildlife image seems embedded with an "ecological message." In 100 years, nature has shifted from something awesome and dangerous, which we need to be protected from, to something fragile, which we need to protect. Such a dramatic change in a concept so fundamental as nature undoubtedly has had a profound effect on a range of philosophical, moral, aesthetic, religious, and social ideas.

an-my lê: The very subjects of landscapes, nations, and even climate are fraught with paranoia and other anxieties. In this respect, the idea of a contemporary benign landscape is dubious.

joanna lehan: Perhaps that's why so many of the works in this exhibition have a subtext of violence and anxiety, for instance, Francesco Jodice's noirish treatment of a rural Italian community, or the palpable fear in Yannick Demmerle's nighttime images of forests. Is it fair to say that your works deliberately tap deep-seated apprehensions about the unpredictable or even menacing forces of nature?

yannick demmerle: The way in which you pose this question implies that my series "Les nuits étranges" is convincing! In fact, I did want to convey a particular kind of fear, one which could be defined as a handed-down or inherited fear: the fear of wolves, the fear of the night and its phantoms. It is a fear that one can sense in a few texts by E. T. A. Hoffmann. One could describe these photographs as nightmarish moments that I have tried to extend. In this series the trees seem soothing: one can hide behind them, they are like candles—yet, one does not see what happens *behind* them, what lies behind this mighty night, threatening and yet so . . . *calm*.

francesco jodice: I was born and raised in the real urban jungle of Naples, which means that "dangerous" cities are unscary for me, but nature is a different space altogether. The strongest image of "Nature" in my mind comes from the news on TV: a journalist, cameras, policemen, an ambulance, all stuck on the border between the end of a road and the beginning of a dark bush. In this image, not only vehicles and people stand on the border, also phone cables and electricity wires, sewer systems and Internet lines. In my imagination, that is the thin line between civil matters and unpredictable behaviors. As soon as you leave the road and get lost in the bush, rational behavior gets discontinuous, just like the line on your cell phone. For me, nature has always been the place where your behaviors get rid of all the historical, religious, political, and social boundaries. You're free to piss in the middle of the bush, such as you're not when in the middle of a piazza! You're free to make love with your girlfriend on a picnic towel. And you're free to kill a four-year-old kid and hide the body under a bed of leaves. You're free to "misbehave" because you're unseen. And when we are unseen we feel unjudged by the conventions of our society rules, we feel free. Well, *Natura: Il Caso Montemaggiore* happens in exactly this place. This is the *Natura* I represent.

joanna lehan: Would anyone else care to comment on these observations about violence and anxiety? Do they apply to your work?

kayana szymczak: Yes. As long as photography has existed, photographers have been compelled to capture the sublime and awe-inspiring natural beauty of the landscape in which we live. Less sublime but equally awe-inspiring is the magnitude of human impact on our environment. In this age of climate change, species extinction, and unprecedented toxic pollution, I am compelled, as a documentary photographer, to record the living reality of our dying landscape. And, through these images, I want to inspire a stronger bond between the viewer and the landscape through which they move every day.

victor schrager: If anything, I tried to minimize the level of anxiety in my subjects [in "Bird Hand"]— many had been caught (by licensed field biologists) only moments before the pictures were made (and released shortly thereafter). Although none were harmed, the birds instinctively assumed that someone was trying to kill them. While many may seem to be posing for their portraits, they are actually trying to become invisible.

noriko furunishi: A lot of people who've seen my work have said that it makes them dizzy or motion-sick. I think this disorientation comes from upsetting the way people are conditioned to read traditional landscape photography or painting. There are rules about how to look at or interpret them. I intentionally destroyed—well, *destroy* is a strong word, but I deliberately *changed* the rules. People realize that my work doesn't "make sense."

joanna lehan: So you think that this refusal of your images to adhere to our traditional ways of looking at a picture is what causes the anxiety?

noriko furunishi: I think that's the biggest part.

clifford ross: But anxiety, in the context in which we're using it, is a *beautiful* anxiety, as opposed to a deeply unpleasant one. We're really talking about an almost dangerous heightening of awareness of one's personal radar about the world, which is an exhilarating kind of anxiety, rather than one which generates fear.

brian wallis: Well, that's really interesting. Because I think that the thing that you are bringing to this, which I don't really find elsewhere in notions of, or examples of the sublime, is this kind of hyperrealism— this scale, this exactitude, and this detail—that certainly *does* produce a kind of anxiety born of over-abundance of information, an over-abundance of visual information.

carol squiers: I think a different kind of fear—definitely *not* exhilarating—informs the film *Otolith*.

the otolith group: We made *Otolith* in 2003 during the months in which antiwar demonstrations were taking place across the world. The group experienced intense sensations of political impotence in the face of a war [in Iraq] that seemed inevitable. This impotence infused the meteorology of mood that is particular to *Otolith*, a mood that we termed "ambient fear." Ambient fear, a notion that we extracted from the writings of the theorist Brian Massumi, is a perpetual, low-level panic that seeps across and between the social and the symbolic. In such a context, it becomes difficult to separate a specific concern about global warming from a worry about avian flu from depression about impending war from anger over the aftermath of Hurricane Katrina. Ambient fear is osmotic and porous; it is inseparable from the environment understood as a complex ecological matrix. We can then begin to see how this matrix informs *Otolith*, from the estranged perspective of what J. G. Ballard calls the science fiction of the present. *Otolith* operates through the temporality of the future anterior from this time. Our protagonist perceives our present as a historical ruin.

catherine chalmers: Science has accelerated our understanding of the animal world and, simultaneously, across the world, there has been a rise of fundamentalist religions, which in many cases take the opposite position from science. That division or tension is perhaps what underlies the fear. There's a generalized fear, an apprehension about the future. What's going to happen, and what's going to be left a hundred years from now? Is it going to be an environment that we really want to live in? Will it just be the animals and plants that have been discarded and have somehow managed to survive in our wake?

The animals that have succeeded in living among us—who have made the leap from living in nature to living in an urban environment—are precisely those animals that are most despised. So the pigeon is a rat with wings, and cockroaches are the worst things in the city. Why? There's really nothing about cockroaches that should elicit that kind of response. They're not poisonous; they don't carry the pathogens that, let's say, mice do. On the other hand, cockroaches always seem to be beyond our control. They're invasive. They steal into our homes. They breach our walls. And the walls are what separate the things that are inside from those we don't want to let in. They define how we allow nature to come in.

brian wallis: This raises a very good point about how we allow a relatively innocuous aspect of the natural world to disproportionately represent a threat and, potentially, violence. So your films, Catherine, often seem like science-fiction or horror films, even if they just star bugs. And, similarly, Sam Easterson's films—which are relatively straightforward, simply placing a camera on the head of an animal—elicit a distinct anxiety, as if the animals, or nature in general, are somehow out of control.

sam easterson: I do feel there's a sense of anxiety. Part of the reason for that is all of the uncontrolled motion. Most cameras, as you know, have optical stabilizing systems to smooth out the motion. We're accustomed to seeing things, on TV or wherever, relatively stabilized; they're easy to look at. I don't use those stabilizing systems. The cameras are placed right on the animals' heads. The result is a very jarring image. People sometimes get dizzy or grab onto something when watching, say, the camera rolling along with the tumbleweed.

But also, when my work ends up on cable TV or whatnot, I find myself fighting the tendency on National Geographic or Animal Planet to focus on predators, like alligators, or bears, or great white sharks. Instead, I put cameras on slow animals like frogs or snails. They are just as interesting, if not more so, when they have a camera on their head. I'm always saying to those TV folks: This is just as interesting as those violent images—the camera on the snail, or the camera on the frog.

brian wallis: But interesting in what way? What are you trying to show?

sam easterson: That gets back to political context. I'm trying to give a video voice, so to speak, to a lot of animals that don't have a voice, because they get pushed out by all the violent, fear-driven images. It almost never fails. Right now I'm working on a show putting cameras on birds, including a falcon and a pheasant. Inevitably, the violent animal yields the least interesting footage. The pheasant will never get

airtime, yet it was probably some of the best footage I've collected. And the falcon was not very notable, to my mind, but will undoubtedly get shown.

brian wallis: Another political issue related to the representation of animals—in fact, all sorts of natural forms—is the issue of their survival or extinction. Historically, a key theme centers around the destruction of species, particularly in relation to cohabitating in an ecosystem with humans. I wanted to ask you, Harri, whether you see your very poignant pictures of the dodo as a metaphor for the potential extinction of any species.

harri kallio: Certainly, in Western culture, the dodo serves as the ultimate symbol for all the extinct species.

brian wallis: And the extension of that, I guess, is the way that this potential for absolute destruction colors our vision of the future. If we're considering the idea of utopia, or ecotopia, as a counter to current environmental fears, I wonder whether you see that future as hopeful or dystopic.

the otolith group: For many of us, including the Otolith Group, it is more comforting and more satisfying to imagine the end of the world than to imagine the end of capitalism. Would we rather die under capitalism than live under postcapitalism? The inability to imagine life after capital might be restated as the heat death of utopia; for many of us, these times demand pessimism of the emotions and optimism of the act.

joan fontcuberta: For a long time I have been interested in the paradox of two parallel but contrary processes: the degradation of the natural environment and the artificial reconstruction of nature. For instance, in my project "Palimpsests," I reflected on popular decoration and ornamental elements taken from the natural world: flowers, leaves, birds, and so on. The bourgeoisie responsible for an industrialization not at all sensitive to the environment was keen to decorate their homes with wallpaper recreating that vanishing nature. In "Landscapes without Memory," I deal with simulation programs able to provide virtual experiences of nonexistent places and situations. Both wallpaper and 3D-simulation software focus on illusion and share that paradox I mentioned with regard to nature. In "Science-Fiction," there is a recurrent story: the world is destroyed by a nuclear disaster and humans must flee to other worlds. "Landscapes without Memory" can also be understood as samples of those fantasy "other worlds" where we will find shelter when our environment no longer supports life conditions. Does that sound apocalyptic?

mary mattingly: Well, we might come to the point where our reliance on technological communications creates a distance between people. That's a truly frightening dystopic future that I see as a possibility. But maybe we'll have online communities that will have a stronger presence than people sitting around a table like this. We're already beginning to see this kind of thing right now. And this is a new landscape, of sorts. A large part of my work is to consider how to bring these new communities together in this new environment. One of the strongest things that we can do politically right now, as artists and academics, is to

form robust communities. And to branch out into other areas of science, into other robust communities and help to keep those linkages alive. That's what I struggle with.

catherine chalmers: Underlying all these "political" ideas about nature is respect. In terms of our discussion about fear, we seem to fear the insect the most, and have the least amount of respect for it. Yet, if insects, as a group, were wiped off the face of the earth, the ecosystem would probably crash; some scientists think this would happen within a matter of two months. Soil would rot, plants wouldn't be pollinated, and we'd all be dead. Insects are crucial to the functioning of our planet. On the other hand, insects live the most different sort of lives from us. They do things that we consider amoral, horrifying, and really bizarre: they bury themselves; they come out as something else; they change forms; males offer themselves up to females to be eaten. They do things that are completely nonmammalian. And so I think—if it were possible to bring respect to a group of animals that is so bizarre and yet so essential to the planet, that could really change things.

mitch epstein: I think we have a tremendous amount to learn from your work with insects—especially in terms of what insects do to survive. And what human beings, at their most base level, do to survive. It provides a way of looking at our own behavior as a society. Of course, scientists have been doing that for generations. But I think we need an imagery that's generated from an artistic consciousness, in a form that's different from scientific data and illustration. That's how I see work like yours having a direct relevance to how we can reconsider our own social situation as human beings.

Landscape and the Environment

edward earle: I want to return to one of the issues that Mary raised, which might be referred to as the "landscape of politics." And I think Mitch, too, talked a little bit about the velocity of change that we've experienced over the last few years. Catherine addressed certain constancies within a culture of animals, and yet our understandings of biology have changed radically in the past five, ten, fifteen years. To what extent, I wonder, has your work undergone changes by virtue of observations of the political and social conditions within which we are living? In other words, to what extent do you address environmental concerns within what might be thought of as an activist view—even if, in fact, you're working as an artist?

wout berger: Over the last few years, I have increasingly directed my view to the foreground, and the horizon has disappeared out the top of the picture. I photograph close-ups within a receding frame of a few square meters; I do not need more. As a pleasant consequence, the somewhat boring pattern of "foreground, horizon, and sky" no longer plays a role. One reason I photograph small patches of land is that "nature" is persistently withdrawing from the landscape. The BeNeLux landscape is a nature/culture land-

scape from which "nature" is disappearing as a result of human interventions, making a place for a so-called culture-landscape. My photos do not make a value judgment.

david maisel: I don't know that the actual subjects of my work have changed that much over time. But I do feel that the audience has changed. And their reception of the work has changed the most. Take one example: I built a website for the "Lake Project" that was associated with a series of billboards I installed throughout the city, out of the gallery and fine-art context. There, I felt, one might encounter these billboards somewhat randomly, and perhaps be propelled to investigate the specific area further. It was a challenge for me to address an audience in a different way. And it enabled me to have a much more layered experience of how to deliver information to people. In a gallery context, my mode of address is like the aesthetic sublime. But outside of the gallery context, I had a different kind of voice entirely, one that could engender multiple readings of this specific environmental disaster.

edward earle: Did that have anything to do with your decision to change the captions on your photographs to include a greater degree of what I would call "purposeful ambiguity"?

david maisel: Sure. I think that decision dates from seeing some viewers at an exhibition in 1990 or so, in which they went up to one of my photographs and read the caption, which was telling what and where the image was—of cyanide leaching into fields in Ray, Arizona. That became the lens through which they looked at the work and the work became simply about the evil multinational corporation that must be foisting these poisons on us. That wasn't my intention. If anything, my hope was to show that we are complicit in making these kinds of sites ourselves. And we have to come to that understanding first before we can really move forward. This prompted the more ambiguous way of titling works, with just the numbers. The "Lake Project" does not name the lake; and "Terminal Mirage" does not reveal what the viewer is looking at or where it is. I wanted to ask the viewers for more participation; if they wanted to learn more, they would have to work a little harder for it. But I also wanted the viewer to have an aesthetic response to the image first. And, looping back to what Brian and Joanna were saying about images of fear and anxiety, I have been increasingly working with the idea of an aesthetic of terror or dread, a sort of "apocalyptic sublime." To take that emotional response and simply explain it away with a literal description seemed to undercut the power of the image itself.

edward earle: Kim, your work has reached many different alternative venues, to the extent that the Internet is an important part of it. Do you get much audience feedback in that particular environment?

kim stringfellow: Actually, I do. I usually set up some sort of interactive forum, where people can contact me. I like to have more audience participation. Some of my earlier projects, not dealing with environmental issues, were pretty successful at that. And I think of the Internet as an important forum for public art. It's an excellent way to disseminate information, text, and image, and also multimedia formats. I'm interested in reaching an audience outside of the traditional art world, and in educating that audience. As

someone was saying before, an artist's mode of address is very different from the scientific community's. Artists are good at drawing the connections between diverse issues—pointing out the contradictions and suggesting new ways of seeing. And this is important to a discussion. So, I believe artists have a lot to contribute to the scientific community. I'd like to see more art and science people working together, and to see that transdisciplinary collaboration embraced more in the art community.

edward earle: In everybody's work now there seems to be a proposition about the future. But let me ask Mary: How do you see our ecological future?

mary mattingly: Several possible directions interest me. One is globalization, which might lead to a homogenization of many cultures and many ideas. Already, McDonald's and Banana Republic are everywhere. Lately, I've been making wearable homes based on this idea. My idea is that if we put together clothing from all over the world it might resemble this one thing, and this would be like a global uniform. Another interesting tendency is the open-source model, which we're seeing all over the Internet. That can be seen as a positive development. For instance, what I would love to see in the future is that we could actually print out our clothes from the computer, and it would be a free service. It would be like 3-D modeling, but on a different level, with a sewing machine. And it could be offered to whole towns of people that need clothing. I've also been working on water purification systems, and through open source I'm getting lots of feedback on the best and most practical ways to do that in a variety of situations. This is a kind of collaboration that could even be done in corporate settings.

david maisel: This question of how our work relates to the future—or what our views might be of the future—is a very provocative one. My personal sense is perhaps less utopian than others. But these works may lead to certain dialogues, or to certain kinds of change of consciousness. I would be thrilled if that were the case.

We were talking earlier about the political nature of the work—perhaps the political nature of the work is the making of the work itself. It's difficult to predict what effect the work may have, but within the realm of human behavior, the choice to make this kind of work is, in and of itself, a political act.

mitch epstein: And in strange ways, art often does foretell the future. It can send up signals. In the year 2000, I made a picture without an overt political agenda, photographing my father and his family business. I took a flag that was wrapped in dry-cleaning plastic and put it on a pink wall. The image wasn't intended to be a profound statement on the flag. It was about something that had meaning for my father. Then, a year later, after 9/11, that flag took on a host of loaded political connotations. And so imagery that is sensitive to the landscape has the potential over time to resonate within a larger social context.

Environmentalism and Art

joanna lehan: Do you consider your work a form of activism?

broomberg and chanarin: Photography is an efficient space in which to act, a language with a vocabulary that is relatively easy to master and reproduce and with which you can infiltrate many different public spaces, from newspapers to the walls of galleries. If you are nimble, you can use the vocabulary and the contexts to communicate different things to many different people.

stéphane couturier: We do not need to appear naive, or believe in a photographic neutrality. Photography is not simply a document, it is a tool for thinking about the world, a revelation on the upheavals that will affect our way of life in the years to come.

carol squiers: Put another way, do any of you consider yourselves activists or environmentalists?

yannick demmerle: Absolutely not, especially as photography is a very polluting artistic practice.

harri kallio: Sure. Why not? I have nothing against that kind of label. But I think, also, in terms of the context of the work, I'm just as interested in the dodo as a historical character.

an-my lê: I am not an activist. While political realities inform my work, my photographs are personal documents, they are the result of my own experience. It's a personal response that is contradictory, unresolved, and far too messy to be defined as coherently political.

joan fontcuberta: I am sensitive to environmental issues, which are important to me when political parties propose their programs—but I don't consider myself an activist.

wout berger: I do not consider myself to be an environmentalist. In the current environmental discussions my contribution as a photographer is purely visual. Text and explanation are more to be trusted to scientists and academic journalists. Artists use their imagination to support the discussion by making associative connotations; an emotional process can stimulate rational consciousness. Art is not a literal medium; at most, art can start the discussion.

francesco jodice: I try to be an activist. I consider my art "political." For me, political art doesn't mean to talk about political facts. In my research I try to make my projects trespass through different systems of communications in order to reach a different and more diverse audience.

lou dematteis: I am not an activist per se. I consider myself a concerned photographer. My job is to bring public awareness to problems in the hope that the documented wrongs will be righted. As a concerned photographer, I have used my camera in the fight for social justice. Included in this, and indeed becoming increasingly important, is the fight for environmental justice.

carol squiers: Returning to a question broached by David Maisel—whether art can stimulate political engagement—do you believe artists can effect concrete social change?

victor schrager: Rarely—most often their work is only accessible/meaningful/tolerable to viewers with sympathetic sensibilities in the first place, and influential primarily in hindsight.

patrick brown: I am primarily a photographer who works on issues that need attention brought to them. Of course, the point of working on such issues is to bring about greater awareness, which is hopefully a step toward change, although it requires much more than me doing this work to achieve this. In essence I am giving information to people so that hopefully they can then be affected enough to do something further, which I can't necessarily do myself. So, in a sense, I think it is possible for artists to be involved in political change, though it requires the involvement of many others to make this happen. What I do is just one step in a long process.

simon norfolk: Can artists effect change? Not "artists" as I understand the term—not as it is defined in practice by those around me who call themselves "artists." In modern usage, the term has come to mean "useless self-indulgent, self-referencing layabouts." I imagine the powers-that-be must be delighted that artists, who once represented a powerful force for social critique, have been so emasculated by years of art-school mumbo-jumbo and state financing. I've been reading recently about the artists from around the world who put their beliefs on the line and volunteered to fight fascism in the Spanish Civil War. I was brought to a dead halt by the phrase "a trench full of poets"—I can't think of anything more beautiful or more tragic. And I can't think of a phrase that I miss hearing these days so much. That the question can even be asked shows how far we are from having a meaningful conversation about this. If a photographer has a picture in the *Daily Worker*, they are "political," an "activist," a "propagandist." If they have a picture in *Time* magazine, they are "objective" and "balanced." But I read *Time* (as a non-American, i.e., like most of the world) and it reads to me like English newspaper reports of the 1850s—self-satisfied and self-censored jingoism of the ugly flag-waving, teaching-the-Fuzzy-Wuzzies-a-lesson, white-man's-burden kind. What you call "patriotism" I call "ultra-nationalism." That all of this is wrapped in the bullshit of "editorial integrity" and "journalistic objectivity" is just laughable. We're all propagandists, and one day my trench full of poets might be facing yours. Who'll be "an activist" then?

robert adams

Landscapes of the American West have remained the principal focus of Robert Adams's work since the late 1960s, when he began to photograph his adopted home state of Colorado. Eschewing the romantic allure of the Rocky Mountains, Adams instead chronicled the growth of suburban communities near Denver and Colorado Springs. These black-and-white pictures of tract housing, strip malls, and parking lots offered a sobering update of nineteenth-century American frontier photography. Not only did they document commercial and residential incursions into previously untouched wilderness, but they also captured ironic scenes of confinement and insularity in an area known for its wide-open spaces.

A similar sobriety informs Adams's most recent body of work, "Turning Back: A Photographic Journey" (1999–2003). This ambitious series of 164 photographs was inspired by the bicentennial celebration of Lewis and Clark's historic expedition through the Northwest Territory. Between 1999 and 2003, Adams partially retraced the explorers' path in reverse. Beginning at the mouth of the Columbia River, he traveled inland through the Cascade Mountains and ended his own abbreviated journey in the plains of eastern Oregon.

All too predictably, Adams's photographic record of his historical backtracking documents a parallel reversal of fortune for the natural glory of the Pacific Northwest. As many of these pictures demonstrate, nearly all the ancient, old-growth forests that greeted the arrival of Lewis and Clark have been harvested by timber companies in the intervening centuries, mostly within the past several decades. This exploitation is expressed by numerous images of vast, unrelieved stretches of felled trees, or the occasional close-up of a massive, violently uprooted stump. But Adams also trains his camera on many ordinary scenes of the contemporary Oregon landscape, as when he shoots a roadside meadow framed by a stand of small, unremarkable pines. Though quieter and less dramatic, the very banality of such pictures speaks volumes to the loss of a regional wilderness that once inspired nothing less than awe.

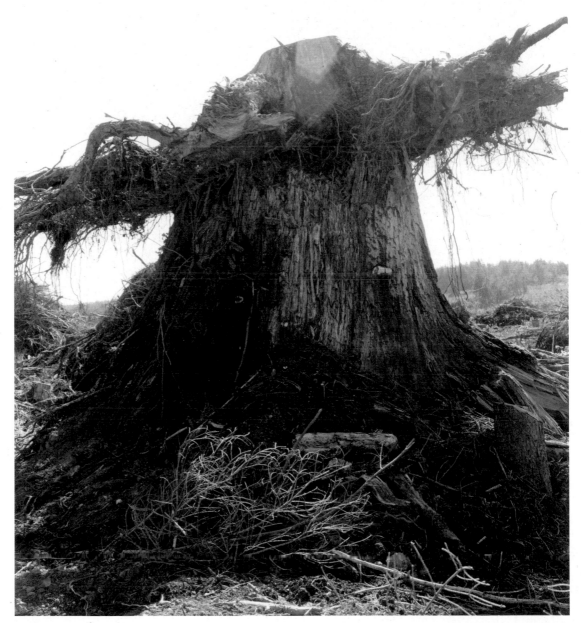

Coos County, Oregon, 1999

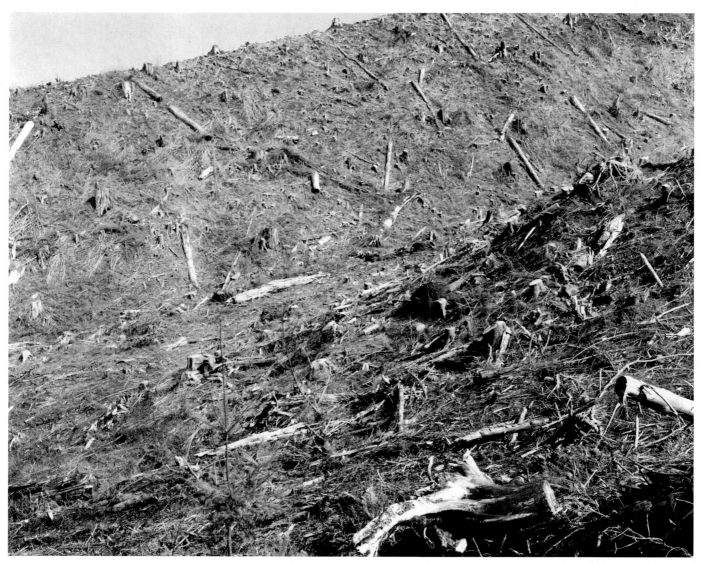

Clatsop County, Oregon, 2001

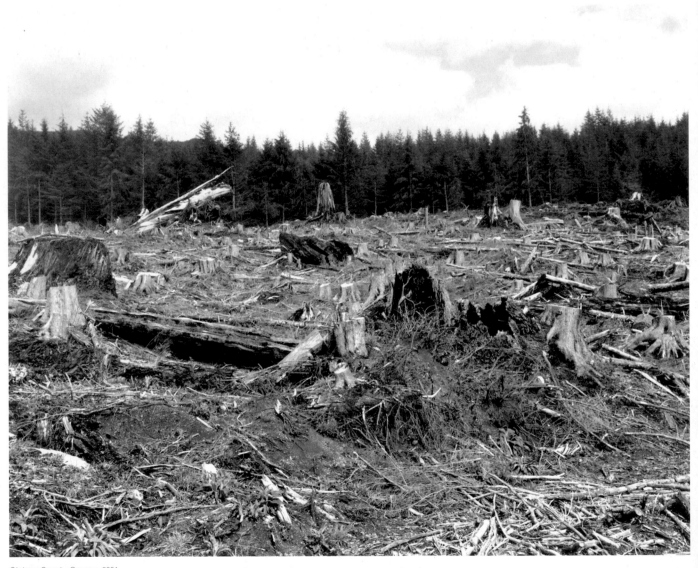

Clatsop County, Oregon, 2001

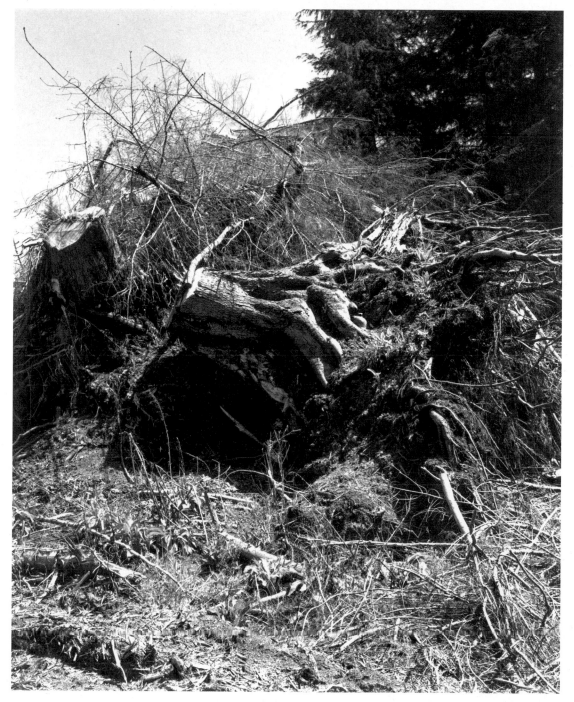

Clatsop County, Oregon, 2001

doug aitken

Best known for his video installations, Los Angeles–based artist Doug Aitken also works in film, photography, and sound. Though his materials are diverse, much of his work exhibits an overriding interest in experimenting with the relationship between time and space, and his multimedia installations sometimes function as environments designed to disrupt the viewer's taken-for-granted sense of temporality and perspective. In video installations, like *Interiors* (2002), individual actors often inhabit fragmentary narratives and struggle with the subjective experience of modernity.

While one might find in his work an interest in the supposedly deterritorialized effects of globalization, it is also in some sense distinctly Californian, often featuring fleeting, bright-as-day juxtapositions that for many characterizes the disorienting experience of such improbable cities as Los Angeles—cities that continue to grow without any apparent relationship to human scale, the environment, or available natural resources. *Plateau* (2002) depicts a convoluted and claustrophobic megalopolis made entirely of FedEx boxes. Other images from the series also feature futuristic cities composed of IBM, Macintosh, or Coca-Cola boxes, populated, if at all, only by swans, sparrows, and other birds. The cardboard birdhouses in *Plateau* were designed to resemble brutalist and utopian building styles by such architects as Mies van der Rohe, Le Corbusier, and Buckminster Fuller. Piled on top of each other, they became a bird habitat in the artist's studio.

The composite photograph frustrates perspective and renders the city a bottomless, overdeveloped maze—as Aitken has said, "like Kuala Lumpur in 2060." At first the image seems like a creative (if neurotic) use of recycled materials, a clever appropriation of the waste produced by global lifestyles that demand "the world on time." But there remains an unsettled tension in the work as well.

Aitken refers to the work as a "meta-city"—a city that is beyond itself and which comments on itself. The building styles remind us of ideologies that contain both utopian and fascist impulses. Emblazoned with corporate logos and built in an apparent frenzy of construction, the city is chaotic, sanitized, and anonymous, humbled by the indifference and the curiosity of the disproportionately large birds. The presence of the birds evokes Darwinian questions of survival, and the work itself then seems to be a metonymic experiment in natural selection, rendering the empty corporate city an artifact of an almost desperate will to build, conquer, and survive.

Three Cards, 2006

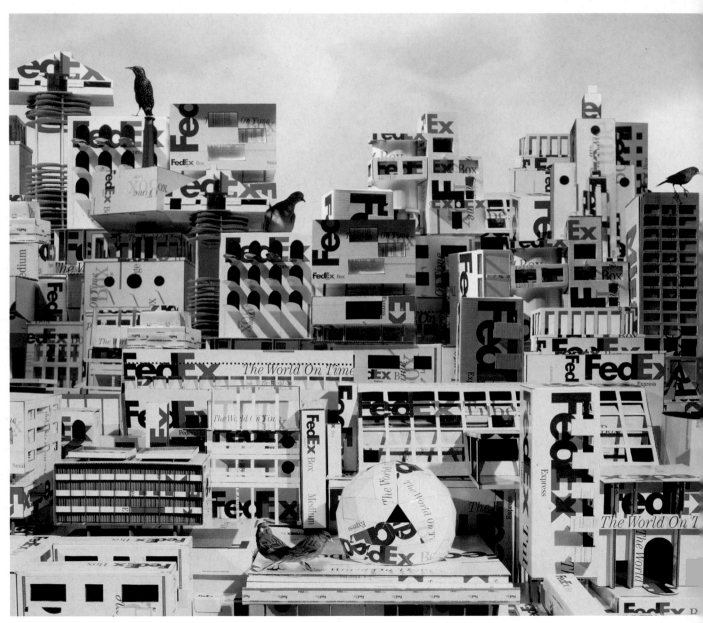

Plateau, 2002

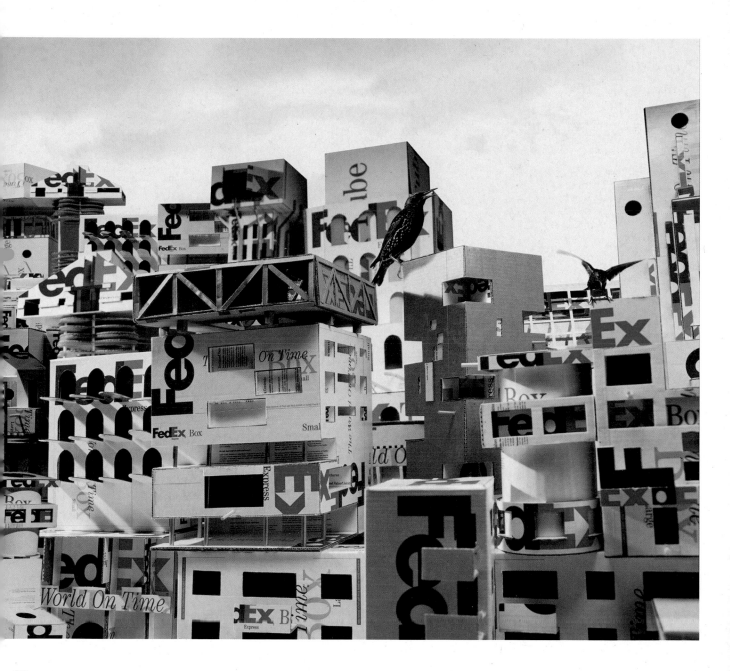

Digital, 2005

New Opposition III, 2003

allora & calzadilla

Working as a collaborative team since 1995, Jennifer Allora and Guillermo Calzadilla have together conceived numerous projects that seamlessly fuse art and activism. Though their work has appeared in galleries and museums, they often operate in the public sphere, where they provide tools and media for interactive events that rely on audience participation. By encouraging specific local communities to articulate a diverse range of creative voices, Allora & Calzadilla seek to counter the homogenizing forces of globalization.

Related issues have been raised in several short films this duo has made in recent years, including *Returning a Sound*, shot in 2004 on the small Puerto Rican island of Vieques, which was used as a bomb testing site by the United States military until 2003. To commemorate the years of local protests that led to the island's eventual reclamation, the artists welded a trumpet to the muffler of a moped, and then filmed a young man driving the noisy vehicle around Vieques. As the mobile trumpet blares through the newly accessible landscape, its changing notes sometimes sound like celebratory music. At other points the same instrument seems to be sounding an alarm, perhaps alluding to the uncertain consequences of the island's ballistic contamination.

A different sort of journey grants a loose, narrative structure to *Amphibious (Login-Logout)*, a short film from 2005 that observes the flow of traffic along China's Pearl River. Here the main protagonists are a group of six tortoises that appear to be sunning themselves on a free-floating log. As they slowly travel downstream, alternating point-of-view shots capture scenes of development along the river's banks. Early daytime sequences of swimmers, fishermen, and small, ramshackle boats gradually give way to evening views of apartment complexes, industrial loading docks, and massive cargo ships piled high with international shipping containers. Dwarfed by this context of increasing construction and commerce, the vulnerable tortoises may speak to the ecological degradations that attend China's rapid entry into the globalized economy. Yet their curious refusal to leave their log also seems to demand recognition of this phenomenon.

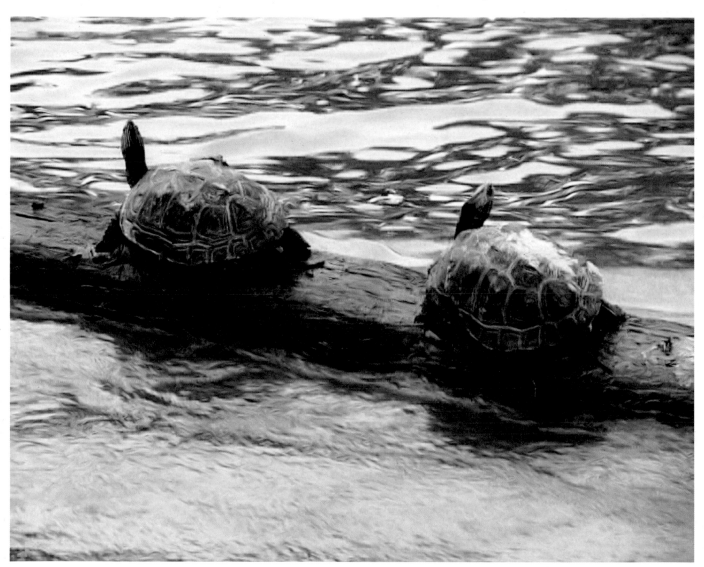

Amphibious (Login-Logout), 2005

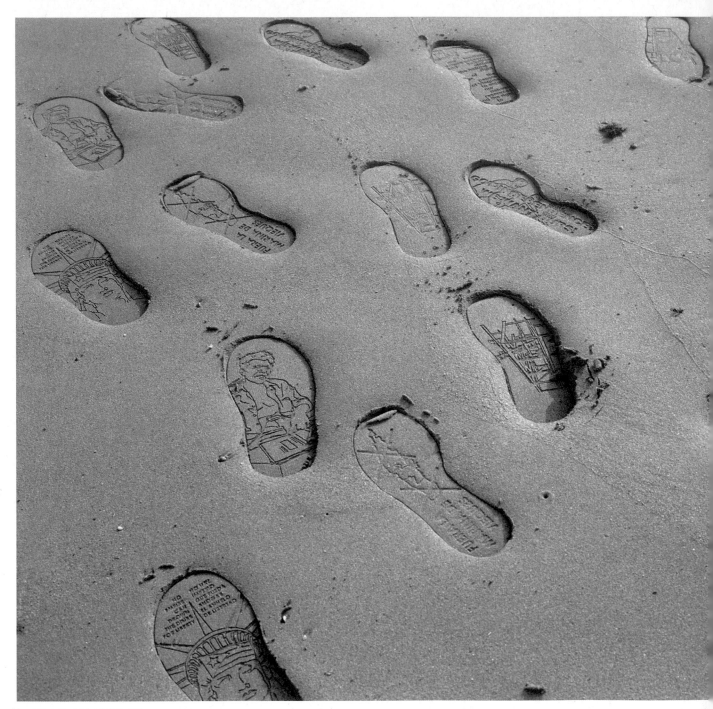

Land Mark (Foot Prints), 2001–2002

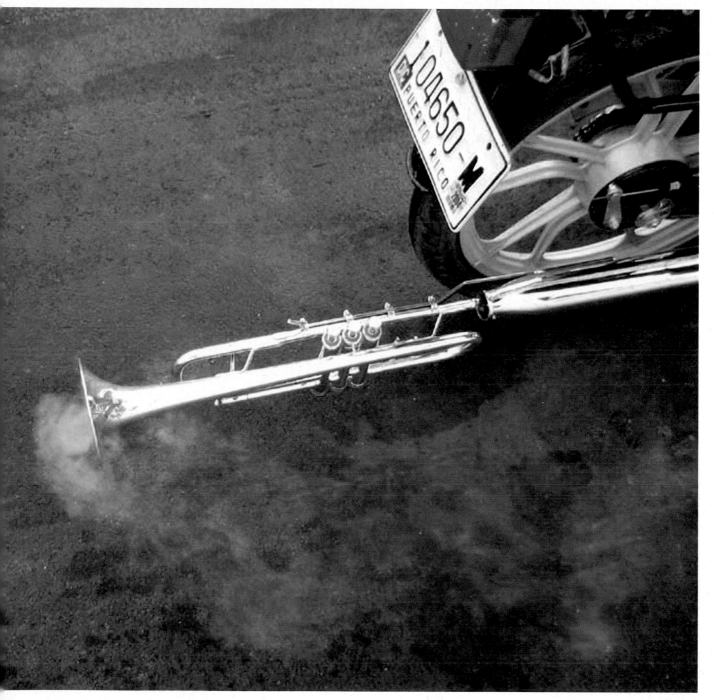

Returning a Sound, 2004

wout berger

To many, the Netherlands are synonymous with flowers. Mention of the country often conjures thoughts of sunny daffodils, fragrant hyacinths, and tall, stately tulips. Dutch photographer Wout Berger addressed this stereotypical image of his homeland in a 2000 series known as "Sand, Water, Peat." Though replete with colorful blossoms, Berger's photographs also depict the enormous greenhouses and manicured fields that contain and control their growth. His pictures remind us that many of these flowers were imported to the Netherlands in the seventeenth century and have since been carefully cultivated, hybridized, and modified into aesthetically pleasing cash crops.

The commercial exploitation of nature has remained a theme of Berger's photographs and informs a more recent series titled "Ruigoord" (2002). Named after a small village near Amsterdam, these pictures document a large plot of land that was recently covered in sand to accommodate urban sprawl and future building projects. To protect against erosion, the loose sand was heavily seeded and now supports an array of common weeds and wildflowers. Berger's photographs offer intimate views of this provisional soil. The chalky, gray sediment cloaks the ground like volcanic ash, and we may be surprised that any plant can survive in this altered environment.

Yet this same barren backdrop heightens our awareness of the struggling seedlings. Individual stems are clearly legible against the neutral ground. Pale blue cornflowers and pink cosmos occasionally punctuate these photographs with unexpected flashes of color. Because Berger shoots downward and eliminates the horizon, these rather ordinary plants become striking, painterly elements in flat compositions. This aesthetic transformation certainly speaks to the resilience of nature, its ability to adapt and flourish in the wake of human encroachments. But the "Ruigoord" series also demands a reconsideration of the pastoral tradition. As bucolic vistas increasingly shrink from the realm of possibility, Berger's photographs urge us to appreciate organic beauty wherever we can find it.

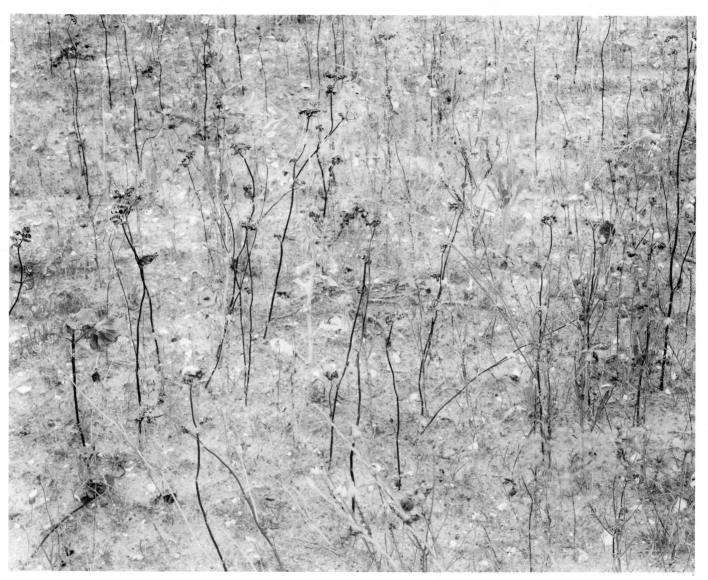

Ruigoord 2, 2002

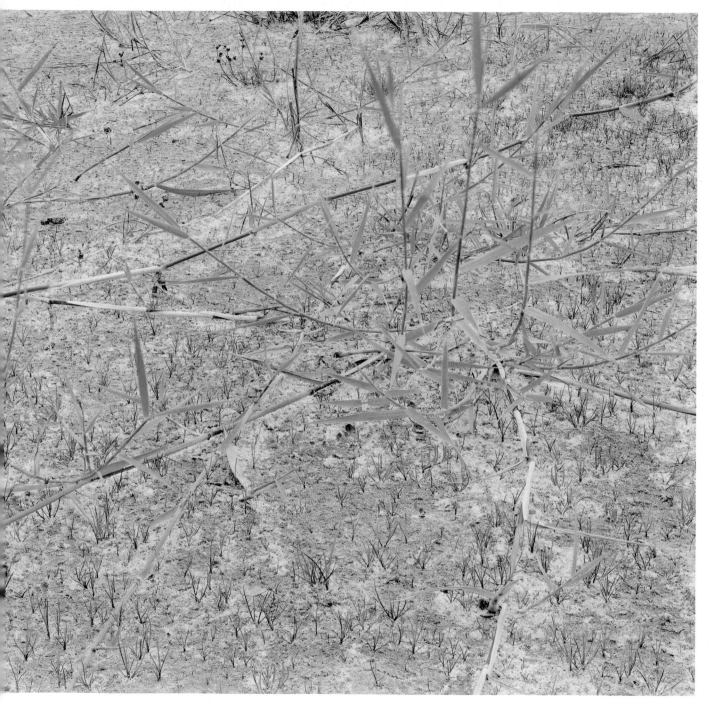

De Kerf, 2002

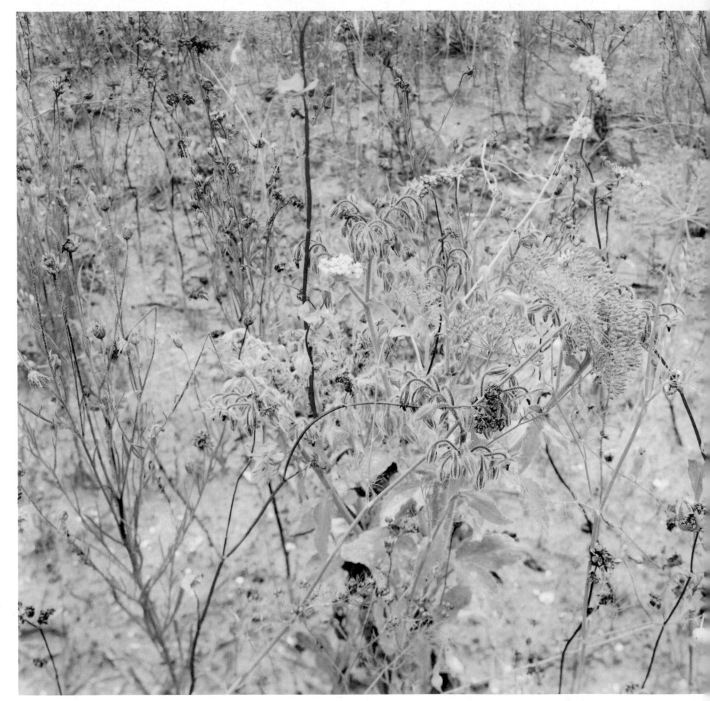

Ruigoord 3, 2002

adam broomberg and oliver chanarin

Since the founding of Israel in 1948, more than ten million pine trees have been planted within the country's shifting borders. This ongoing endeavor is largely overseen by the Jewish National Fund, which secures donations for saplings from around the world, organizes planting excursions for tourists, and often incorporates this green gesture into state visits by foreign dignitaries. Though many of the trees are planted as personal memorials to loved ones, the expansion of Israeli forests is broadly promoted with the slogan, "Making the desert bloom," an ostensibly ecological phrase that also functions as a metaphor for revitalized Israeli identity in the modern era.

Adam Broomberg and Oliver Chanarin have explored this general phenomenon in a series of color photographs titled "Forest" (2005). But the specific sites they have chosen to document are former Palestinian villages that were evacuated and destroyed at various times since 1948. Each razed village has since been planted with stands of pine trees that gradually colonize the reclaimed lands and obscure their histories of devastation. That this aspect of Israeli forestation efforts is rarely acknowledged is illustrated by the ongoing debate surrounding Canada Park, a West Bank picnic area that has flourished among the ruins of Imwas and Yalu, two ancient Palestinian villages that were decimated in the Six Day War of 1967. Recent petitions to describe this history in the park's informational signage have met with resistance.

In light of such events, one is inclined to interpret the depopulated stillness of the "Forest" series as a metaphor for historical erasure, and perhaps read the well-worn paths and rock-strewn grounds as traces of villages that are no longer there. Yet without prior knowledge of these sites, Broomberg and Chanarin's photographs are rather opaque, and appear to depict a pristine wilderness of old-growth trees that has witnessed little human intervention. While underscoring the influence of contextual information, these ambiguous pictures also challenge our readiness to attribute mostly positive values to the growth and nurture of the natural world.

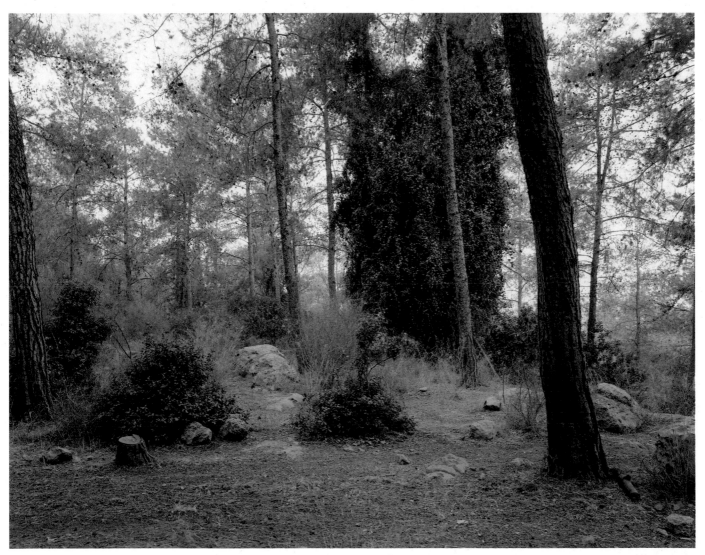

Rabin Park, 2005

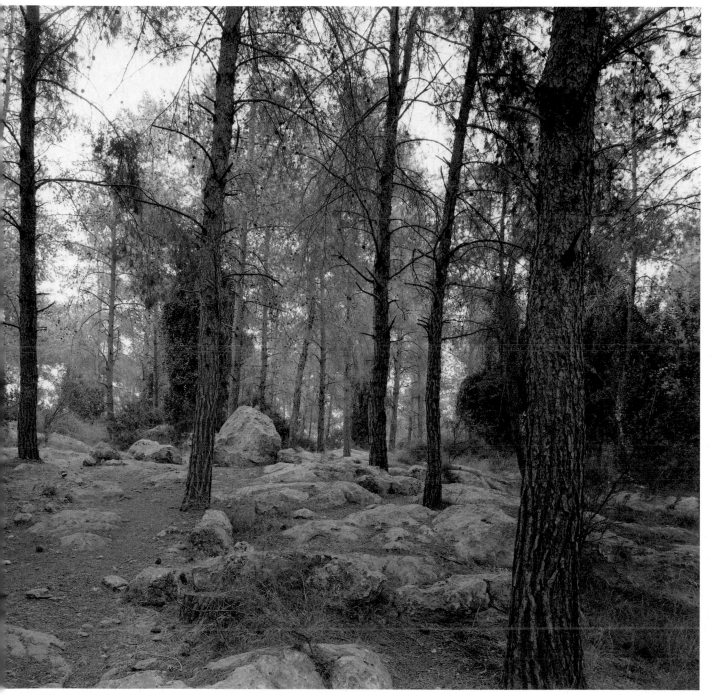

Canada Park, 2005

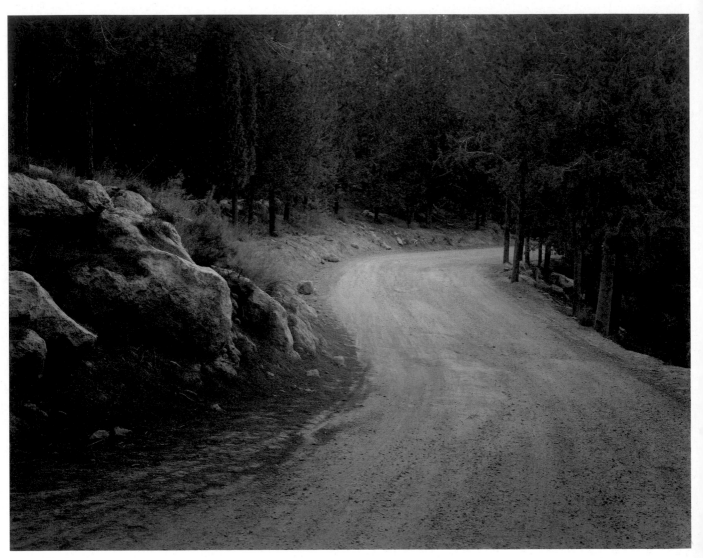

Ben Shemen Forest, 2005

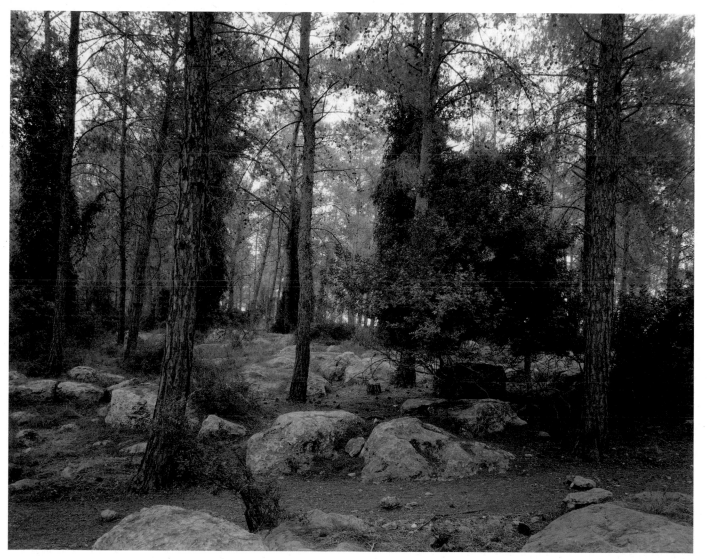

The Saints Forest, 2000

patrick brown

A native of Perth, Australia, Patrick Brown lives in Bangkok and photographs throughout Southeast Asia for mainstream publications such as *Time*, *Der Spiegel*, and *The Guardian*, as well as organizations like UNICEF and the United Nations Development Programme. Over the years, he has photographed coal-mining strikes in Vietnam, street kids in Nepal, and the results of the 2004 tsunami in Aceh. In his recent project "Black Market: The Trafficking of Endangered Species in Asia" (2002–2005), Brown has documented the poaching and trafficking of endangered species throughout Asia. The numbers are staggering: according to Brown, between 25,000 and 30,000 primates, 2.5 million birds, 10 million reptile skins, and 500 million tropical fish are exported each year from Asia. They are sold for their skins or tusks, or because their organs or body parts are believed to have health benefits if consumed.

The consequences of poaching are dire, in terms of endangering rare species as well as the ecological balance of a given region. But Brown's dark, rich images elicit a degree of sympathy for the poachers, too, who are often trapped in economically desperate circumstances. An image of a group of poachers in a dank, dark cell of a military jail, for instance, shares a sense of despair with a photograph of a visitor poking at a tiger through the bars of a cage in a decaying zoo in Calcutta. Beyond the larger issue of endangered species being plundered, Brown's pictures illustrate the base cruelty that trickles down from humans to animals in this trade: a fifty-year-old elephant in Chitwan National Park in Nepal, whose front legs are chained together; a rare Burmese python sitting unprotected in the midday sun while its owners wait for tourists to have their pictures taken with it; or the blinding lights from the cameras of journalists surrounding a lone pangolin—a kind of anteater considered a delicacy in Asia—that had been intercepted at Bangkok's airport.

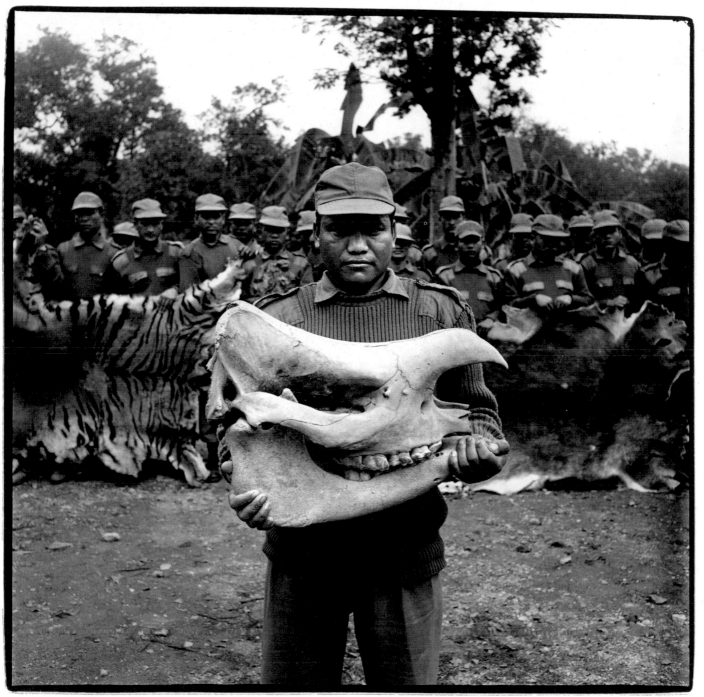

from *Black Market: The Trafficking of Endangered Species in Asia*, 2002–2005

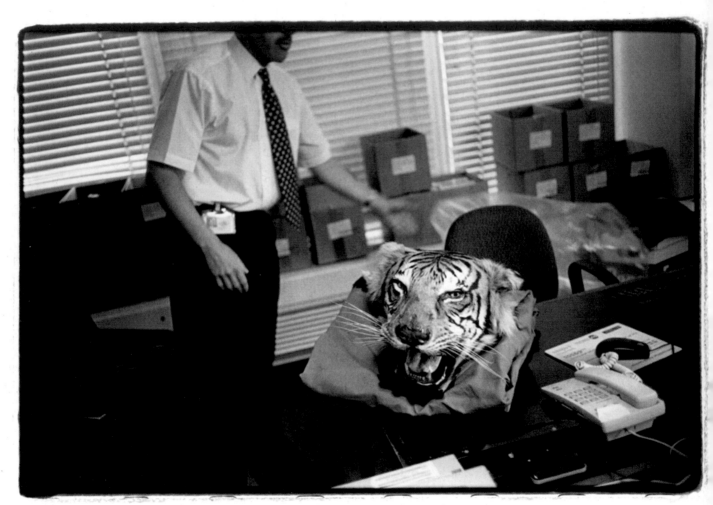

from *Black Market: The Trafficking of Endangered Species in Asia, 2002–2005*

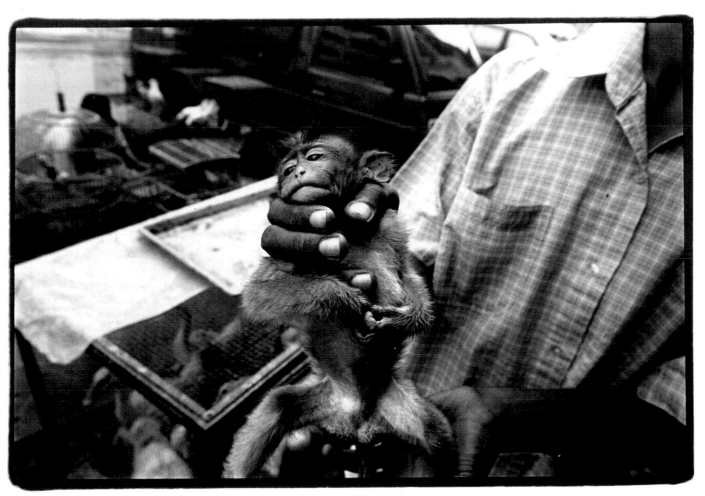

from *Black Market: The Trafficking of Endangered Species in Asia*, 2002–2005

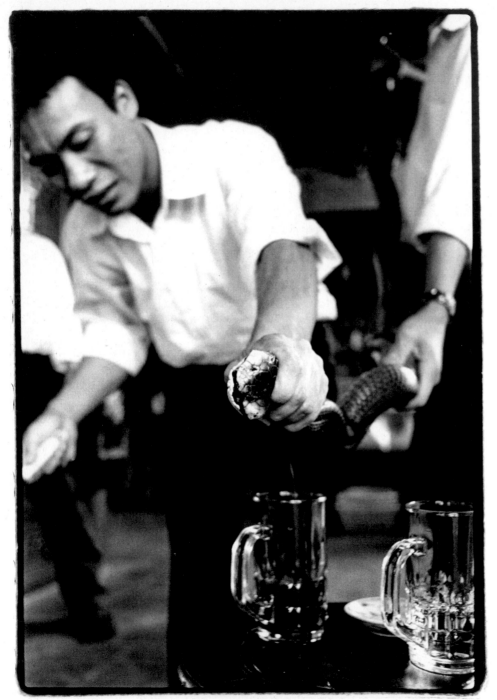

from *Black Market: The Trafficking of Endangered Species in Asia*, 2002–2005

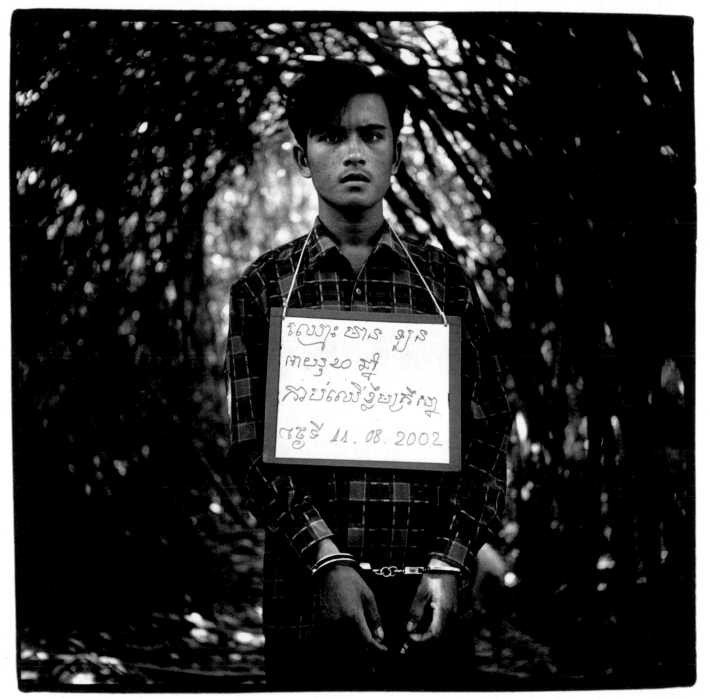

from *Black Market: The Trafficking of Endangered Species in Asia*, 2002–2005

catherine chalmers

Working out of a loft in Soho and a barn in upstate New York, Catherine Chalmers raises a variety of insects, rodents, and reptiles that are the principal subjects of her photographs and videos. Chalmers first commanded significant attention for "Food Chain," a 1997 series of color photographs that documents the eating habits of several small animals. Among other encounters, "Food Chain" features a group of tomato-devouring caterpillars that eventually provide nourishment for a praying mantis, which in turn becomes a quick meal for a hungry tree frog. Shot in extreme close-up against blank, white backgrounds, these sequential images guide viewers through an orchestrated spectacle of predatory consumption that is alternately fascinating and repellent.

In subsequent bodies of work, Chalmers has continued to plumb our ambivalent feelings toward creatures that occupy the lower rungs of the evolutionary ladder. In the late 1990s, she began to focus on the common cockroach, eventually producing a series of sculptures, drawings, and photographic images inspired by this widely reviled insect. Titled "American Cockroach," this project includes several photographs and videos that stage mock executions of the artist's homegrown bugs in miniature tableaux of electric chairs, gas chambers, and mass lynchings. By depicting cockroach death in distinctly human terms, Chalmers solicits an unexpected sympathy for an insect that most viewers would readily squash beneath their feet without a moment's remorse.

A similar empathy is demanded by *Safari* (2006), a recent film that surveys the animal kingdom from a roach's perspective. Navigating a lush, verdant set that Chalmers constructed in her studio, the ground-hugging camera encounters a variety of insects, amphibians, and reptiles that assume gigantic proportions before our eyes. This illusion of immense size, especially when two rhinoceros beetles lock horns in aggressive combat, can evoke B-movies of the Cold War era that imagined irradiated insects ruling the earth. Yet this intimate vantage point also magnifies the striking physical beauty of these truly tiny creatures, inviting an appreciative reappraisal of numerous species we typically overlook and devalue as mere pests.

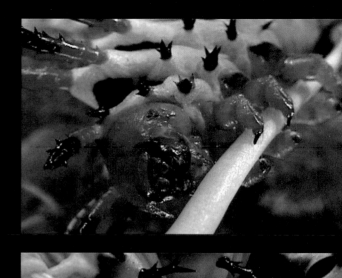
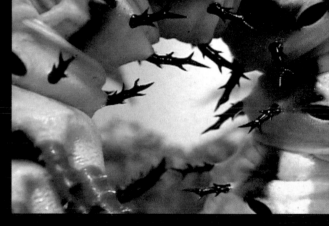
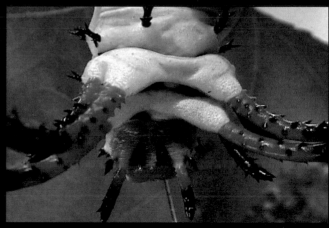

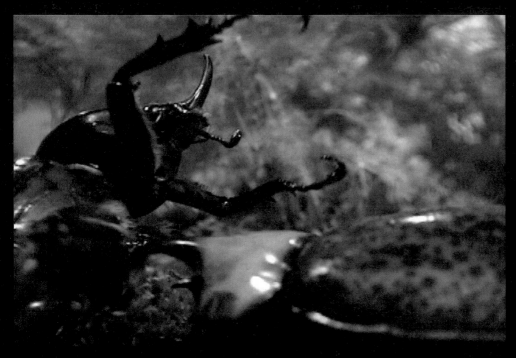

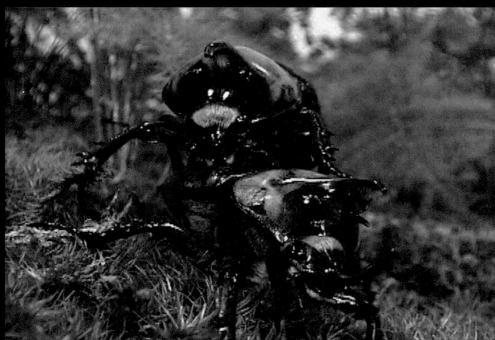

Safari, 2006

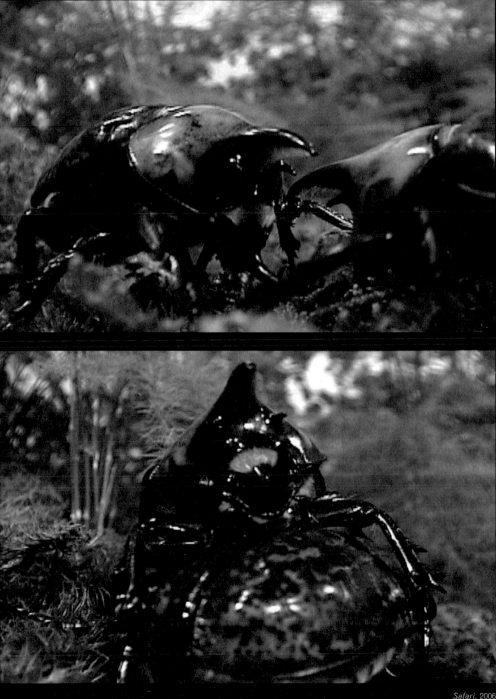

Safari, 2006

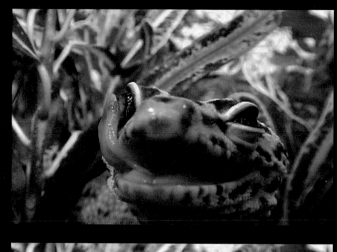

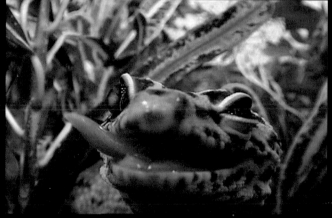

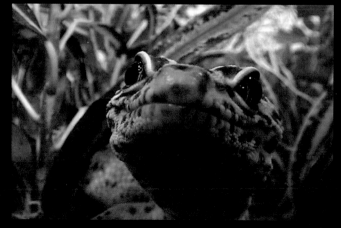

Safari, 2006

stéphane couturier

Stéphane Couturier has photographed construction sites for the past decade. Working in Paris, Berlin, Moscow, and other major cities, Couturier documents the physical transformation of urban environments. His pictures focus on facades, foundations, beams, pipes, scaffolding, and cranes while also indulging a rigorous formalism. Typically using frontal perspectives and careful, deliberate cropping, Couturier tends to flatten his construction scenes into striking geometric abstractions. Though saturated with vivid color, his compositions can recall the work of Charles Sheeler, Paul Strand, and other modernist photographers who distilled pictorial order from the rapidly changing urban realm. Indeed, such precedents only underscore Couturier's principal theme of cities in transition.

In 2001, Couturier embarked on a distinct series known as "Landscaping." Traveling to the American southwest, he photographed housing developments on the outskirts of San Diego and Tijuana. Forsaking the dense congestion of his earlier work, Couturier presents expansive stretches of desert, highway, and tract housing in mostly horizontal formats. A calculated formalism continues to govern these pictures, as horizons are often expunged and the landscape is frequently subdivided into wedges and bands of alternating colors.

The "Landscaping" series also addresses the subject of construction by documenting suburban sprawl. While manicured lawns and parked cars indicate that some of these houses are finished and inhabited, dozens of similar structures are being erected nearby. Couturier emphasizes the curious manipulation of nature in these soon-to-be-suburban settings. Naturally arid hills may be glimpsed along the margins of these photographs, but lush, green oases are being carefully fabricated for the housing developments. Some pictures reveal sod carpeting the desert floor. Others contain freshly planted saplings marshaled into orderly rows. Perhaps most remarkable are the trucks that spray a green vegetable dye onto roadside embankments. While undoubtedly meant to lure residents to the area with the promise of future verdure, these artificial lawns lend a disturbing irony to the notion of a "painted desert."

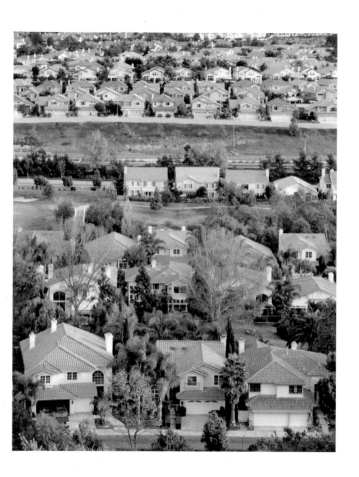
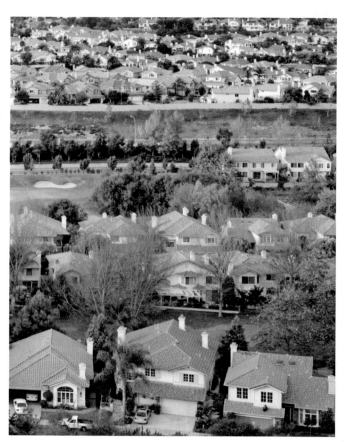

San Diego, Diptych, Carmel Valley, 2001

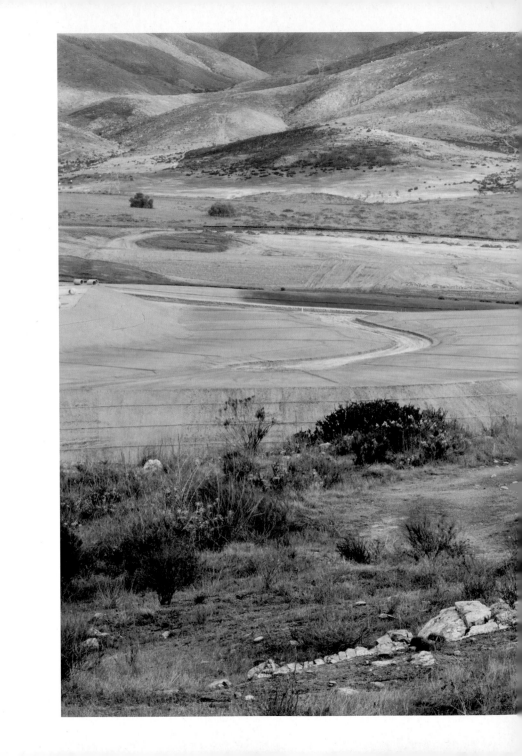

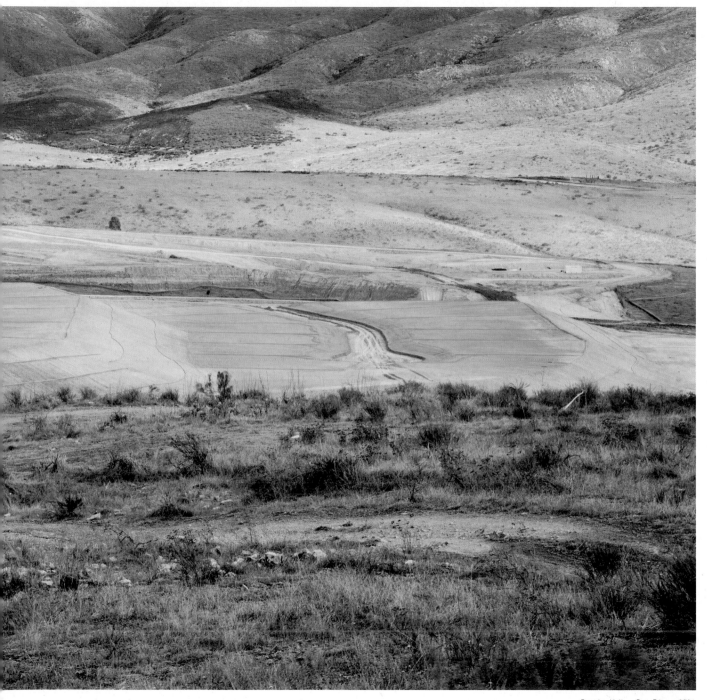

Proctor Valley, San Diego, 2004

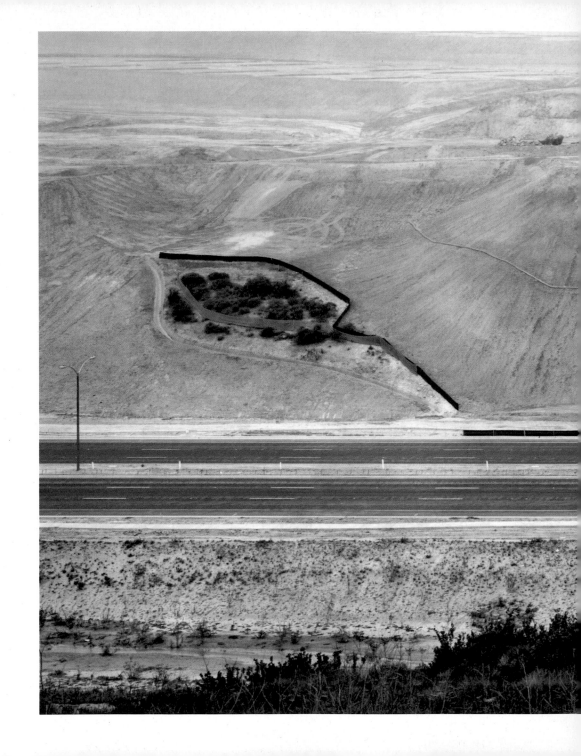

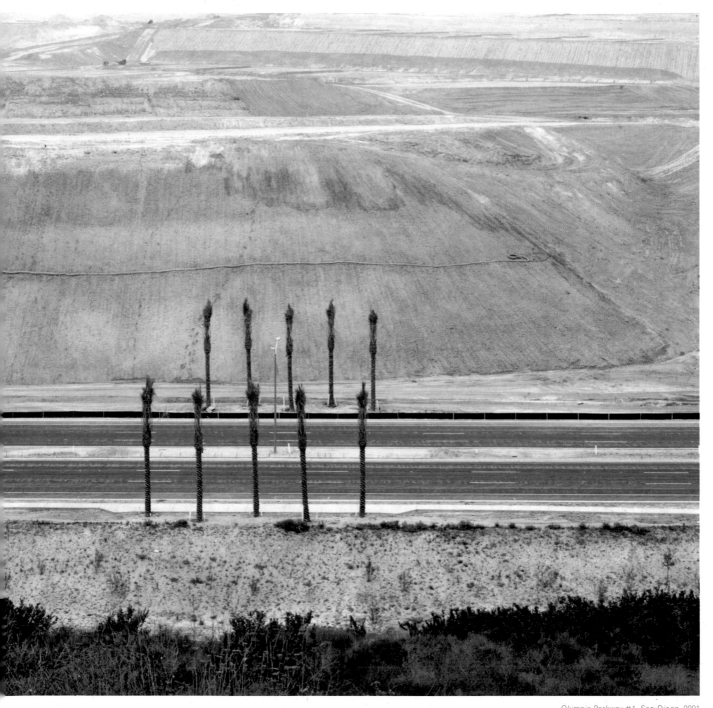

Olympic Parkway #1, San Diego, 2001

lou dematteis and kayana szymczak

"Crude Reflections: ChevronTexaco's Rainforest Legacy" (2003) is part of an ongoing campaign demanding remediation from Texaco (now owned by Chevron) for their oil waste disposal practices in the Ecuadorian Amazon from 1971 to 1992. Texaco is accused of the negligent disposal of 18.5 billion tons of toxic waste in over 600 sites, resulting in what critics refer to as a "Rainforest Chernobyl." In October 2003, a case was brought against the company (*Aguinda v. Texaco*) on behalf of 30,000 residents, including five indigenous groups, whose water and natural resources have been severely polluted by toxic dumping.

In "Crude Reflections," the photographers, Lou Dematteis and Kayana Szymczak, worked with Amazon Watch, an organization founded in 1996 and dedicated to protecting the Amazon rainforest and promoting the rights and interests of its inhabitants. In addition to the photographs, Dematteis and Szymczak also collaborated with journalist Joan Kruckewitt, who gathered first-person accounts from victims of the pollution. Throughout, residents report an extremely high incidence of leukemia, stomach, and other cancers, and birth defects. The images depict a seemingly relentless catalogue of open-air toxic-waste pools, contaminated streams, oil flares burning off excess gas adjacent to active farm land, and families debilitated by multiple deaths, amputations, and chronic illnesses. The photographers also followed the plaintiffs, many of them Amazonian Indians, as they engaged in demonstrations against Chevron and attended the hearings of the ongoing case.

Lou Dematteis is a San Francisco–based photojournalist best known for his images of the Iran-Contra scandal from Nicaragua, where he worked as a Reuters staff photographer from 1986 to 1990. He has been documenting the effects of the oil exploitation of Ecuador's Amazon since 1993. Kayana Szymczak is also based in San Francisco. Of Native American descent but without ties to her native roots, she uses photography to address the problems of endangered indigenous groups, especially those threatened by the development of oil.

While the case filed against ChevronTexaco is still pending, "Crude Reflections" and other related media projects remain critical assets in the campaign, countering the more seductive theories of globalization with evidence of the everyday human and environmental impact of the transnational pursuit of oil resources.

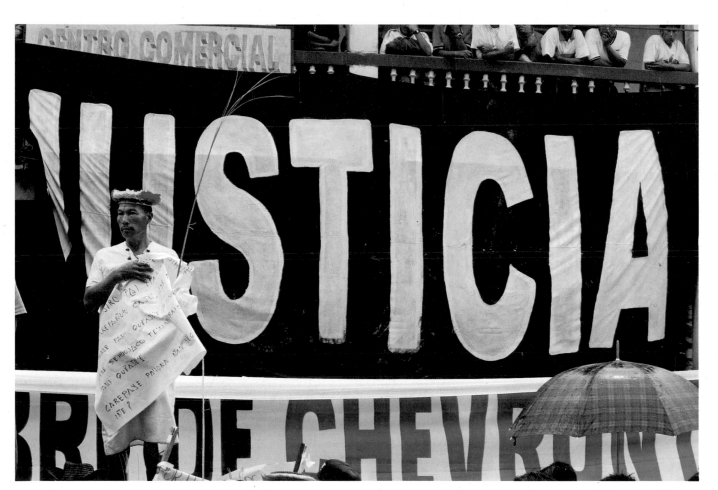

A Secoya elder at a demonstration on the opening day of the trial against Chevron Texaco in Lago Agrio, Equador, 2003

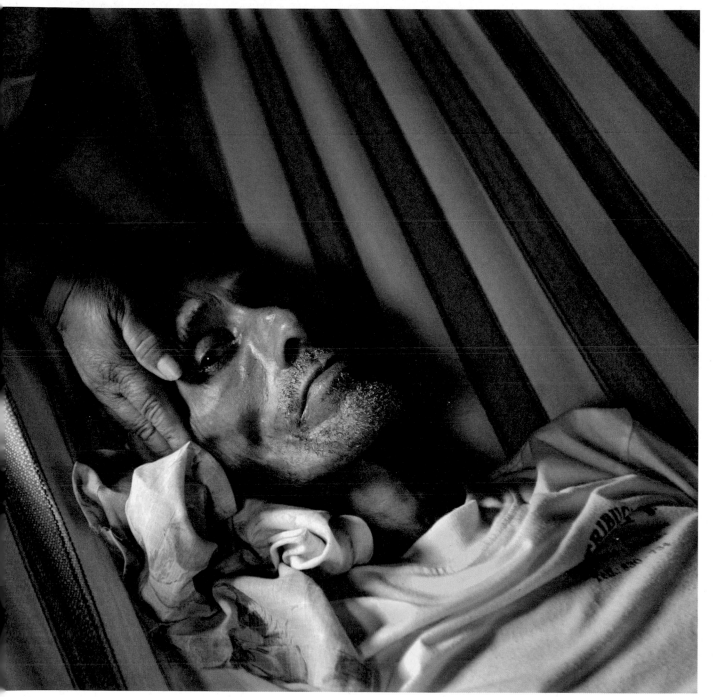

Liz Maria Marin holds the head of her husband Angel Toala one day before he died of stomach cancer in his home in Shushufindi, Equador, 2003

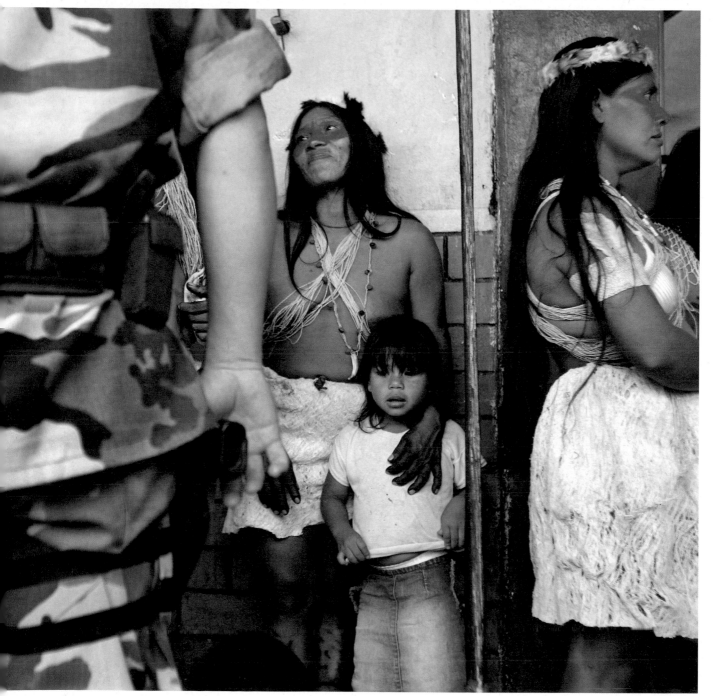

Huaorani women and military police before a march on the opening day of the trial against Chevron Texaco in Lago Agrio, Ecuador, 2003

yannick demmerle

Though based in the town of Eberswalde near Berlin, Yannick Demmerle rarely photographs the urban environment. His principal subjects are forests, which he has explored on solitary tours through rural Germany, Tasmania, and elsewhere. Working with an 8 x 10 camera, Demmerle tends to shoot at eye level from the forest floor, aiming his lens into dense tangles of branches, vines, and other natural growth. The resulting photographs are presented in mural-size formats and designed to hang low to the ground, effectively recreating his experience for the spectator.

In 2004, Demmerle shot a series of black-and-white photographs known as "Les nuits étranges." While technically similar to his other work, these nocturnal images of a German forest possess a distinctive austerity. A few slender tree trunks divide each pitch-black frame, and each is softly illuminated by an implied moon. The silvery light clarifies gnarled bark in the immediate foreground, but the rest of the forest quickly disappears into the thick, enveloping night.

Demmerle has aligned his practice with the northern Romantic tradition of landscape painting. Not unlike the work of Caspar David Friedrich or Carl Gustav Carus, his photographs typically posit a solitary viewer who quietly contemplates the majesty of the natural world. But in "Les nuits étranges," one also detects a note of the sublime, that curious mixture of awe and terror that many Romantic artists revered in nature and sought to capture in their work. Here it is summoned by the impressive scale of Demmerle's photographs and their subtle, provocative lighting, which together invite us into close, physical communion with the shimmering trees, yet ultimately leave us on the brink of a forbidding, unknowable darkness. This ambivalence is heightened by the careful cropping of the photographs, which tends to eliminate both the ground and the treetops and assert the visible trunks as rootless, vertical elements. If these trees sometimes read as the bars of an enormous cage, we are left to decide whether they keep us safe or trap us inside.

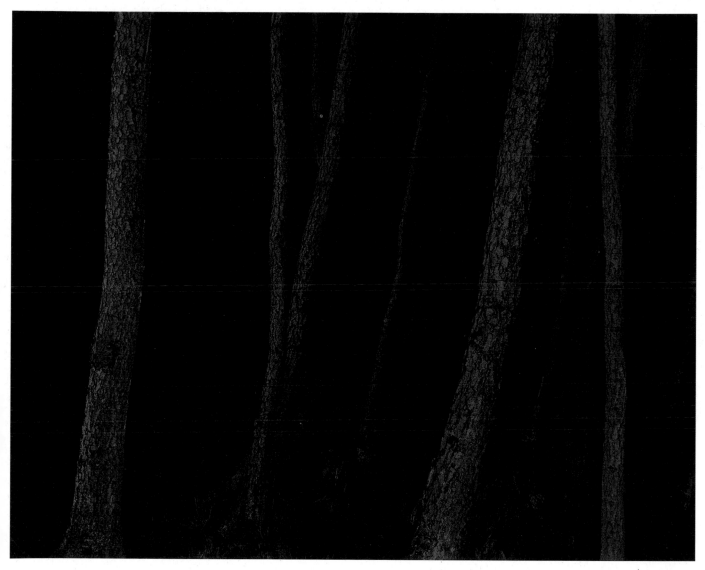

Untitled (#6), from the series "Les Nuits Étranges," 2004

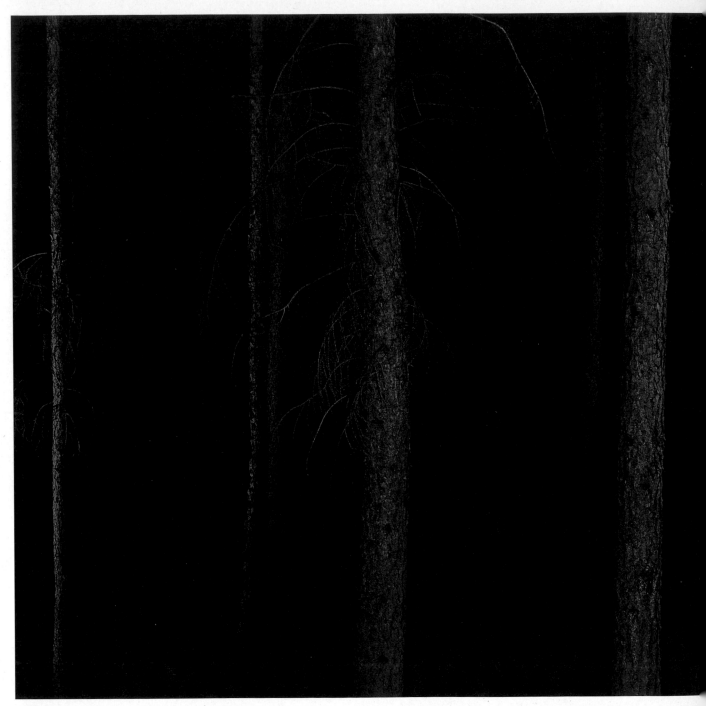

Untitled (#14), from the series "Les Nuits Étranges," 2004

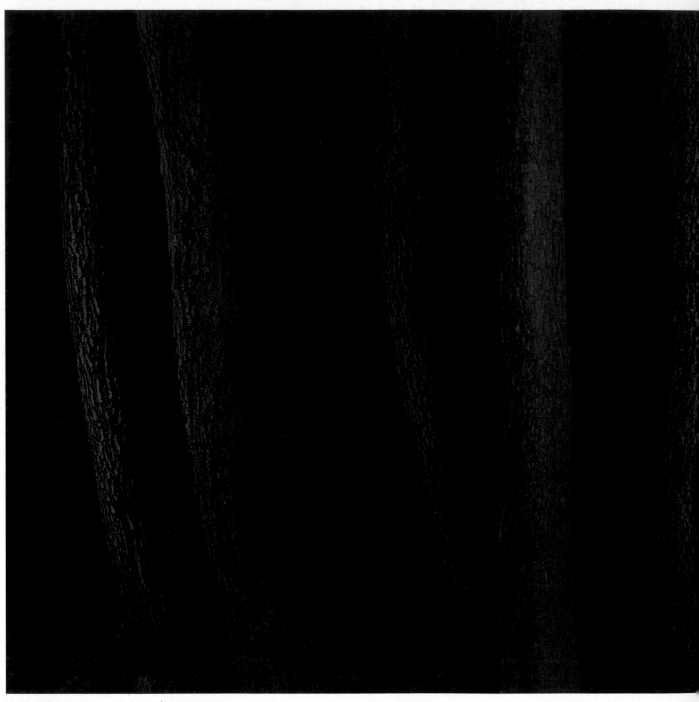

Untitled (#8), from the series "Les Nuits Étranges," 2004

goran dević

In the 1950s, when gypsy moths infested the forest near the small town of Sisak, Croatia, a flock of crows was imported to the area to control the unwanted insects. Locally known as "Veber's crows," after the government official who supposedly acquired them from Russia, the birds have since flourished in Sisak, becoming the focus of passionate debate among the town's residents. Goran Dević, a native of Sisak who currently lives and works in the Croatian capital of Zagreb, has documented recent attempts to eradicate these birds in *Imported Crows* (2004). This award-winning short film also obliquely addresses the recent history of the former Yugoslavia, demonstrating how the region's unresolved ethnic tensions can be displaced onto the natural environment.

The crow has long been a highly symbolic creature, figuring in ancient mythologies as a divine messenger and guide. In more recent times, artists from Van Gogh to Hitchcock have deployed the crow as a harbinger of death and destruction. In Dević's film, a series of informal interviews reveals that many of Sisak's residents feel the same way. They consider the crows a menace, describing how they disturb the peace, ruin flowerbeds, and multiply like the insects they were originally sent to destroy. Mere annoyance occasionally veers into hatred, as some of the residents angrily advocate the systematic extermination of the crows. Especially in these moments of heightened emotion, *Imported Crows* probes beneath the immediate issue of pesky birds and seems to unearth the deep-seated xenophobia that has plagued Croatia and other Balkan states for decades.

At least one of the town's residents explicitly links the environmental and political landscapes. A Bosnian refugee whose home was destroyed in the ethnic conflicts of the early 1990s describes the crows as victims rather than aggressors, and laments the annual efforts to reduce their population. While this man speaks to the camera, several young workers are dispatched to the surrounding treetops. Wielding long poles, they loosen countless crows' nests from the highest branches and send them crashing to the ground.

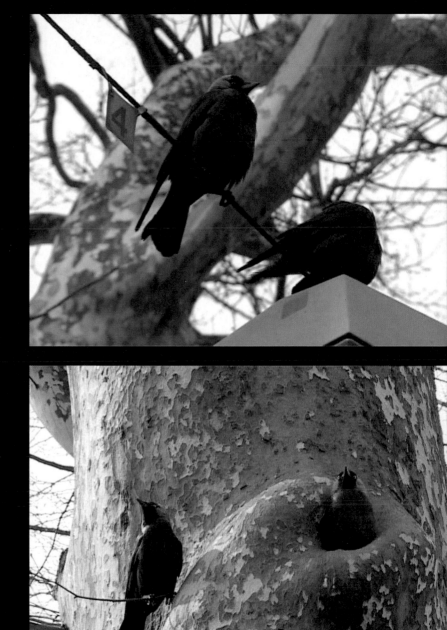

Imported Crows, 2004

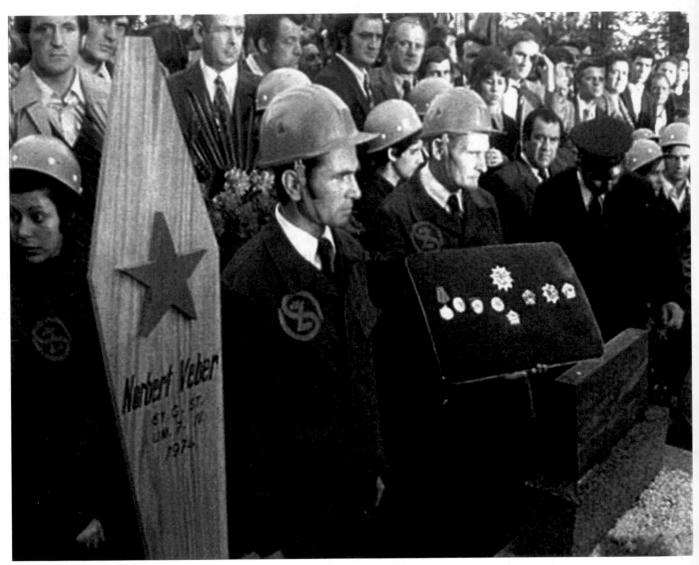

Imported Crows, 2004

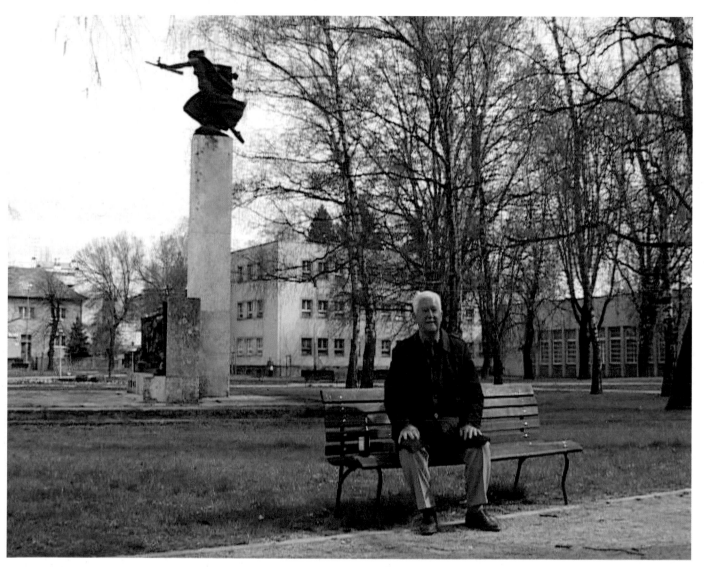

Imported Crows, 2004

mark dion

Mark Dion has spent much of his career investigating how knowledge is produced by natural-science taxonomies, distinct histories of collecting, and their associated exhibition practices. Dion recognizes the ways in which the display of specimens and objects of material culture are used to augment dominant historical, artistic, and scientific narratives, as well as the arbitrary nature of those constructs. In his ongoing series of photographs of natural history museums' polar bear tableau, for instance, he does not efface the museum context. His bears are clearly taxidermied, appearing ferocious, forlorn, cuddly, and inquisitive, and with electrical sockets, museum visitors, other displays, and even gun collections in full view. The photographs were taken in natural history museums across North America and Europe over the last decade. Together they offer a kind of typology of Western display practices and ways of engaging with nature, a range that includes the scientific, anthropomorphic, and the adversarial.

In installations, photography, and film, Dion playfully appropriates scientific modes of investigation and display not only to deconstruct museum practices but also to expand our appreciation for material culture and its relationship to collective memory and social history. As such, he maintains a real affection for the processes of collecting and discovery, and is sensitive to the aesthetic qualities and the elements of fantasy and memory that capture our attention in the first place. During the early stages of the Museum of Modern Art's renovations in 2000, Dion conducted an archaeological dig in order to produce a display of artifacts from MoMA's exhibitions and Rockefeller family history (their homes had been located on the site of the former sculpture garden), a practice he continues through his excavation of porcelain chards in the New England region in which he was born.

In his latest installation, Dion continues to gently mock and historicize our own highly contingent and mediated understandings of nature. He has set up a number of heat-sensitive "trap-cameras" on his property in Pennsylvania to capture the comings and goings of forest life, and has used them here as part of the "data" studied by a mock surveillance office. Drably institutional and yet neurotically eccentric, Dion's installation speaks of institutions so obsessed with surveillance that the enemy could be anywhere, even in the form of a retreating white-tailed deer.

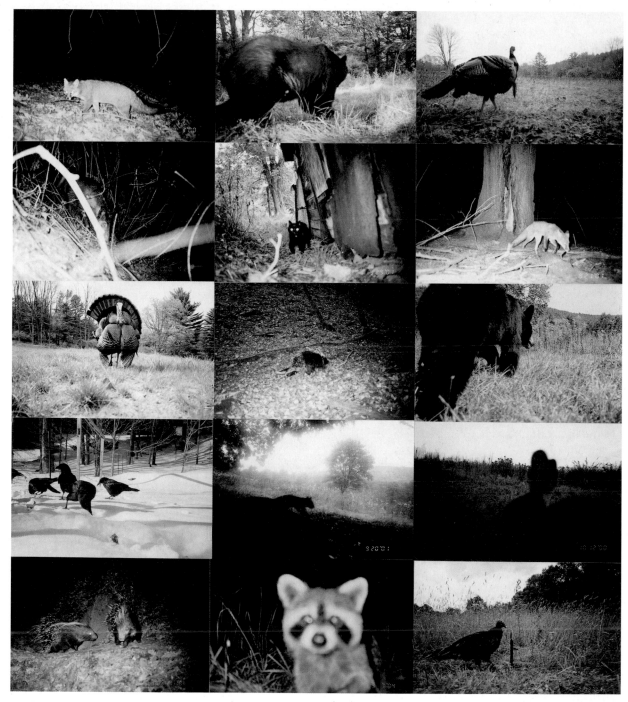

Various Mammals and Birds, 2006

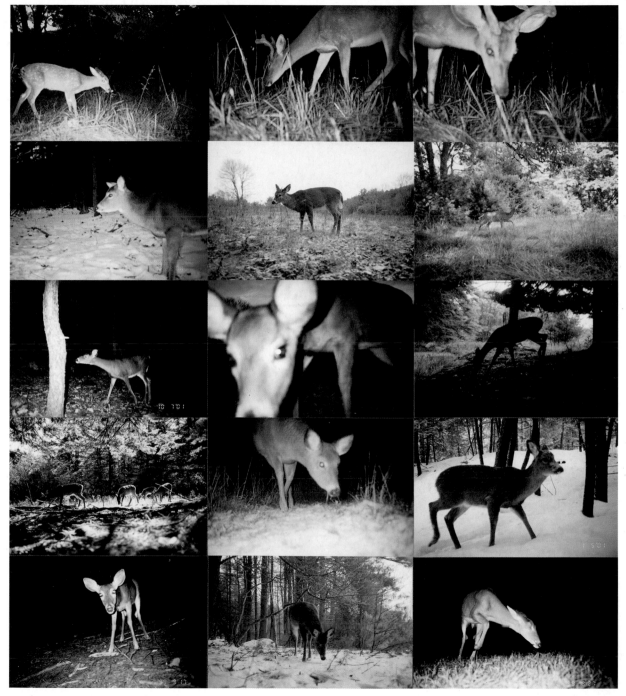

White-Tailed Deer (Odocoileus virginianus) (detail), 2006

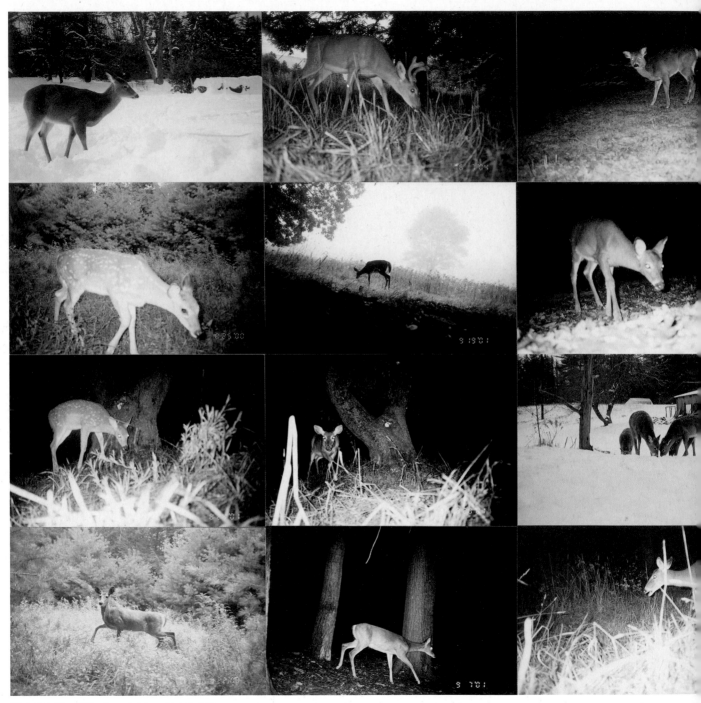

White-Tailed Deer (Odocoileus virginianus)(detail), 2006

sam easterson

Since 1858, when Nadar first photographed the city of Paris from the basket of an ascending balloon, the "bird's-eye view" has remained a popular photographic perspective. While certainly encouraged by subsequent advances in air and space travel, it is nonetheless unsurprising that humans have privileged the lofty perspective of a flying bird over the more circumscribed vantage points of earthbound animals.

Sam Easterson, a Los Angeles-based video artist, counters this bias with his "Animal, Vegetable, Video" project. Since 1998, when he first rigged cameras to a flock of sheep for a show at the Walker Art Center, Easterson has created a growing archive of videos shot from the perspectives of different animals. After practicing on taxidermied specimens, Easterson works closely with veterinarians and professional handlers to attach small, custom-made cameras to the bodies of his live subjects. The resulting videos roughly approximate each animal's unique field of vision, briefly document their movements through their natural habitats, and typically end when the camera falls off its host.

Easterson's cameras are usually mounted in a piggyback fashion (in one case literally), and thus tend to record the frontal extremities of each animal. In a video shot from a tarantula's abdomen, for example, several of the spider's hairy legs bend in and out of view as it traverses a desert landscape. Another camera surveys a snowy field from the head of a male deer, whose overhanging antlers frame the wintry scene on either side. Camera movements also vary widely in these videos—from the steady clip of a galloping buffalo, to the weaving, stop-and-go rhythm of an armadillo inspecting occasional mounds of grass.

What remains constant in all of Easterson's videos is an intimate proximity to terra firma. His cameras consistently hug the ground, rarely glimpse the horizon, and sometimes plunge into streams and mud puddles via pig snouts and wolf muzzles. While reminding us that most animals are inextricably dependent on the earth, these strange, unfamiliar perspectives also underscore our own alienation from the land we share with them.

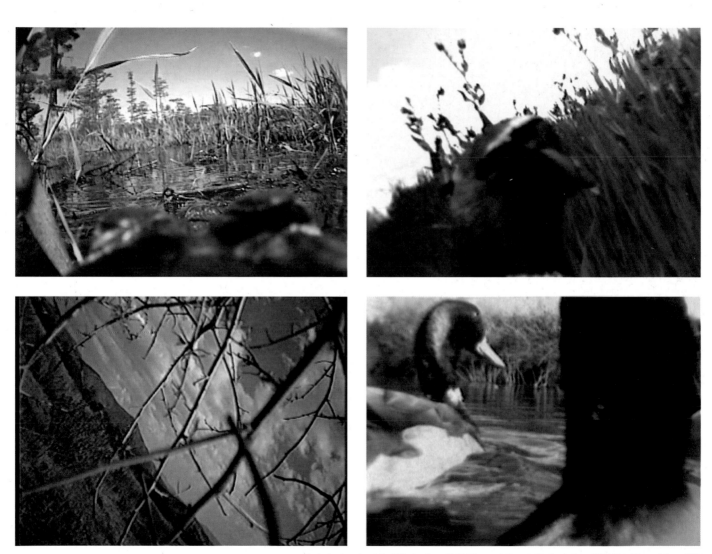

clockwise from top left : Alligator-Cam, 2002; Pheasant-Cam, 2006; Duck-Cam, 2006; Tumbleweed-Cam, 2000

Top: *Chick-Cam*, 2004; Bottom: *Wolf-Cam*, 2004

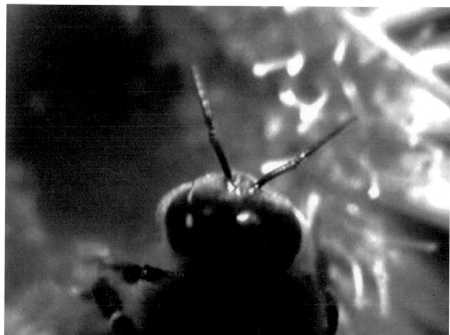

Top: *Sheep-Cam*, 1998; Bottom: *Bee-Cam*, 2004

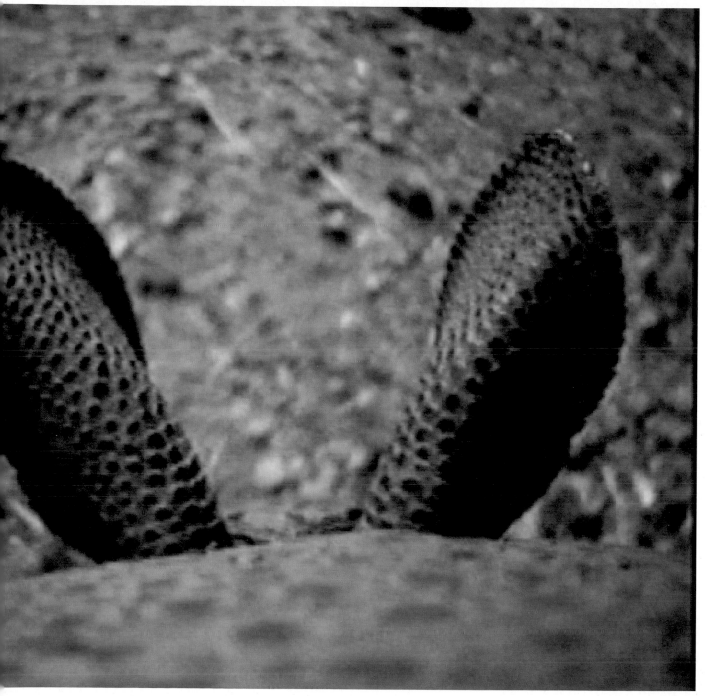

Armadillo-Cam, 2000

mitch epstein

Since 2003, Mitch Epstein has been traveling throughout the United States taking photographs for a project on America's cultural investment in energy. From Pennsylvania to Texas, Ohio, West Virginia, Mississippi, and California, Epstein has photographed nuclear power plants, coal plants, oil-drilling operations, and wind turbines, as well as the people who live in those places, their homes and backyards, and the surrounding landscape. The title of the ongoing project, "American Power," clearly has a double meaning, referring to the way Americans use energy and the ramifications of that use, as well as to America's power with regard to the rest of the world, and its disproportionate consumption of natural resources.

Epstein, who studied with Garry Winogrand and came to prominence in the late 1970s as one of the first practitioners of fine-art color photography, began working on the "American Power" project after he took an assignment for *The New York Times Magazine* about Cheshire, Ohio, a town that sits in the shadow of one of the largest coal-fired power plants in the United States. The photographs in "American Power" have certain affinities with the images in one of Epstein's best-known books, *Recreation: American Photographs 1973–1988*. In both projects, the photographs unfold through the framework of a road trip and many of the images in "American Power" are, like those in *Recreation*, remarkable landscapes that allude to other things—to what it means to be American in a certain time, place, and political climate, and to the balance of power in this country—without being didactic or judgmental. There is the neatly manicured backyard in Raymond, West Virginia, for example, with a view of two enormous cooling towers. Or the photograph of the Gavin Coal Power Plant in Cheshire, Ohio—a strangely beautiful, almost abstract image that looks straight up at the smoke billowing out of two smokestacks in ribbons. Or the small, dilapidated, out-of-service gas station in Snyder, Texas, that tells one of many local stories that are often obscured by the larger national ones: the struggles of one small-business person in a changing economy.

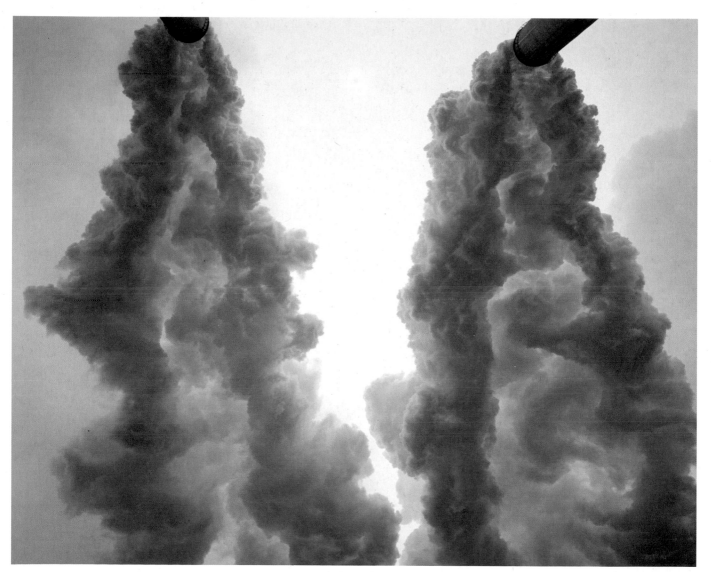

Gavin Coal Power Plant, Cheshire, Ohio, 2003

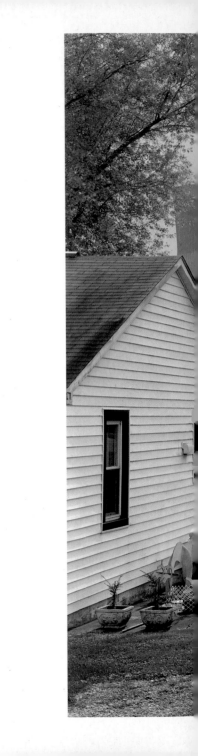

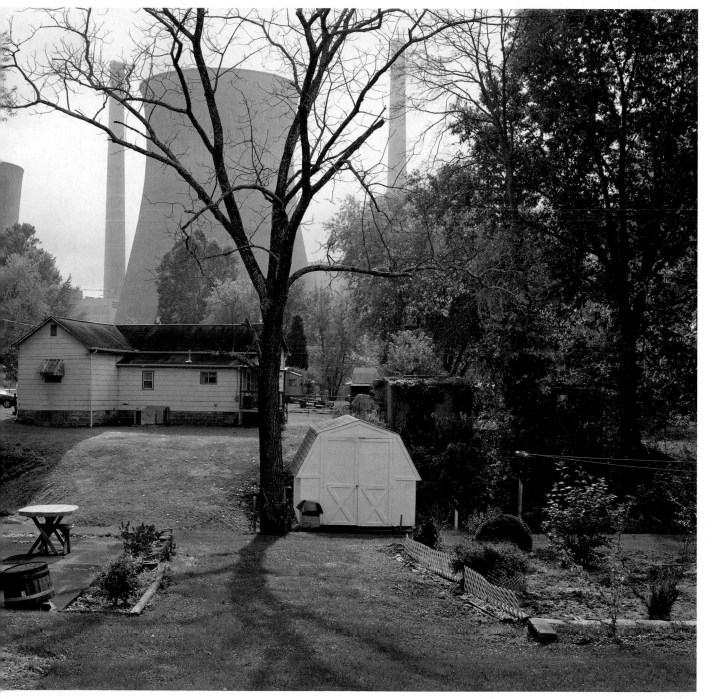

Amos Coal Power Plant, Raymond, West Virginia, 2004

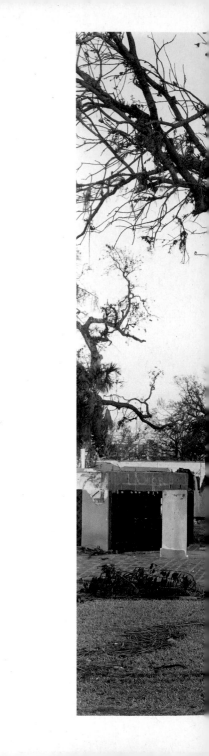

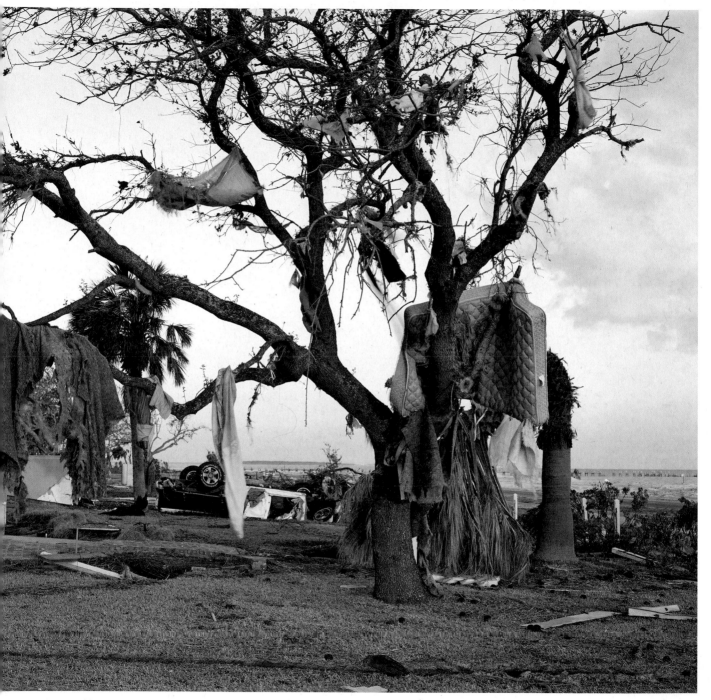

Biloxi, Mississippi, 2005

joan fontcuberta

In her influential 1981 essay *The Originality of the Avant-Garde*, Rosalind Krauss referred to the grid, long a staple of modernist abstraction, as "a system of reproductions without an original," since no one could possibly determine who invented it, or when it first appeared. Spanish photographer Joan Fontcuberta also makes such "reproductions without an original," in his case landscapes filled with towering peaks, undulating plateaus, abundant lakes and rivers, and blue skies festooned with lovely white clouds. However, rather than venturing out into actual nature to take his photographs, Fontcuberta employs the landscape-rendering computer software Terragen, which originally had military and scientific uses. Scanning photographic data into the computer from three sources—famous and not-so-famous images of nature, landscape, and other subjects by photographers including Man Ray, Ansel Adams, Edward Weston, Bill Brandt, Alfred Stieglitz, and Albert Renger-Patzsch; landscape paintings by renowned artists such as J. M. W. Turner, Caspar David Friedrich, Katsushika Hokusai, Piet Mondrian, and others; and photographs of his own body parts—Fontcuberta lets Terragen devise its own landscapes, which look plausible and enticing, but which refer to no place on earth and also seem vaguely creepy and unnerving. Fontcuberta's artificial landscapes undermine photography's traditional role as a trustworthy record of reality, and also underscore how mediated and manipulated our contemporary orientation to nature really is.

In *Orogenesis: Hand* (2003), a black-and-white photograph of the back of the artist's hand was transformed by the software into a purplish blue glacial lake surrounded by jagged outcroppings. *Orogenesis: Skin* (2005) features a rugged ridge, half in shadow and half in sun, ringing a lake. Both works, which bear no resemblance to their sources, conjure the romantic appeal of remote wilderness areas, but also kitschy postcards, immersive artificial realities, and elaborate movie sets. Similarly, Fontcuberta's computer images derived from photographs and paintings yield seemingly "pure" landscape unmarked by human signs which also unnervingly suggest militaristic video games and war zones soon to be invaded by missile-firing aircraft and swarming helicopters. While spectacular, Fontcuberta's false landscapes also seem curiously generic, in the manner of stock photographs, which are likewise devoid of history and memory. One of them is based on *Dust Breeding* (Élevage de poussière), 1920, an already mysterious photograph, credited to Man Ray and Marcel Duchamp, for which Man Ray made a long exposure of a dust accumulation on the surface of Duchamp's work *Large Glass*. In Fontcuberta's hands, the photo is rendered as a disorienting mass of fog-bound outcroppings that tilt up in the picture plane in a manner that is both threatening and inviting. A classic desertscape by Edward Weston, *White Dunes, Oceano, California 1936*, is transmuted into a view of placid water surrounded by a wall of spiky, menacing rock. Fontcuberta taps into our deep desire to, if not visit, at least see pictures of majestic, unsullied, and sublime places in the world, while making those idylls fake, vacant, unreachable, and profoundly disturbing.

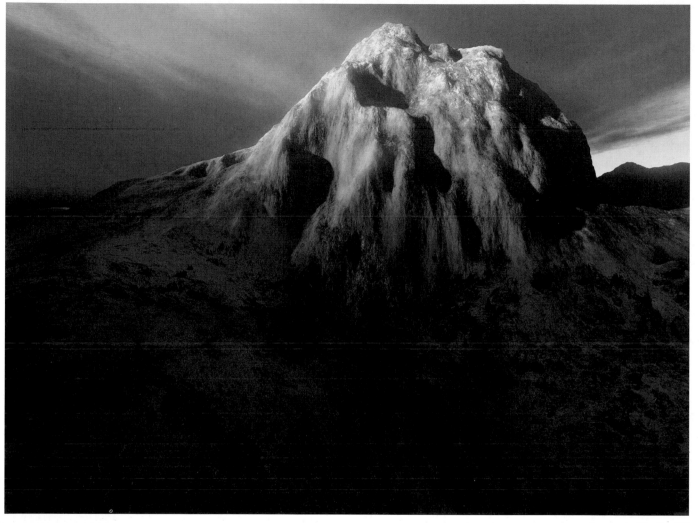

Orogenesis: Stieglitz, 2006

Alfred Stieglitz
Equivalent, 1926
Gelatin silver print, 4 5/8 x 3 5/8 in. (11.8 x 9.2 cm)
The Metropolitan Museum of Art, New York

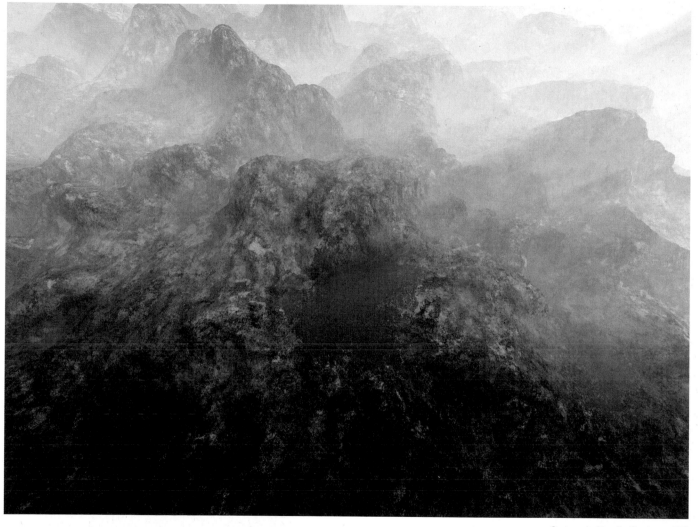

Orogenesis: Man Ray/Duchamp, 2006

Man Ray / Marcel Duchamp
Dust Breeding (Elevage de poussière), 1920
Gelatin silver print, 8 1/4 x 16 in. (21.0 x 40.5 cm)
High Museum of Art, Atlanta

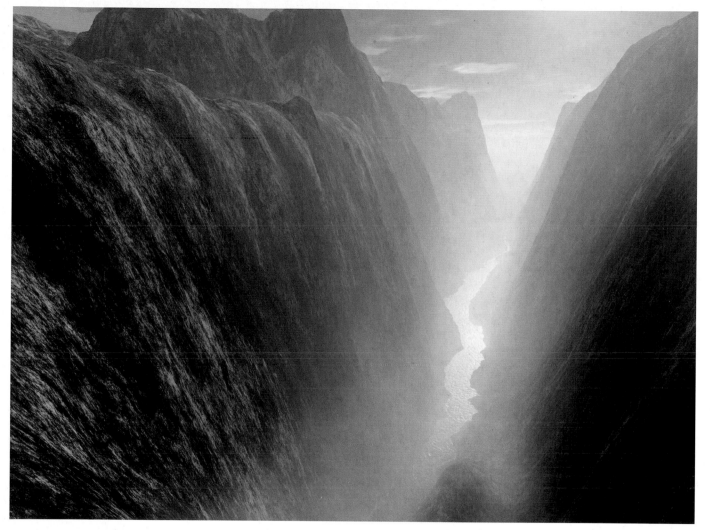

Orogenesis: Brandt, 2006

Bill Brandt
Gull's Nest, The Isle of Skye, 1947
Gelatin silver print, 9 x 7 3/4 in. (22.9 x 19.6 cm)
J. Paul Getty Museum, Los Angeles

noriko furunishi

In 2004, while completing her master's degree in fine arts at UCLA, Noriko Furunishi produced a striking series of color photographs titled "Made in China." Training her lens on rumpled bolts of imported fabric, Furunishi explored the shallow, sculptural depth of these draped and folded materials while also reinforcing pictorial flatness through dramatic cropping on all sides. Similar formal tensions inform her recent landscape photographs, which are clearly modeled after hanging scrolls, a genre of painting that has long been practiced in China and Japan. Invoking this tradition, Furunishi presents her landscapes in tall, vertical formats that typically exceed seven feet in height. Each offers a narrowly circumscribed vista of the arid, depopulated desert of Southern California.

By premising this series on the distinctive formal features of hanging scroll paintings, Furunishi cleverly obscures the digital manipulations that she ultimately indulges. Though not immediately apparent, each of these photographs is a composite image. Furunishi takes multiple pictures of a given landscape, slightly altering her perspective from shot to shot. The resulting photographs are digitally fused together, creating a seemingly continuous landscape that, upon closer inspection, resists conventional expectations of spatial recession. Looking carefully at *Untitled (Tecopa L)*, 2005, for instance, one notices that the "foreground" and "background" are actually images of the same proximate terrain. In other examples from this series, Furunishi seamlessly collages portions of the landscape upside-down, creating warped, undulating spaces that are subtly sensed before they are rationally apprehended.

It seems significant that this series documents the California landscape, where Furunishi currently lives and works. In their topsy-turvy dismissal of a single, coherent perspective, these pictures possess a seismic quality, as though capturing the shifting plates of a tectonic event. Yet they also resonate beyond the geologic realities of a particular state. By radically destabilizing our experience of the natural world, Furunishi's photographs challenge the easy, everyday assumption that the earth beneath our feet is enduring and immutable.

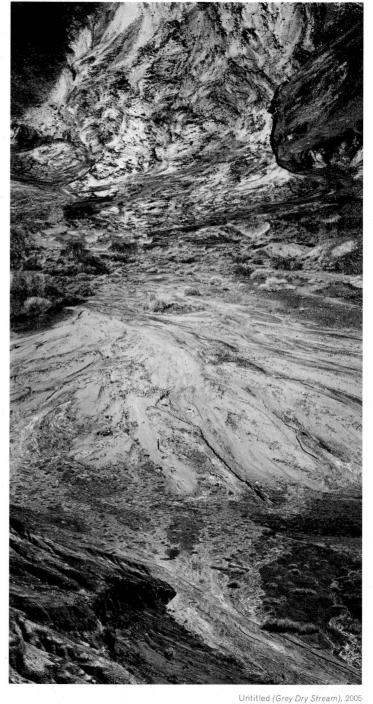

Untitled *(Grey Dry Stream)*, 2005

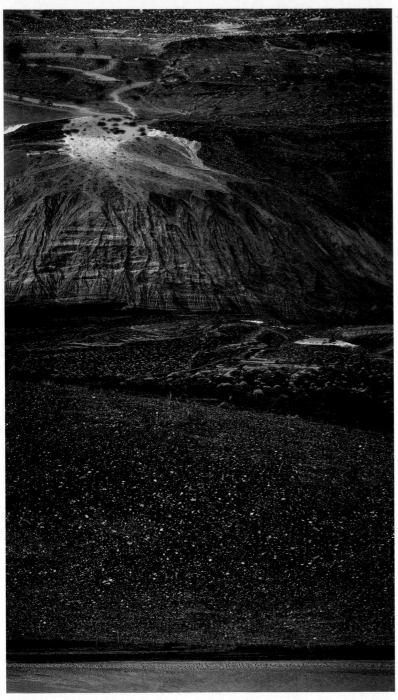

Untitled *(Crater)*, 2005

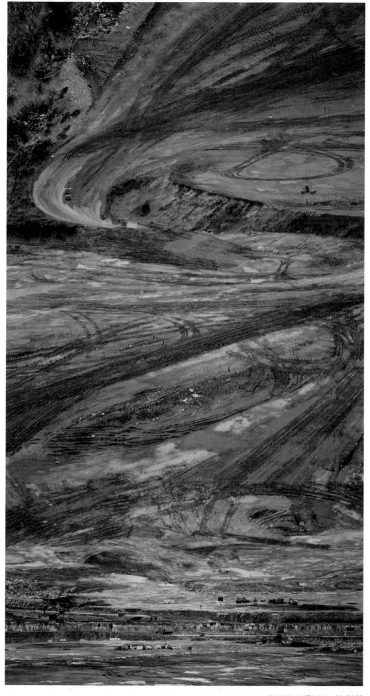

Untitled *(Dirttrack)*, 2005

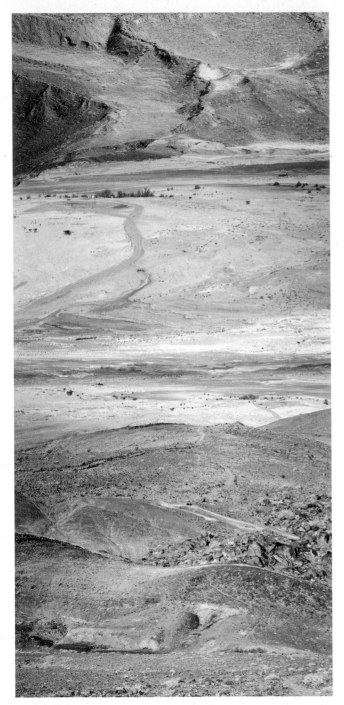

Untitled *(Tecopa L)*, 2005

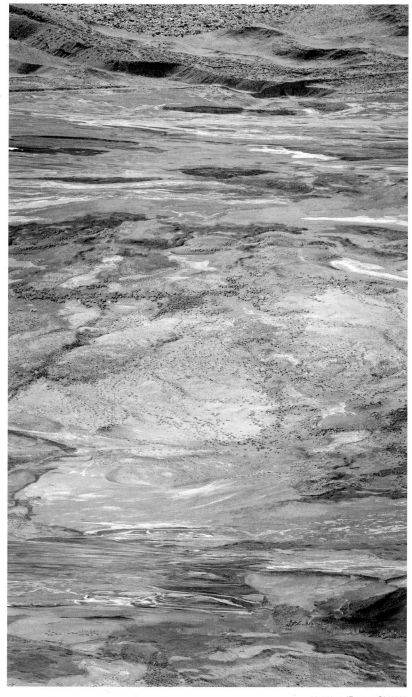

Untitled *(Tecopa G)*, 2005

marine hugonnier

Marine Hugonnier is an intrepid artist whose projects have taken her to Afghanistan, Israel, the Palestinian West Bank, the interior of Brazil, and the Matterhorn in Switzerland, among other places. With captivating short films and photographs, Hugonnier explores how both nature and urban architecture are impacted by and implicated in some of the most pressing contemporary ideologies. For "Ariana" (2003), which involved a film and related photographs, she ventured to the Panjshir Valley in northeastern Afghanistan. Described in classic Persian poetry as a "paradise garden," the impenetrable nature of the valley and its lush, fertile landscape have set it apart from the rest of the country and encouraged a history of independence and resistance. The film considers how the specificities of a landscape help to determine its history. As the crew is unable to film the valley from a vantage point in the surrounding Hindu Kush mountains, the film becomes the story of a failed project that prompts a process of reflection about the "panorama" as a form of strategic overview, as a cinematic camera move, and about its origins as a pre-cinematic form of mass entertainment.

The Last Tour takes as a point of departure the laws that increasingly regulate our access to, and perception of, Nature in our visits to national parks. At its core is what should be a thrilling excursion—a sightseeing tour of the Swiss Matterhorn in a hot-air balloon. Instead, the film is lonely and disturbing, and turns a bedazzling region into a mix of fading memories, anxieties about the future, suggestions of postcards and travel posters, and a seamless blend of fiction and fact. The film is set in the "near future." Intermittent textual announcements declare that the Matterhorn will shortly be closed to visitors, as if it were an aging attraction in an amusement park, and in one section of the film images of the actual Matterhorn mix with archival images of the ersatz miniature at Disneyland in California. The film suggests the possibility of a blank space reappearing on the map, a reference to the world before the Era of Discovery.

Hugonnier excels at working with fragments. In *The Last Tour*, one doesn't see the actual balloon ride but instead an empty road presumably glimpsed by the "final tourists" as they drive toward their destination, snatches of scenery, close-ups of cowering deer and a marauding wolf, and the occasional shadow of the balloon drifting across the landscape. For her 2006 film *Travelling Amazonia*, Hugonnier devised a mobile trolley in order to take a sustained "travelling shot" of a section of the 6,000-mile-long Transamazonia highway in Brazil. This immense road, constructed in the 1970s by the military dictatorship, was designed to showcase Brazil as an emerging great nation, but also unleashed a withering attack on indigenous cultures and an unprecedented exploitation of natural resources, including wood, rubber, and metal—materials which Hugonnier used for her trolley. Filming a straight line through Amazonia, while engaging in another of her quasi-touristic trips to an exotic locale, Hugonnier evokes the upheavals, dislocation, hubris, colonialism, and greed underpinning an allegedly utopian project.

You proudly pretend to be the last where you were once led to believe you were the first.

Ariana, 2003

We wouldn't be able to shoot a panorama...

The Last Tour, 2004

We gave up filming.

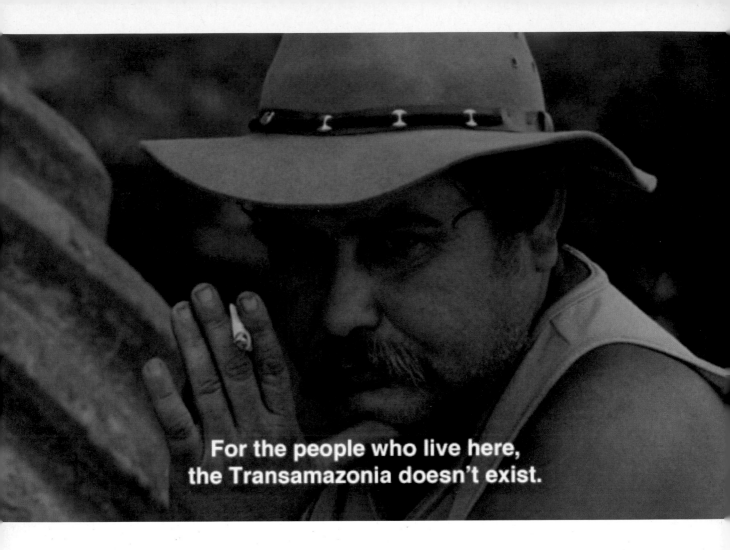

For the people who live here,
the Transamazonia doesn't exist.

Travelling Amazonia, 2006 (FOR THE PEOPLE WHO LIVE...+ picture of the film dolly on the ground)

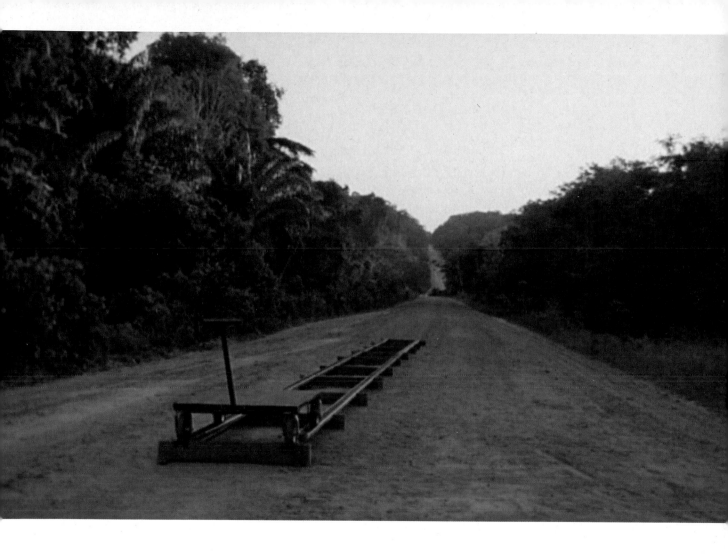

francesco jodice

Trained as an architect and based in Milan, Francesco Jodice uses photography to focus on shifting perspectives and modes of observation in contemporary culture. Jodice is a founding member of Multiplicity, a network of artists, sociologists, economists, and members of various disciplines (architecture, visual arts, and general culture) that documents transformations in the urban condition. Multiplicity's multimedia work *Solid Sea* (2002) was presented at documenta 11 (2002). Jodice's work explores new trends in social behavior, in the urban landscape and in the context of nature. His book *What We Want: Landscape as a Projection of People's Desires* (2002) examines the concept of "landscape as a projection of people's desires" and maps a geography determined by how people inhabit space.

Jodice's series "Natura" is comprised of three videos in which people witness strange occurrences. *The Crandell Case* examines a murder in rural upstate New York. *The Mersey Valley Case* looks at UFO sightings in Liverpool, England. *Il Caso Montemaggiore*, made with San Francisco filmmaker Kal Karman in 2003, reconstructs the story of six elderly persons who disappear into the woods of southern Italy. Although some body parts have been found, the cases remain unsolved. The facts are recounted by a cast of highly symbolic characters: the Family members, a Forest Ranger (the woods keeper), a journalist (the truth-seeker and storyteller), a deacon (the bearer of religious beliefs), a lawyer (the interpreter of justice), and a waiter (the common man). Some of the townsfolk talk of "diabolic forces,"—witchcraft or Satanism at work in the wood—others refute such stories as myth. These talking heads are spliced with random shots of the surrounding woods, at first serene in sunlight, gradually becoming more ominous at night in the glare of headlights. In an aerial shot, the camera pans the lush green treetops and speeds upward until the green is a blur and the hum of the surveillance helicopter drowns out any sounds of nature. The camera lifts off and opens up to a wider view of mountains, and then to a shot of the entire region, as all that is human becomes distant and diminished.

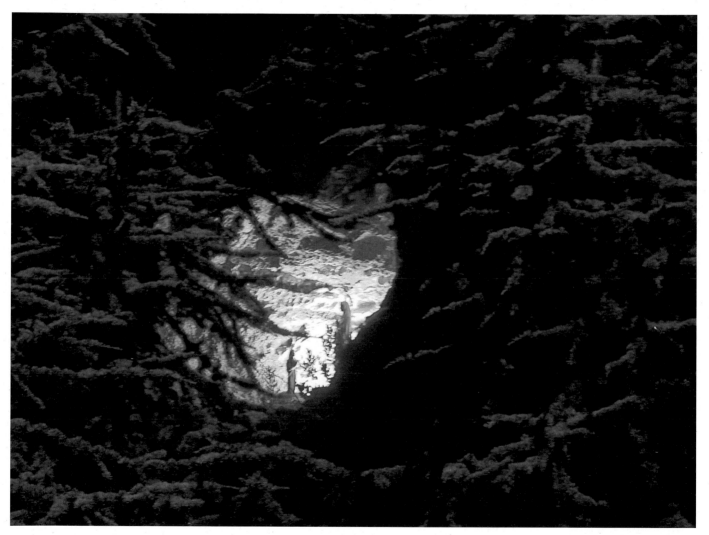

Il Caso Montemaggiore, 2003

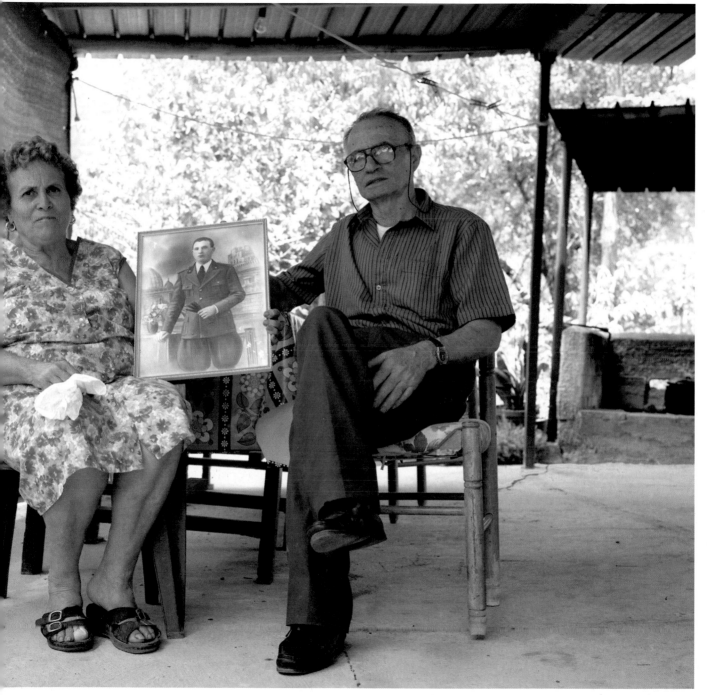

Il Caso Montemaggiore, 2003

The Mersey Valley Case #04, The Lovell Telescope, 2004

harri kallio

When European explorers discovered the island of Mauritius in 1507, they also encountered the dodo for the first time. A large, flightless bird that nested on the ground, the dodo became an easy quarry for the Dutch settlers who began colonizing Mauritius in 1598. Excessive hunting, deforestation, and the introduction of foreign species rapidly diminished the island's dodo population. Within a few decades the bird was extinct; the last recorded sighting of a dodo in the wild is dated to 1662.

Finnish artist Harri Kallio has made this famously ill-fated animal the subject of a recent series of color photographs. After extensive research in libraries and museums, Kallio surmised the dodo's appearance from fossilized remains, eyewitness descriptions, and various paintings and drawings. He then painstakingly crafted two movable, lifesize models of the extinct birds that represent both sexes. Kallio ultimately flew to Mauritius, where he photographed his reconstructed dodos in various natural settings on the island. Digital post-production allowed Kallio to turn back the hands of time and multiply his two models into a large flock.

Kallio's photographs imagine the dodos in a prelapsarian paradise, alive and flourishing in their native habitat. In some pictures they waddle through a sun-dappled jungle. In others they cluster on coastal rocks, squawking and beating their slight, ineffectual wings. They appear quite content and we find ourselves wishing them well, even when detecting a note of artifice in some of these images, a preternatural stillness that suggests we are looking at mere puppets. Indeed, this willingness to suspend disbelief should remind us that Kallio's project is as much a meditation on photography as a tribute to an extinct animal. Though we know the dodo disappeared centuries before its invention, Kallio enlists the persuasive powers of photography to retrieve a past that is irretrievably gone. By exploiting our faith in the photograph as document, he engenders surprising feelings of loss for a bird we have never known.

Domain du Chasseur #2, Mauritius, 2001

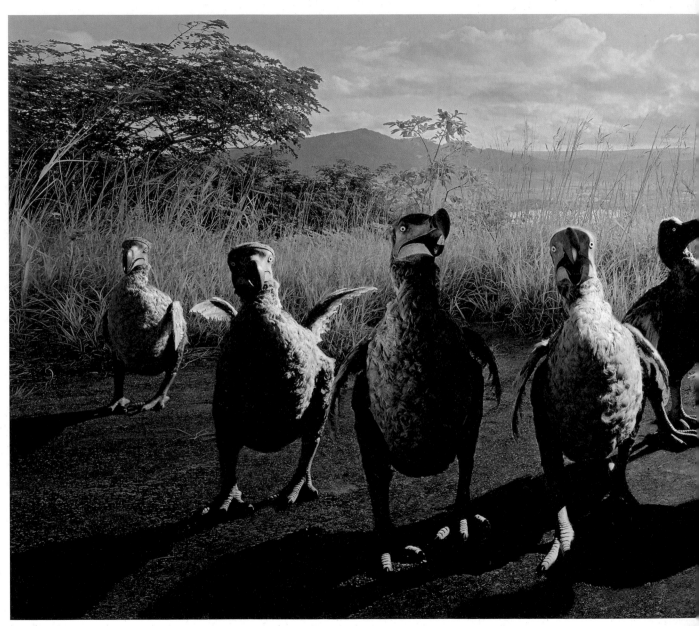

Lion Mountain #5, Mauritius, 2004

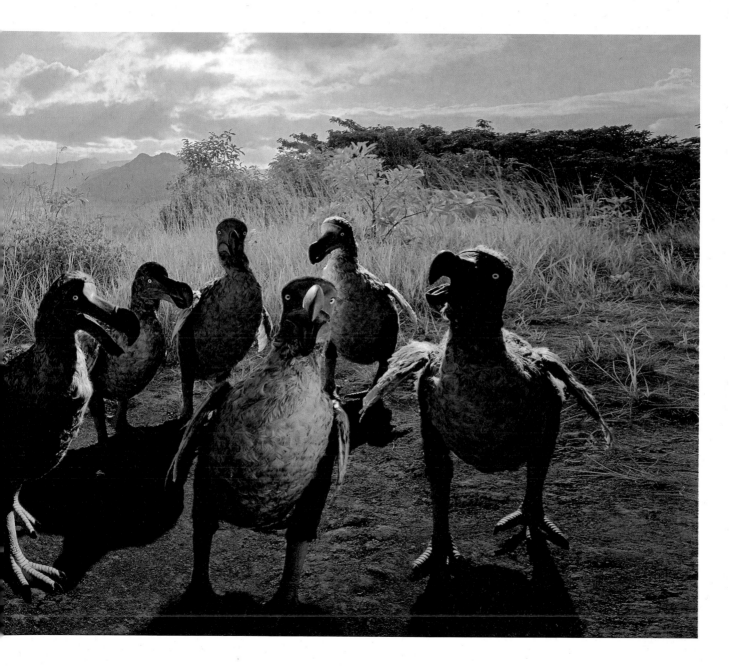

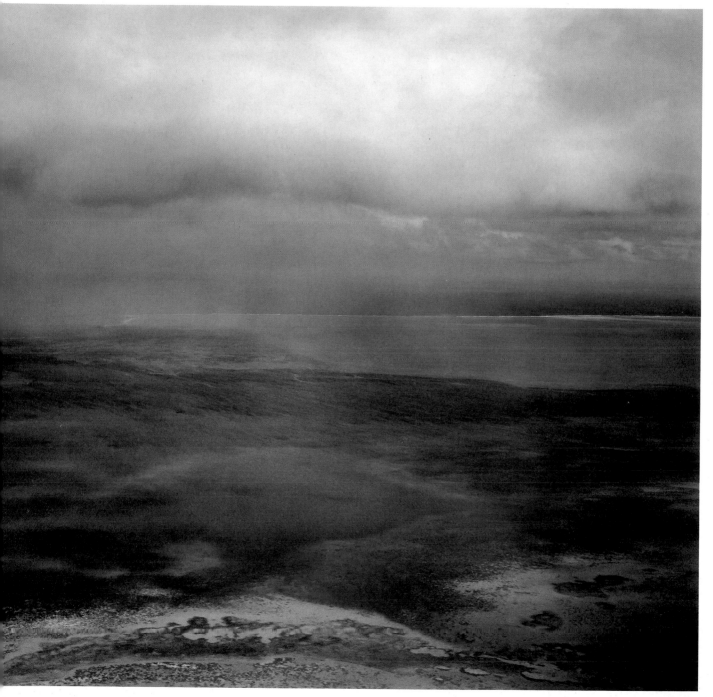

Lion Mountain #1, Mauritius, 2001

vincent laforet

When Hurricane Katrina crossed over southern Florida on August 25, 2005, it was a relatively moderate Category 1 hurricane. But by the time it hit southeast Louisiana on August 29, it had gained strength in the Gulf of Mexico and become a Category 3 hurricane that caused unprecedented devastation up and down the coast and miles inland. In addition to the damage inflicted by the hurricane itself, the levees that separated Lake Pontchartrain from the city of New Orleans were breached, and an estimated 80 percent of the city was flooded, leaving thousands of people stranded without food, clean water, access to medical help, or a way out of the city.

New York Times photographer Vincent Laforet was among the first photojournalists who found their way to New Orleans in the days after the hurricane, and his pictures provide a glimpse of the scale of that disaster. One of his best-known images, which appeared on the front page of the *Times*, showed a young girl in a boat, clinging to a rescuer. Others showed people desperately waiting for help: elderly patients in hospital gowns, in stretchers and wheelchairs in an airport, for lack of any better place; mothers with their children waiting for bottles of water, specific people with dire and urgent needs. But Laforet, who is known for his aerial photography, also took images from a helicopter—water surging in waves across an already submerged landscape; a capsized boat in oily, toxic water; a parking lot of submerged cars—photographs that captured at a distance the enormity of Katrina's destruction.

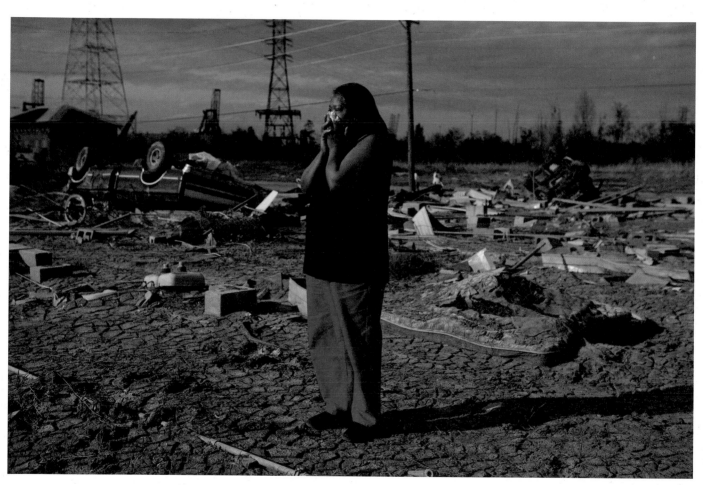

Hurricane Katrina, 2005

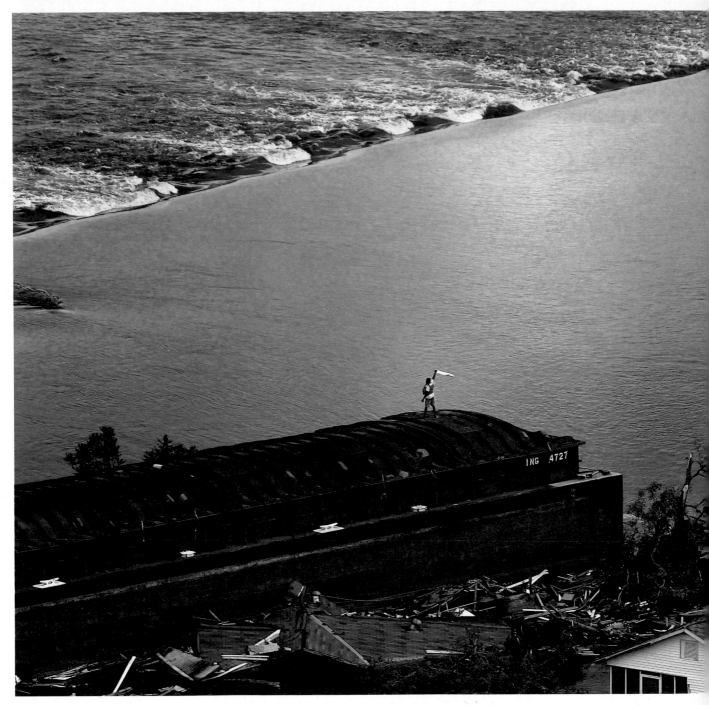

Hurricane Katrina, 2005

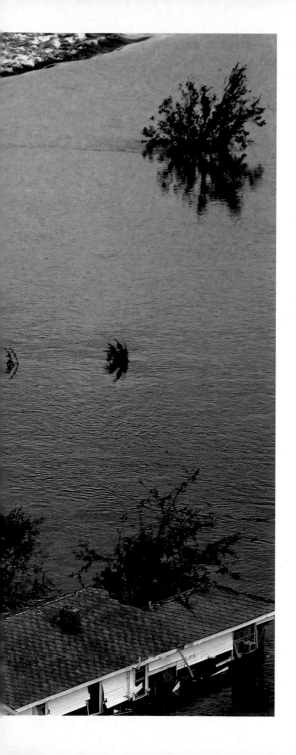

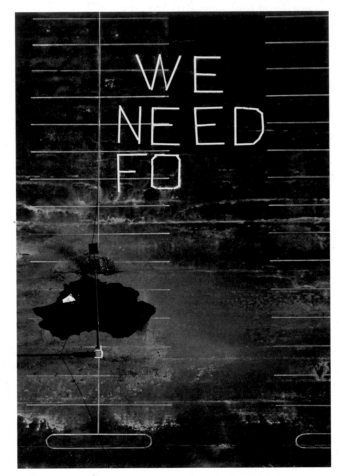

Hurricane Katrina, 2005

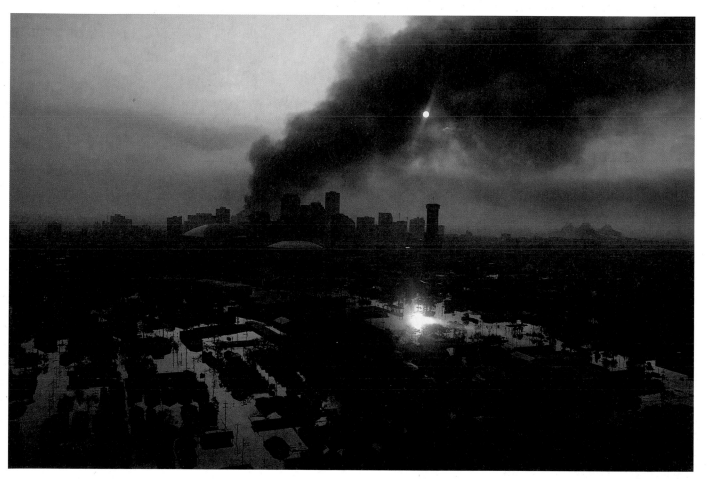

Hurricane Katrina, 2005

christopher lamarca

Since 2002, Christopher LaMarca, a graduate of ICP's documentary and photojournalism program and a regular contributor to such publications as *Newsweek*, *The New York Times*, and *National Geographic* online, has been photographing environmental activists in Oregon who are protesting logging activities that have been expanded by the Bush administration. Though these "Forest Defenders" are often stereotyped as radicals and ecoterrorists, LaMarca was drawn to this group of people who, as LaMarca has described them, are willing to make significant personal sacrifices to stand up for their beliefs.

In March 2005, the Bush administration began permitting logging activity in old-growth reserves, sections of the National Forests set aside for wildlife habitats. Two months later, the administration repealed the 2001 Roadless Rule, which protected "roadless" areas of the National Forests, some of the oldest and most pristine forests in the country. The governor of Oregon, as well as the attorneys general of both California and New Mexico, filed suit against the Bush administration for its failure to meet its own environmental regulations, but the Forest Defenders responded as well.

LaMarca's photographs include portraits of such long-time activists as one seventy-five-year-old woman who has been involved in Forest Defense since the 1980s, and a breathtaking image of a tree-sitter who had been living on a platform 100 feet above ground to prevent logging in an area of old growth reserve until she was evicted by the Forest Service. In one photograph of a Forest Defender checking the logging roads for Forest Service activity, all we see are the activist's legs; his pants are rolled up, and climbing up the length of each of his calves is a tattoo depicting a pine tree. There is a certain irony in this image, given that those tattooed trees may be more permanent, in the end, than their real-life models.

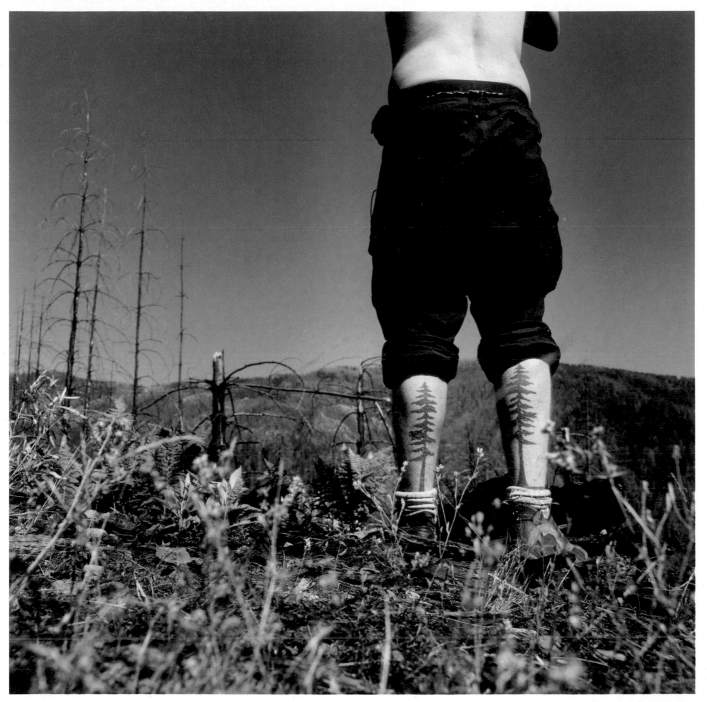

Forest Defenders, 2002–2005

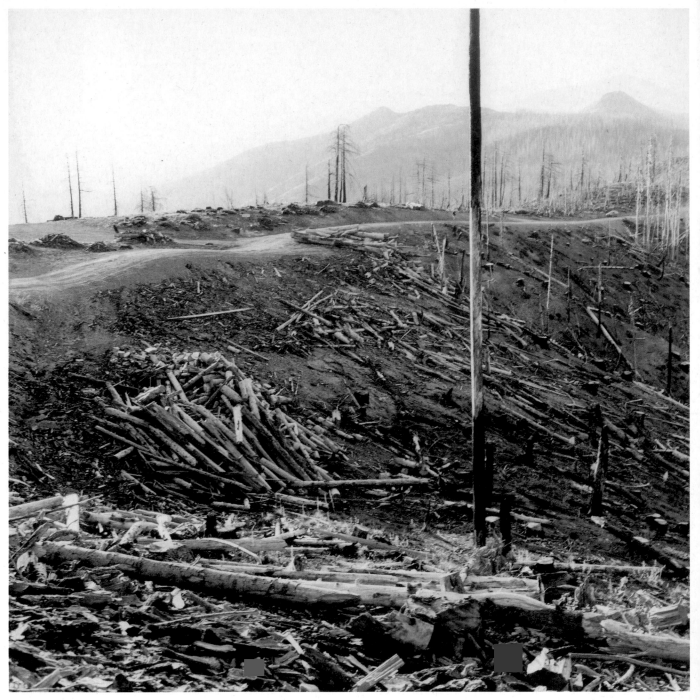

Forest Defenders, 2002–2005

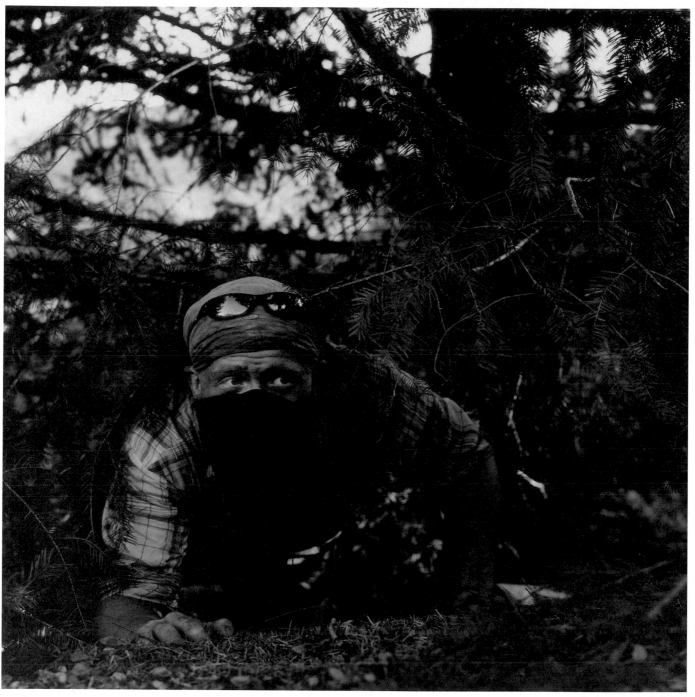

Forest Defenders, 2002–2005

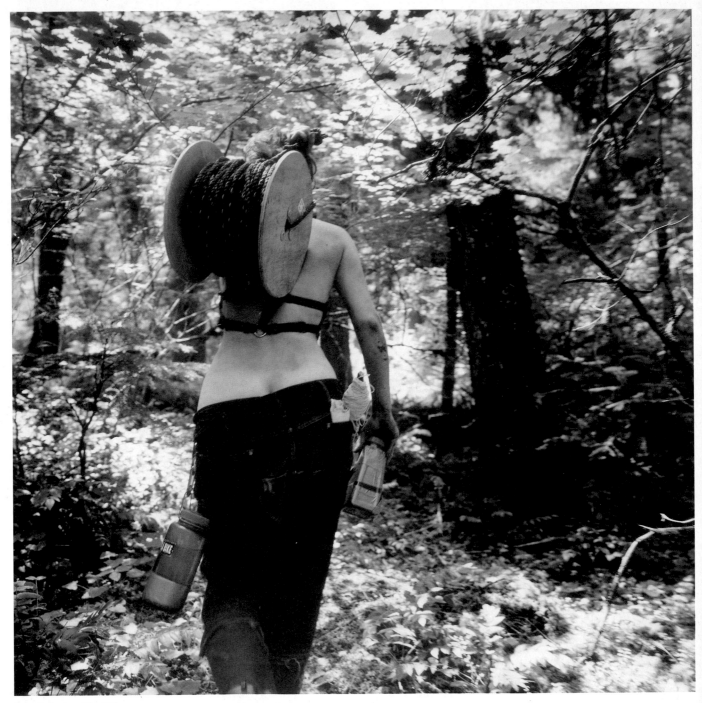

Forest Defenders, 2002–2005

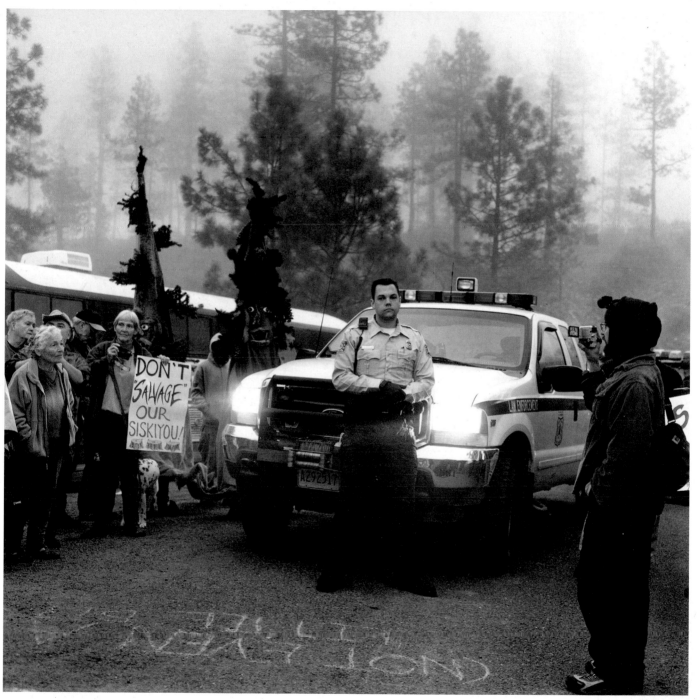

Forest Defenders, 2002–2005

an-my lê

An-My Lê was born in 1960 in Saigon, and grew up in what was then South Vietnam and France. During the 1975 Communist takeover, she and her family fled their native country and settled in the United States. Originally intending to enter medical school, Lê discovered photography through a required arts course at Stanford University—a fortuitous encounter that helped to launch her singular career. After receiving a master's degree in fine arts from Yale in 1993, Lê was able to return to Vietnam for the first time in almost twenty years. Revisiting sites she remembered, and those suggested by her mother who is from the north, she took enthralling, deeply evocative black-and-white photographs of landscapes, urban scenes, and people with her signature large-format camera. Lê excels at gorgeous, reverie-inducing landscapes affected by drastic cultural pressures, especially war and militarism. For her next series "Small Wars" (2001), Lê photographed Vietnam War reenactors in Virginia. Realistic simulations of U.S. soldiers fighting, bivouacking, and on patrol in the jungles of Vietnam occur in an incongruous landscape of pine trees and farmlands. Treating these devoted hobbyists with respect, not irony, and occasionally enlisted by them in the war games, as a Vietnamese sniper or prisoner, Lê made photographs generated by her own experience of war, dislocation, and cross-cultural negotiation. For "29 Palms" (2003), conceived during the buildup to the current Gulf War, Lê essentially embedded herself not with U.S. soldiers fighting in Iraq or Afghanistan, but with soldiers preparing to fight, as they conducted training exercises in a Southern California desert.

Lê's new, two-part film is also called *29 Palms*. On the left, one sees close-ups of young soldiers during a briefing. Here are the intent, thoughtful, fidgety individuals who will soon be transported to actual war. On the right, the view becomes expansive and the landscape immense. Miniature battalions on practice combat missions seem antlike, crawling across the desert while dominated by the surrounding vastness. This engrossing, reality-bending film—in which California convincingly resembles distant battlegrounds, training exercises mimic actual war, everything resembles a staged, Hollywood extravaganza, and soldiers are simultaneously close and remote—is a major addition to Lê's impressive oeuvre.

29 Palms, 2005

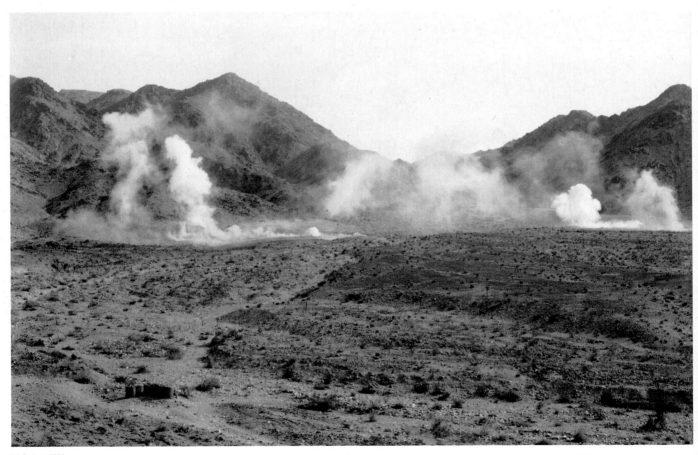

29 Palms, 2005

29 Palms, 2005

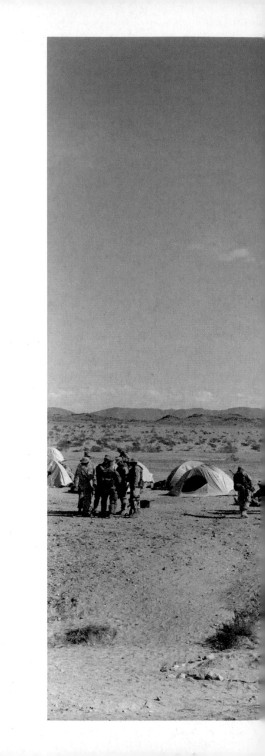

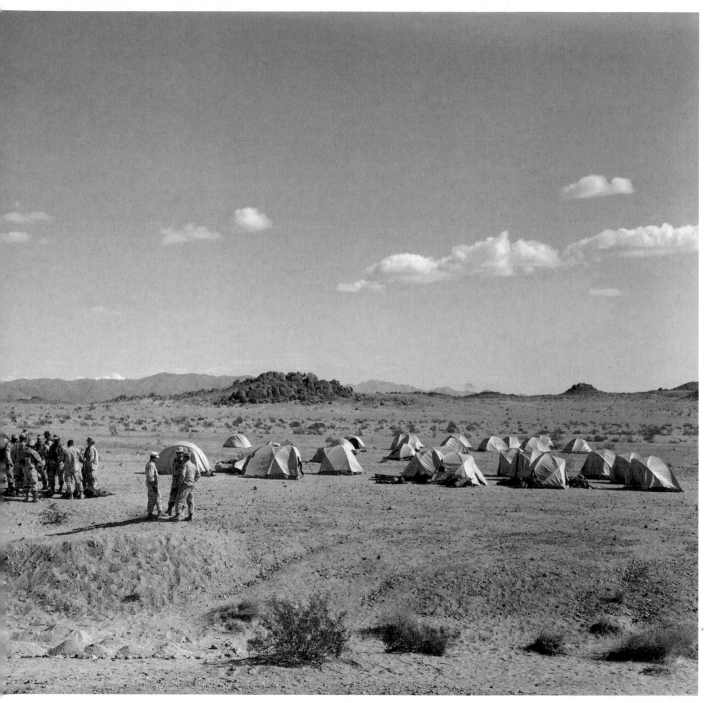

29 Palms, 2005

david maisel

As a student at Princeton in the early 1980s, David Maisel accompanied his photography professor, Emmet Gowin, on several flights above the recently erupted Mount Saint Helens and heavily logged forests in the Pacific Northwest. These bird's-eye views of both volcanic and manmade destruction had a profound impact on the young photographer and helped shape the direction of his subsequent career. Since then, Maisel has produced several related series of photographs that he collectively titles the "Black Maps." Each series has employed remote, aerial perspectives to document the effects of strip-mining, deforestation, and other forms of environmental degradation throughout the United States.

Maisel created an especially striking chapter of the "Black Maps" in 2001 and 2002. Titled "The Lake Project," this series bears witness to disastrous alterations of the Owens Lake region of southeastern California. Since 1913, when the lake's waters were first diverted to Los Angeles via aqueducts, the depleted and exposed salt flats have engendered carcinogenic dust clouds in the surrounding area and unnaturally high concentrations of minerals in the remaining waters. When photographed from above, the saturated shallows of crimson, orange, lavender, and blue can resemble painterly abstractions. Though we are first seduced by the formal beauty of these images, their otherworldly palette ultimately betrays the toxicity of the landscape at hand.

More recently, for his "Surveillance" series, Maisel has photographed military storage facilities in the American West, including the Hawthorne Army Ammunition Depot near Reno, Nevada. Touted as the largest such facility in the country, the depot comprises over 2,000 munitions "igloos" and various disposal sites for chemical weapons and bomb detonation. Not unlike his earlier work, Maisel's aerial surveys of the facility flatten the terrain into attractive, geometric designs. But here the lofty perspectives also underscore the regimented efficiency we expect from military subjects, as countless storage bunkers are plotted against the barren desert landscape like so many rows of tract housing. Indeed, by summoning an eerily abandoned suburbia in these pictures, Maisel conflates these dormant tools of militaristic aggression with a distressing suggestion of their possible consequence.

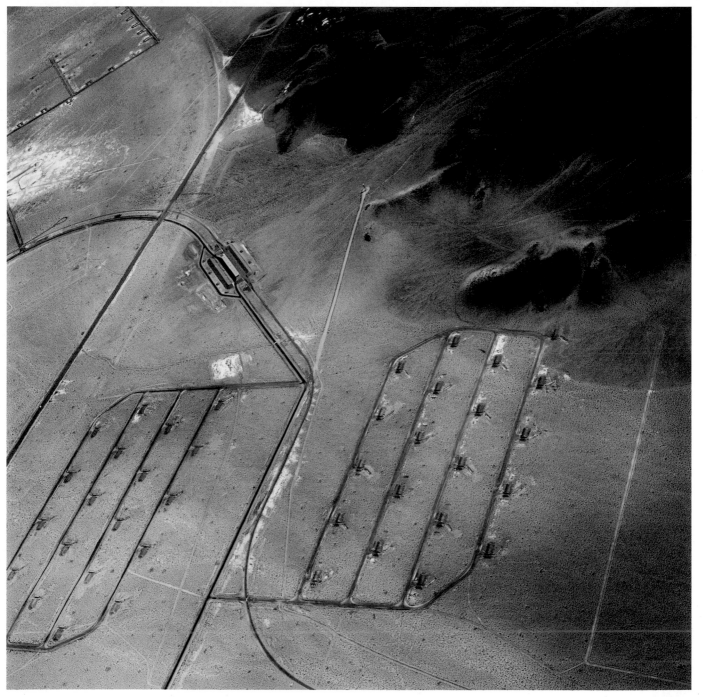

Surveillance 976–8, 2005

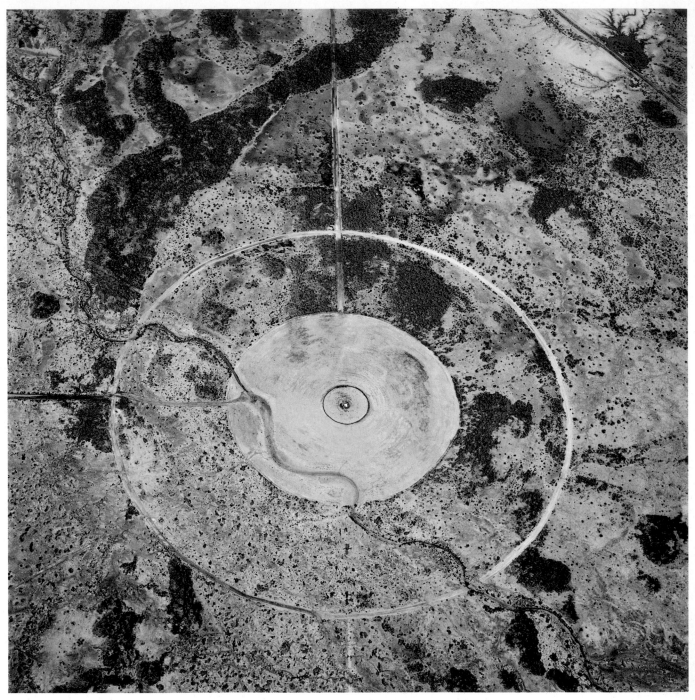

Surveillance 982–7, 2005

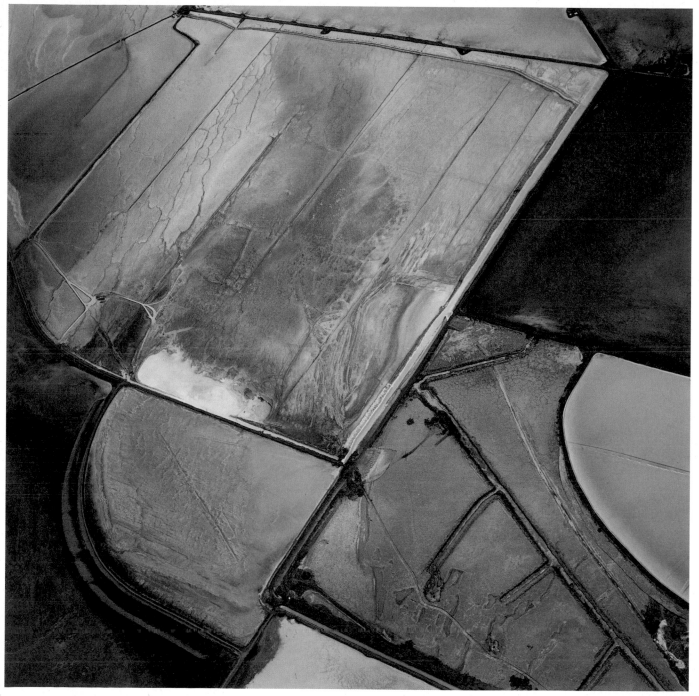

Terminal Mirage 980–7, 2005

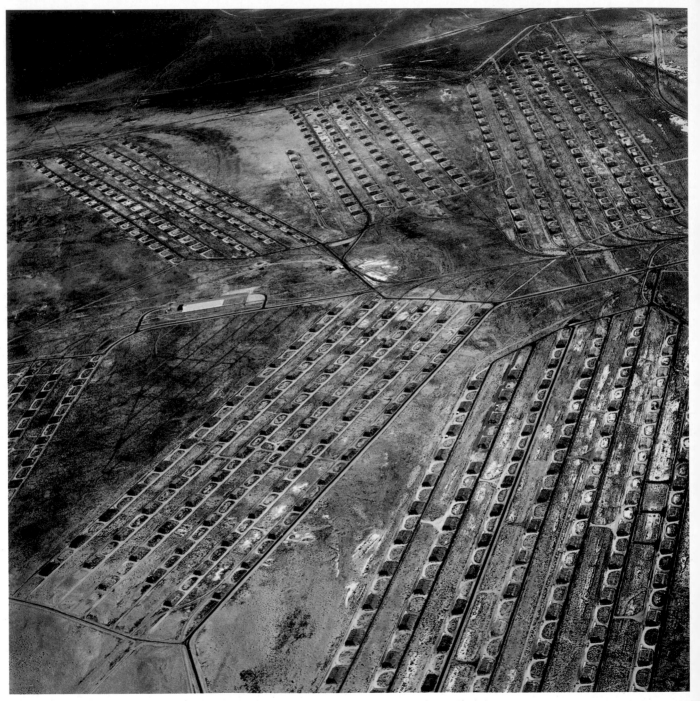

Surveillance 973–10, 2005

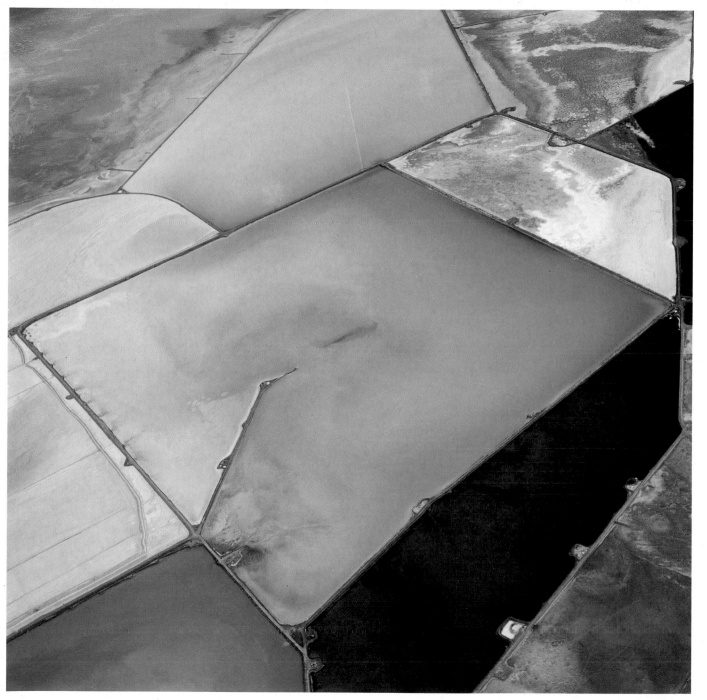

Terminal Mirage 980–1, 2005

mary mattingly

In Mary Mattingly's view of the future, the earth's fate is a foregone conclusion. The only allusion to the forces that have colluded to engender the water-bound Eden she foretells in her work is the occasional appearance of corporate entities, glimmering on distant islands. She focuses instead on the lives we will lead.

Mattingly presents us with a future in which civilization as we know it has been dismantled, and a generation of nomadic post-consumers roam the irretrievably altered landscape. These "navigators," as she refers to them, busy themselves creating and utilizing adaptive technology. Natural beauty remains, and human communion with technology has become organic and, to some degree, sustaining.

Mattingly's photographs are but one iteration of artmaking, which is, like all science fiction, informed by extant and experimental technology, and a voracious curiosity about their possibilities. The look of the sculptural khaki uniforms, or "wearable homes," her characters inhabit, for instance, is based on her investigations into the anthropology of fashion and architecture. They are made of temperature-adjusting, weatherproof fabric, and incorporate micro-equipment that monitors both the external atmosphere and the health of the navigator. Her richly imagined future also includes new online religion ("The New Way"), a new calculation of time ("New Time"), and a new lexicon of words and symbols.

The images, digitally stitched composite photographs, which utilize 3-D imaging technology like Maya and Bryce, are replete with gaudy sunsets, and do not entirely disguise their artifice. This attention brought to the artist's own hand mirrors the activities of her characters, whose boundless creativity is their only true survival mechanism. If their ad hoc inventions seem dubious in the face of the powerful presence of nature, in Mattingly's new world all is far from lost. Her faith in our physical survival reflects a faith in the promise of technology. The alienation reflected in her isolated navigators reflects Mattingly's underlying concern: How will technology address our enduring need to connect?

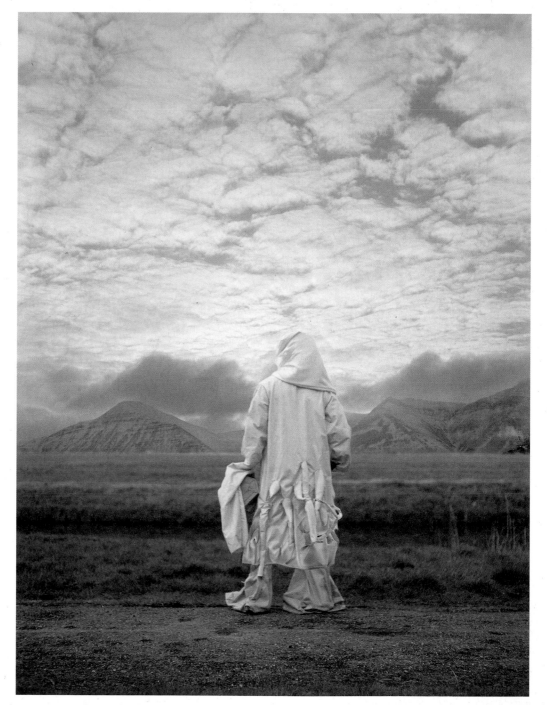

The New Mobility of Home (The Nobility of Mobility), 2004

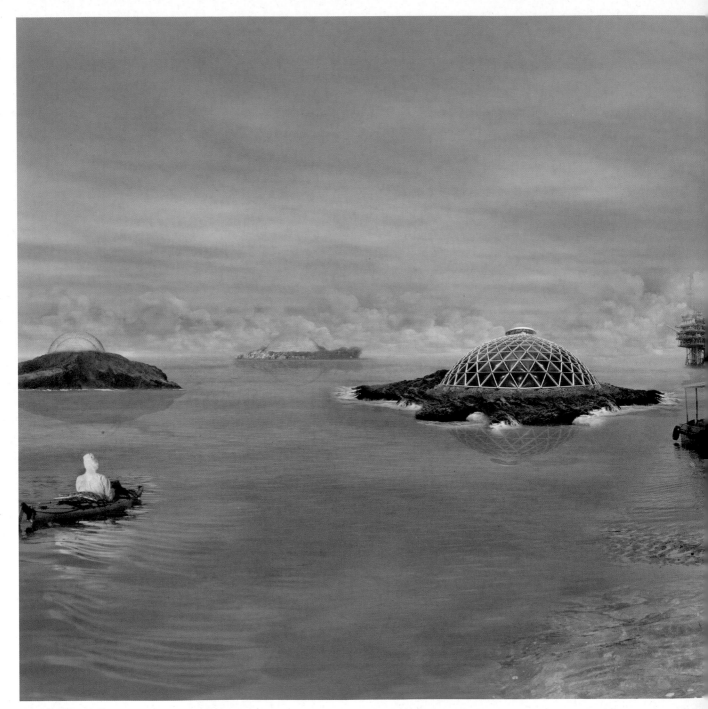

Seven Firm Oligopoly, 2006

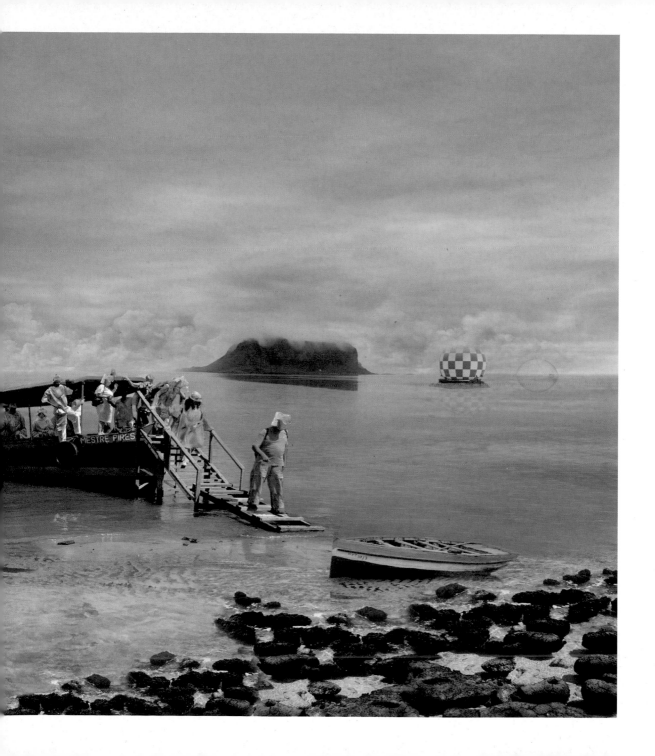

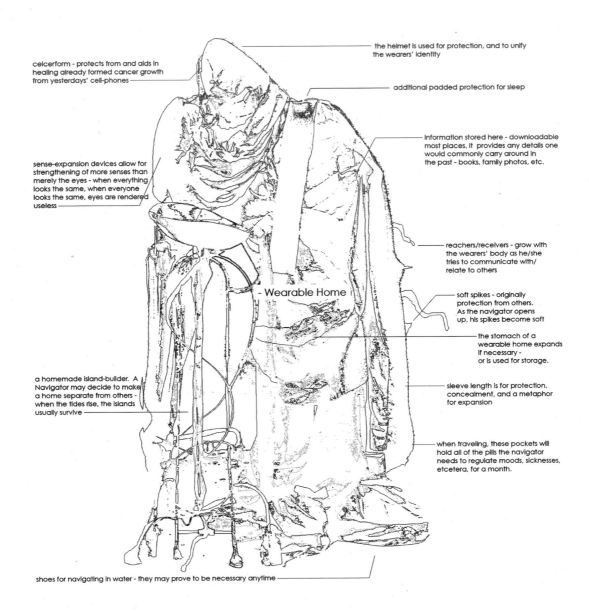

celcerform - protects from and aids in healing already formed cancer growth from yesterdays' cell-phones

the helmet is used for protection, and to unify the wearers' identity

additional padded protection for sleep

information stored here - downloadable most places, it provides any details one would commonly carry around in the past - books, family photos, etc.

sense-expansion devices allow for strengthening of more senses than merely the eyes - when everything looks the same, when everyone looks the same, eyes are rendered useless

reachers/receivers - grow with the wearers' body as he/she tries to communicate with/ relate to others

- Wearable Home

soft spikes - originally protection from others. As the navigator opens up, his spikes become soft

the stomach of a wearable home expands if necessary - or is used for storage.

a homemade island-builder. A Navigator may decide to make a home separate from others - when the tides rise, the islands usually survive

sleeve length is for protection, concealment, and a metaphor for expansion

when traveling, these pockets will hold all of the pills the navigator needs to regulate moods, sicknesses, etcetera, for a month.

shoes for navigating in water - they may prove to be necessary anytime

Wearable Home, 2004

Frontier, 2005

gilles mingasson

Shishmaref, a small village on the coast of the Alaskan island of Sarichef, is home to 591 Inupiat Eskimo. The Inupiat have lived in the village for one hundred years and claim thousands of years of ancestry in the region. They are also set to be among the world's first refugees of global warming. Over the last several decades, rising water temperatures have delayed the annual freezing of the waters around Shishmaref. Without the protection of the ice, the sandy island's coastline has been left exposed to fall storms, resulting in the loss of hundreds of feet of shoreline and several houses.

Los Angeles-based photographer Gilles Mingasson traveled to Shishmaref to document the community as the Inupiat try to maintain their way of life in this shifting climate. What might appear to be minor changes in weather patterns are major threats to Inupiat survival. In their mixed subsistence economy, the Inupiat rely partially on seal hunting, traditionally done in the spring, traveling over the ice on dog sleds or snow machines. Now they risk their lives on the thinning ice, using homemade boats usually reserved for fall hunts. Hides and flesh that were once cured on ice are now stretched on grass and subjected to flies that appear earlier every year. In other images, the villagers have moved stones and other objects to the shoreline in a vain effort to prevent further erosion.

Scientists predict that within nine years the village and the Inupiat Eskimo community will have to be evacuated. The Army Corps of Engineers estimates that relocation will cost as much as $180 million. The government would like to resettle the village in the suburbs of Nome, some 200 miles away, but the Inupiat, fearing the loss of their traditions, are lobbying to move to the less developed Tin Creek, just sixteen miles from their current home.

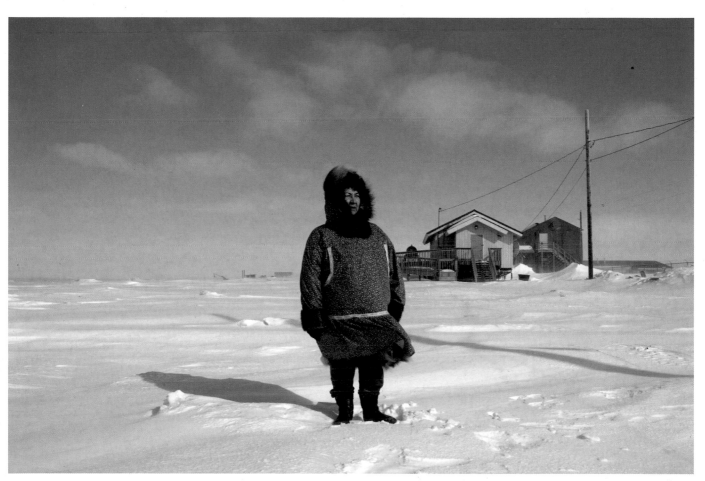

Luci Eningowuk, an Inupiat Eskimo and Chairwoman of Shishmaref's Relocation Commitee, 2005

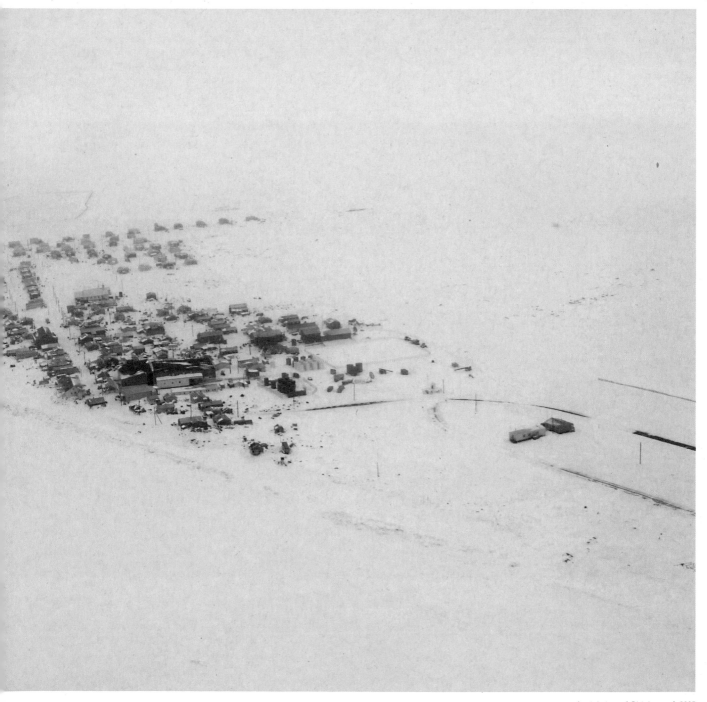

Aerial view of Shishmaref, 2005

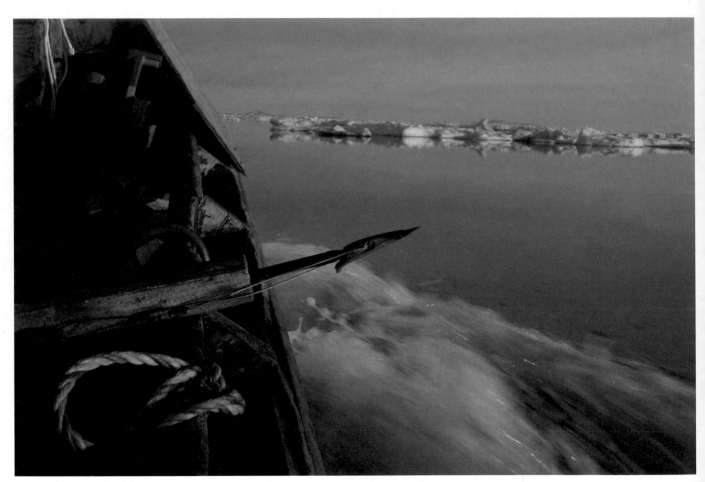

Spring seal hunting, traditionally done by dog sled or snow machine, now done in boats due to climate change, 2005

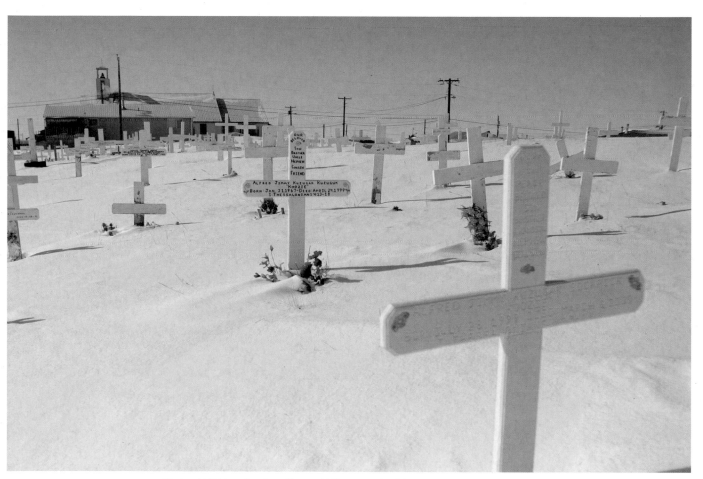

The Inupiat Eskimos, for whom elders are highly respected, will have to decide whether to move their graves, or move on without them, 2005

simon norfolk

Simon Norfolk has written that "anybody interested in the effects of war quickly becomes an expert in ruins." And indeed, Norfolk has built up a body of work that focuses on the ruins left in the wake of wars and conflicts in such places as Bosnia, Liberia, Afghanistan, and Iraq. He may be best known for his book on Afghanistan, published in 2002, which documented a smoking, decimated landscape strewn with weapons and the twisted skeletal remains of buildings. But Norfolk is also interested in the portrayal of ruins in works of art throughout history, and the meanings and metaphors attributed to them. He cites the seventeenth-century painters Jean-Baptist-Camille Corot and Nicolas Poussin, for example, who depicted ruins as metaphors for the foolishness of pride and the vanity of empire.

Norfolk's *North Gate of Baghdad* (2003), with its muted colors, painterly sweep of tree branches, and the remnant of the mustard-colored gate, does evoke, more than anything, the tradition of history painting, or a landscape by Lorrain. We cannot help but appreciate the aesthetic aspects of such an image—and so a certain tension arises from our resistance to the notion of aestheticizing suffering or making metaphors out of terrible destruction. At the same time, Norfolk's images of Iraq might encourage us to consider the awesome nature of the ongoing destruction there, and perhaps our part in the lineage of violence. But modern warfare, he seems to suggest, is an altogether different animal, wreaking destruction on an unimaginably huge scale. Rather than romantic views of crumbling ruins, other photographs by Norfolk show, for instance, the blackened windows of the bombed out Ministry of Planning in Baghdad, a small child standing in a desolate, dangerous sea of rubble, next to an arm from a fallen statue of Saddam Hussein, or a date grove, whose ground is littered with missiles, a kind of paradise lost.

Surface-to-Surface Missile System, Orange Grove, Northern Baghdad, 2003

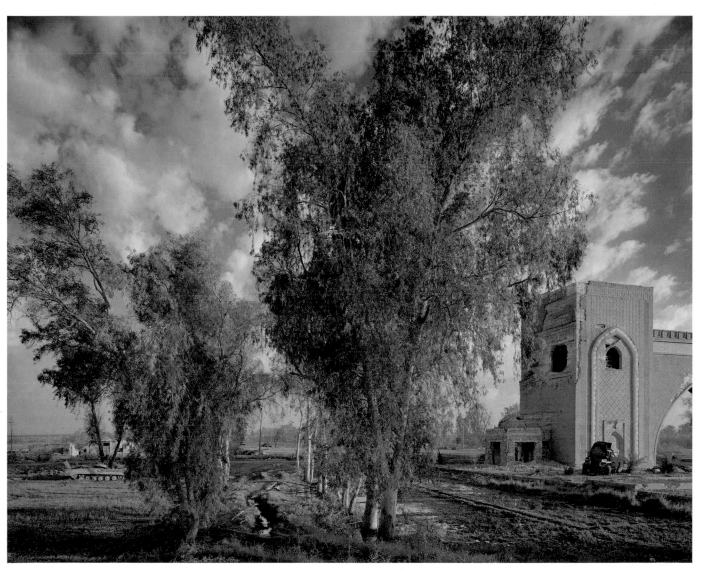

The North Gate of Baghdad (After Corot), 2003

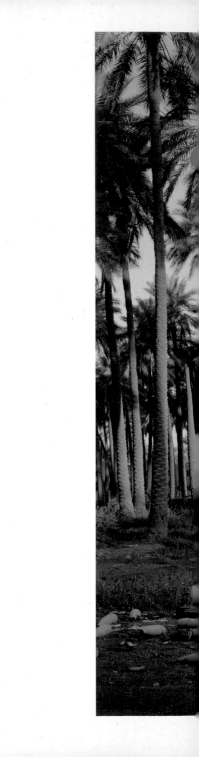

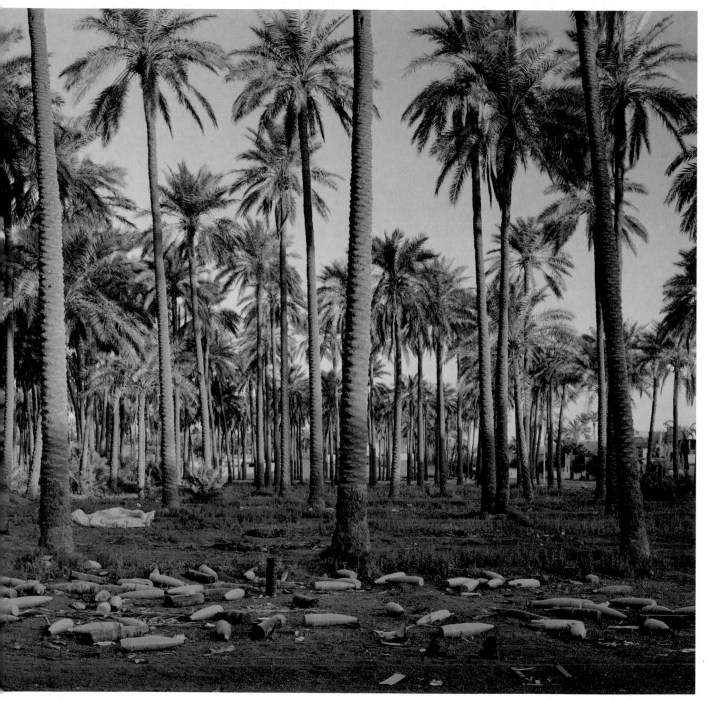

Date Grove, Atifya, Northern Baghdad, 2003

the otolith group

The Otolith Group's name, from *oto* (Latin for ear) and *lithos* (Latin for stone), refers to the micro-particles found in the inner ear. These particles establish our subjective sense of gravity, acceleration, horizontal and vertical orientation. In Otolith's eponymous sci-fi video, long-term space travel has led to the mutation of the otolith in human fetuses, and by the twenty-second century the human race is no longer able to survive on earth and lives instead in zero-gravity space stations. A paleoanthropologist from this future is researching preadaptive life on earth, a life that, as she announces early on, she can experience only through media.

The video-essay *Otolith* (2003) was produced by group founders Kodwo Eshun and Anjalika Sagar in collaboration with Richard Couzins. Sagar narrates, portraying her own future descendant, Dr. Usha Adebaran Sagar, who comments on her archival discoveries and reads from fictionalized letters Anjalika wrote to her grandmother, a twentieth-century Indian feminist. These are read over images from anti–Iraq War protests in London, mushroom-cloud nuclear experiments, diplomatic scientific exchanges between socialist countries in the post-independence era of the twentieth century, personal archival footage, and images of the zero-gravity future filmed by the group at a contemporary Russian cosmonaut training center.

Otolith pays homage to the film-essays of Chris Marker and to the novelist J. G. Ballard. The film's mix of public and private archival footage and narration-from-the-future are part of multiple distancing strategies through which it produces a "science fiction of the present." Science fiction is often noted for its utopian impulses, its direct and indirect commentary on contemporary social life. *Otolith* is in many ways a distinctly postcolonial sci-fi look at the imagined future of global history, reminding us of the stunted trajectories of Third World social movements and utopian experiments that linked the people's of Africa, Asia, and Eastern Europe for a good portion of the last century.

The Otolith Group's apocalyptic vision of contemporary life stems from the devolution of that utopian optimism into a world pervaded by a low-grade sense of panic infesting both the social and symbolic. They are not concerned necessarily with any one particular geopolitical threat or impending environmental disaster, but with the impossibility of the future in general. For them, a science fiction of the present leads to a scrutiny of a world in which consciousness is increasingly marked by an "ambient fear," where any and all large-scale catastrophes seem equally probable and imminent.

Otolith, 2003

Otolith, 2003

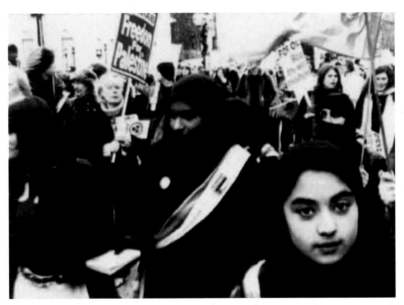

Otolith, 2003

Utolith, 2003

sophie ristelhueber

In Sophie Ristelhueber's large-scale art works and installations, the photographed landscape appears in fragments, damaged, rent, pockmarked. These traces of history and conflict, what the artist calls "details of the world," are like scars on a body, and they convey a similar tale, of wounds scarcely healed. Ristelhueber has photographed these metaphorical landscapes in war-torn places like Beirut, Kuwait, Bosnia, and Iraq, recording the violence inflicted on the surface of the earth by the machinery of war. Her images, often exhibited unframed, sometimes leaning against the wall, one overlapping the other, or in a floor-to-ceiling grid, can read initially as abstractions, and she generally offers little contextualizing information to help viewers understand them. Rather than focusing on the geopolitical meaning of a particular conflict, Ristelhueber is engaged with the ambiguities of what she calls the "terrain of the real and of collective emotions."

Much of Ristelhueber's reflects the vision of history as chaos that has haunted her since she first photographed in Beirut in 1982. Since then, she has traveled to various war-torn territories, including Turkmenstan in 1997, Syria in 1999, Iraq in 2000, and the West Bank in 2003-04. Typical of these projects is what is perhaps her best-known work in the United States is probably "Fait," from 1992, a portion of which was exhibited in the Museum of Modern Art's *New Photography 12* exhibition in 1996. Taken in 1991, some eight months after the end of the Gulf War, her views of the Kuwaiti desert showed the aftermath, the gashes and holes in the ground.

Ristelhueber's magisterial triptych "Iraq," from 2001, depicts an eerie, blasted-out, lunar landscape in which rows of burnt, decapitated palm trees stand like sentinels, like, as she says, the remains of a defeated army. Although the image clearly resonates with the current war in Iraq and ongoing conflicts in the Middle East, Ristelhueber's images suggest that the current situation is part of an unceasing cycle of destruction and construction. Particularly in southern Iraq, in the valley where the Tigres and the Euphrates flow toward the sea, in the ancient land of Mesopotamia, Ristelhueber finds the irreparable psychic wounds of history bound up with the violence of the present. In her photographs, the surface of the land becomes a kind of palimpsest on which the disfiguring traces of decades of conflict continue to be recorded.

Iraq, 2001 (detail)

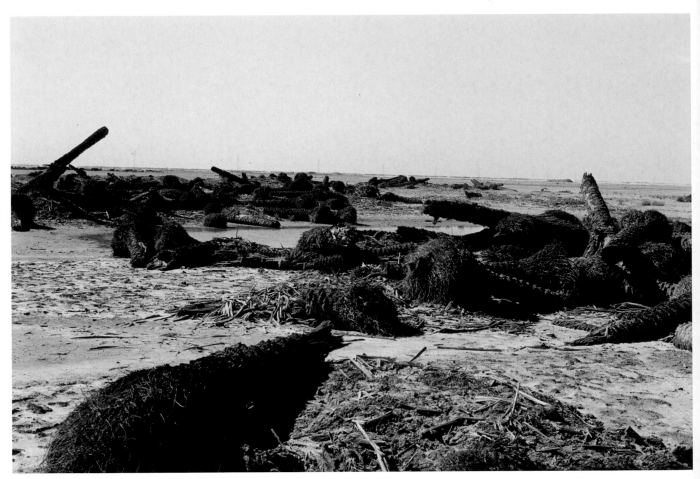

Iraq, 2001 (detail)

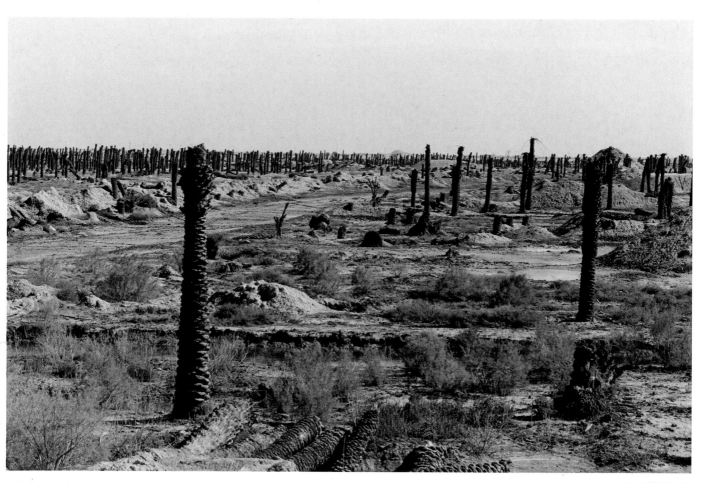

Iraq, 2001 (detail)

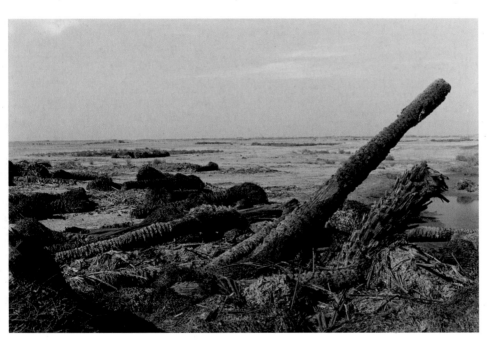
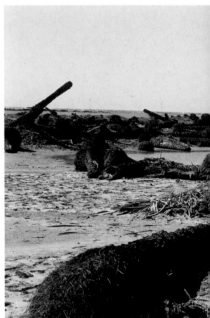

Page 194-5 *Iraq*, 2001

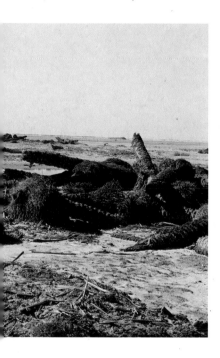

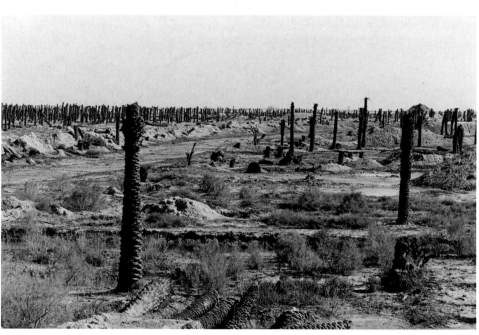

clifford ross

In late summer of 1998, Clifford Ross stood in the hurricane-addled waters off the coast of Long Island (Georgica Beach) and, in just under two hours, took 250 photographs of the waves with a Mamiya 7 medium-format camera. Next he photographed Mount Sopris in Carbondale, Colorado. Disappointed with the results, he invented a camera known as R1 (R is for Ross) that is unparalleled in its ability to sharply render detail. With the R1 he returned to Mount Sopris in the summer of 2003 and photographed from 4 am to 9 pm every day for a month. This time he accomplished what he was after, namely, capturing in an abundance of detail the mountain's splendor. Ross's motive was and remains the achievement of a high "reality quotient," which is integral, he believes, to communicating his own sense of awe to viewers, so they too can be moved.

The R1 camera is made of new and recycled parts, some dating back to the 1940s. Ross had the aluminum housing made in upstate New York and a handcrafted bellows in Montana; various view-camera parts came from Switzerland. The R1 weighs over sixty pounds, stands six feet tall, and records light and shadows onto a 9 x 18–inch film plane. The film is then digitally scanned to produce a 2.6-gigabyte file, creating a near replica of reality. Ross has printed Mount Sopris on 5 x 10–feet sheets of paper; Michael Hawley, MIT's Media Lab Director of Special Projects, calls it the "most technically perfect mural-size photograph ever."

Ross describes himself as a modern artist dealing with "old fashioned values." With an art school background (Yale), time spent as an abstract painter, and a stint in the movie business, he has experimented with multiple art forms. He traces his trajectory to a moment in 1971 looking at Rembrandt's portrait of the Amsterdam merchant Nicolaes Ruts (1631) housed in the Frick Museum in New York. He describes the palpable atmosphere surrounding the subject, the clarity and specificity of the moment depicted in the painting. This, in combination with his musings on Immanuel Kant's "Analytic of the Sublime" (1870) was a life-altering experience and the inspiration for his photography.

For now, the R1 can bring minutiae seven miles away into sharp focus. Ross's photographs suggest a return to the nineteenth-century idealized landscape with a tinge of a twenty-first-century instinct: the desire to experience life on a very large scale. Ross's idealization differs from the Romantics in that he is seeking a heightened sensory experience that triggers a pleasurable response rather than evoking a political inquiry about man and his relationship to nature. Here science is in service to escapism, creating an antidote to reality with hyperacuity.

Mountain XIII, 2006

Mountain IV, 2005

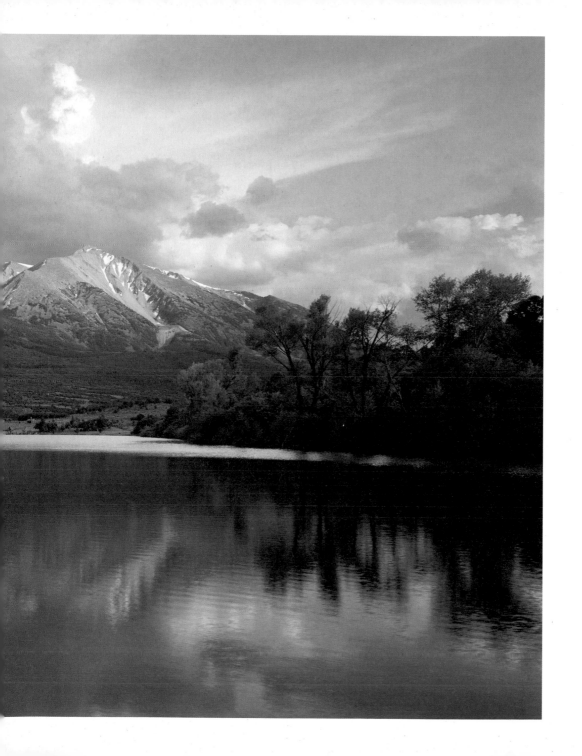

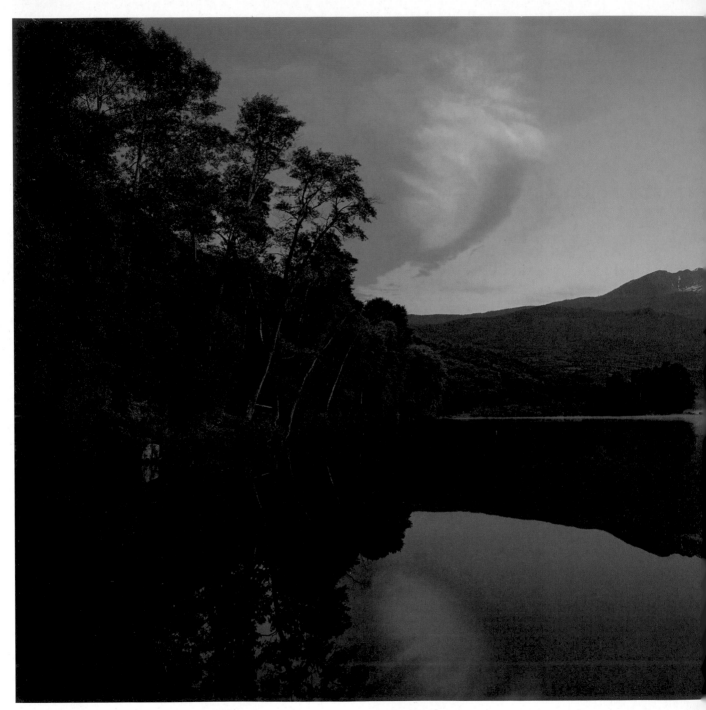

Mountain, II, 2005

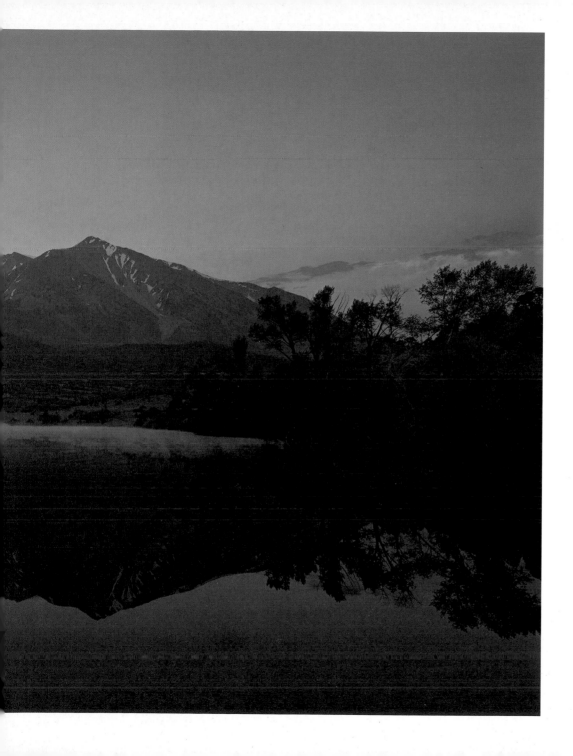

thomas ruff

Since the 1980s, Thomas Ruff has been at the forefront of what is often called New German Photography, or the Düsseldorf School of Photography. Ruff's reputation was established with his color "Portraits," begun while he was a student of renowned German photographer Bernd Becher (and, more informally, Hilla Becher) at the Kunstakademie Düsseldorf. These works, which subsequently became quite large, feature head-on shots of people, primarily fashionable young adults, all of whom have seemingly emotionless and inscrutable expressions. Ruff's seductive "Portraits" evoke fashion advertisements and celebrity photographs, but they also have an air of clinical observation mixed with unnerving alienation.

Ruff has also consistently propelled and extended his medium, including eerie yet spectacular night shots of otherwise mundane streets and architecture taken with night-vision cameras that became prominent in the first Gulf War. Starting in the mid-1990s, he moved from conventional photography to images appropriated from the Internet, which he enlarges and further manipulates, both manually and digitally, especially by altering pixels and colors. His colorful, seemingly abstract series "Substrat" (2002–3) involves transformations of Japanese animé and manga jpegs, while his "Nudes" (1990–2000) turn cheesy Internet pornography into pixelated, willfully blurry images that simultaneously hold and elude one's view. More recently, Ruff's appropriated and then manipulated images of landscapes and architecture constitute some of the most innovative and politically charged artworks of this era. These works form the artist's lexicon of contemporary times, including wars, natural disasters, the World Trade Center attack, famous tourist sites, and reproductions of famous paintings.

In *jpeg bo02*, smoke plumes billow above marshlands in southern Iraq. At issue here is a landscape marked and marred by oil production and rampant war, and several peculiar things happen. From up close the work is an almost purely abstract system of squares and grids; only from a distance does the depicted scene come into view. While this landscape is ominous, it is also dreamy and enticing, with suggestions of both Impressionist painting and the Romantic views of J. M. W. Turner, John Constable, and Caspar David Friedrich. As happens throughout his work, Ruff underscores that this photograph is a highly artificial and manipulated device, which is nevertheless filled with diverse and contradictory information, ranging from nature idylls to the ravages of war.

203

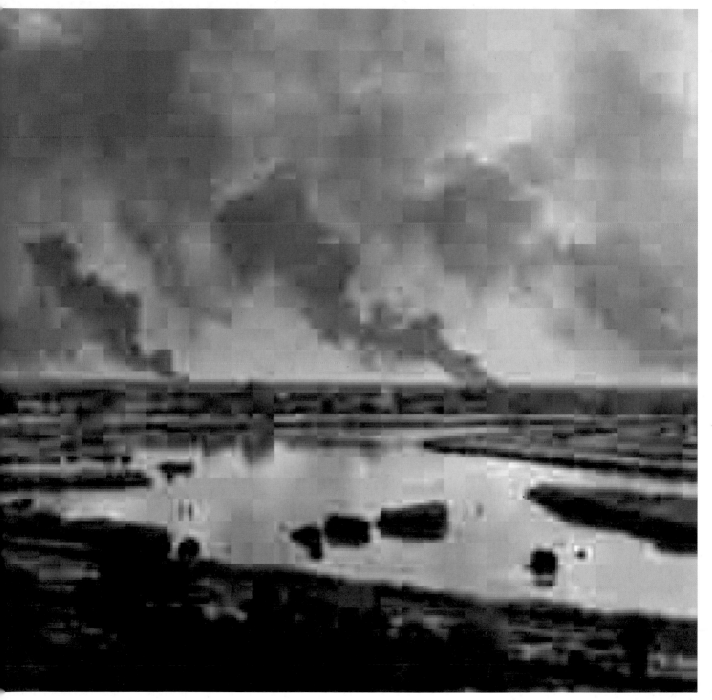

jpeg bo02, 2004

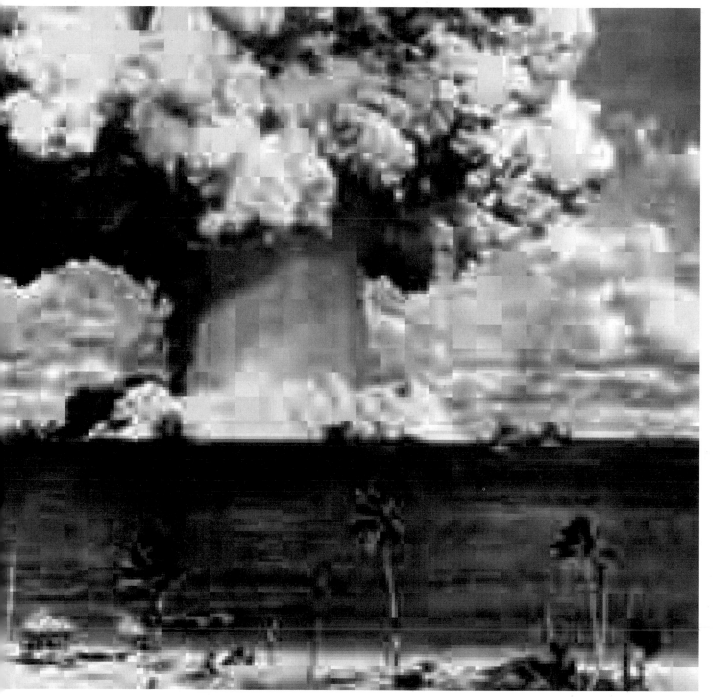

carlos & jason sanchez

Unease, discomfort, and sometimes outright fear are the undercurrents in the large-scale color photographs by the Montréal-based brothers Carlos and Jason Sanchez. The safe and happy veneer has ruptured, and something violent and creepy is seeping out. Sometimes it's the adults who are threatening—as in *Principles* (2002), in which the principal of a seemingly posh private school is pictured on the verge of an inappropriate dalliance with a uniformed female student. But then again, sometimes it's the children themselves who are frightening, as in *While You Were Sleeping II* (2002), in which an angry looking boy in the woods at night holds up a limp, possibly dead, cat by the scruff of its neck. And sometimes nature itself seems to have burst malevolently out of control.

A kitchen sink overflows violently, water turns to blood, or, in *Natural Selection* (2005), two German shepherds revert to their feral animal instincts, baring their teeth at a black dog, which appears to be backing off. It's an unsettling picture of untamed and untamable animals, made scarier still by the tight cropping. At 24 x 96 inches, the picture is long, narrow, and claustrophobic. Like the cowering black dog, we feel trapped. There is a similar tension in *Rescue Effort* (2006), which suggests, as we have surely learned in the last several years of devastating tsunamis, earthquakes, and hurricanes, that nature is a force beyond our ability to control.

The Sanchez brothers' filmic sensibility, with their elaborate staged sets and open-ended narrative possibilities, recalls Gregory Crewdson, another artist who has dealt with the eruption of uncanny natural forces in otherwise serene suburban backyards. Like Crewdson, they can spend months creating the set for one of their photographs, paying close attention to each evocative detail. But their images also recall the stories of domestic violence and natural disasters we see on the news almost nightly, tapping into existing fears and anxieties. If you're worried, their highly charged images seem to say, you should be.

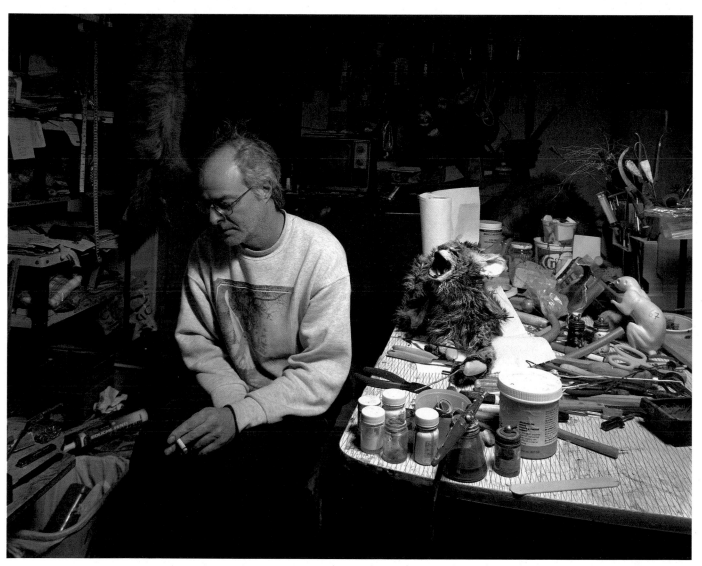

John, 2002

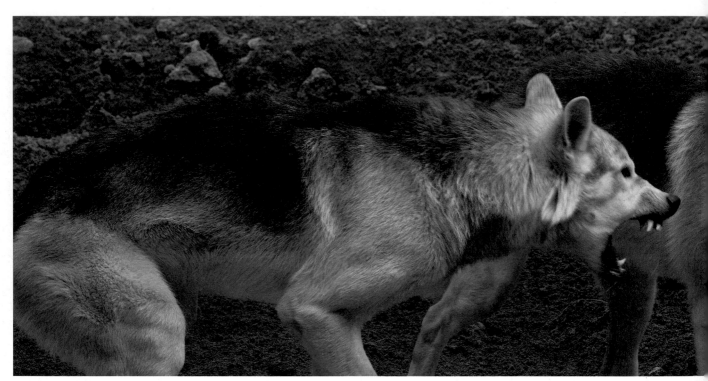

Natural Selection, 2005

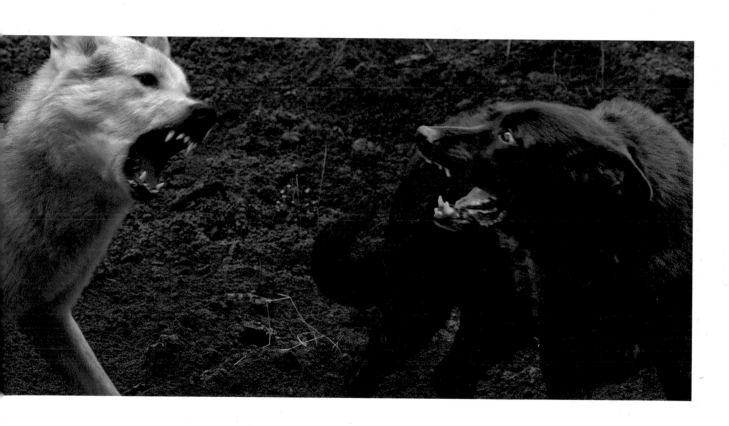

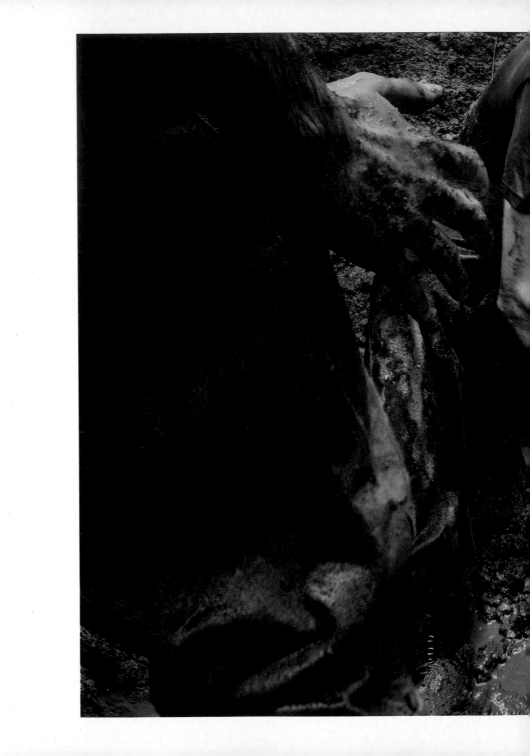

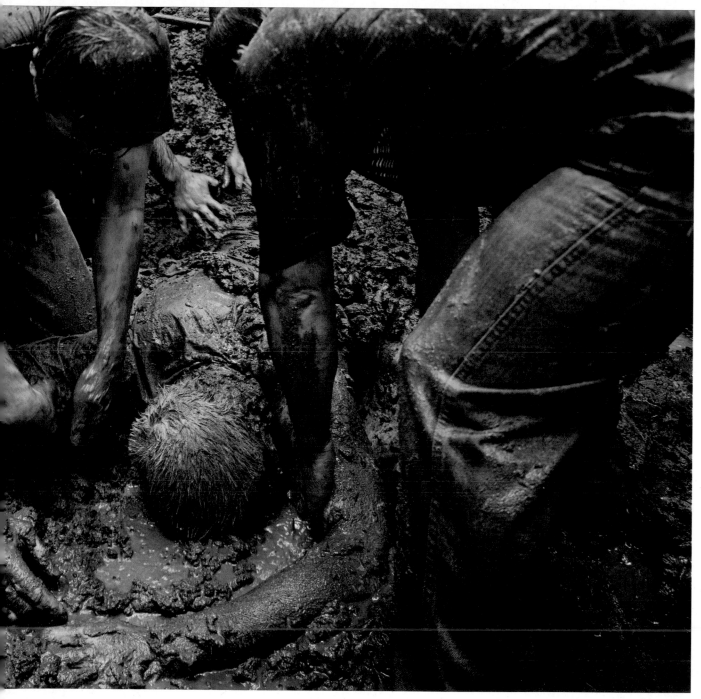

Rescue Effort, 2006

alessandra sanguinetti

Most of us, unless we are among the dwindling number of small farmers who manage to survive in today's economy, are far removed from the reality behind the plastic-wrapped packages of meat we buy in the supermarket. Alessandra Sanguinetti's recent photographs seem to suggest that we have lost something essential in that distance. Sanguinetti was born in New York City, but her family owned a cattle farm outside of Buenos Aires, where she spent her summers and many weekends. It was there that she took the photographs for her well-received first project, "The Adventures of Guille and Belinda and the Enigmatic Meaning of Their Dreams" (1998–2006), which focused on the playful fantasy life of two young cousins in that pubescent period just before adult responsibilities set in. And it was there, over a period of nine years, that she took the photographs for "On the Sixth Day" (1996–2004)—a series of surprisingly intimate images of farm life that bring the viewer right down onto the ground and into the middle of things, among the pigs, cows, ducks, and chickens.

Sanguinetti's photographs do not anthropomorphize the animals. They are not cute, and their demise is presented pragmatically, as an inevitability. A farmer points a gun at a cow in one image; in another, we see a cow's wide, terrified-looking eye as it peers over the gate of a paddock; still another shows a bloody cowhide drying on a branch. Her images do not preach against the practice of eating meat, but they do wrestle with something less tangible, perhaps: a fuller understanding of the rhythms of life on a farm, and a respect for the cycle of life and death. And, what's more, a sense that we are a part of that cycle. Sanguinetti's photographs—of a skinny dog on a dirt road, a pig gnawing on a corn cob as a chicken looks on—confer a certain dignity on her subjects. The pigs and ducks and cows and dogs return our gaze, and we must, at least, acknowledge their existence as living creatures.

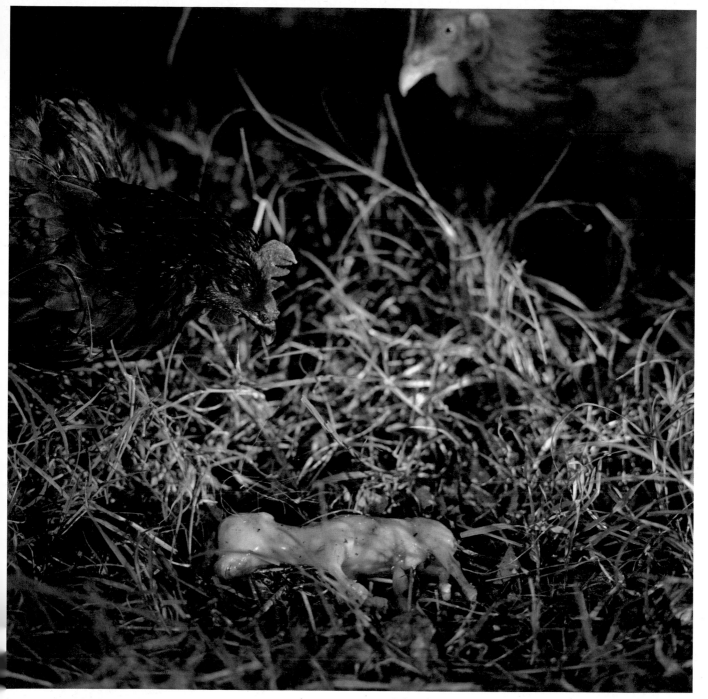

Untitled *(XIX)*, from the series "On the Sixth Day," 1996–2004

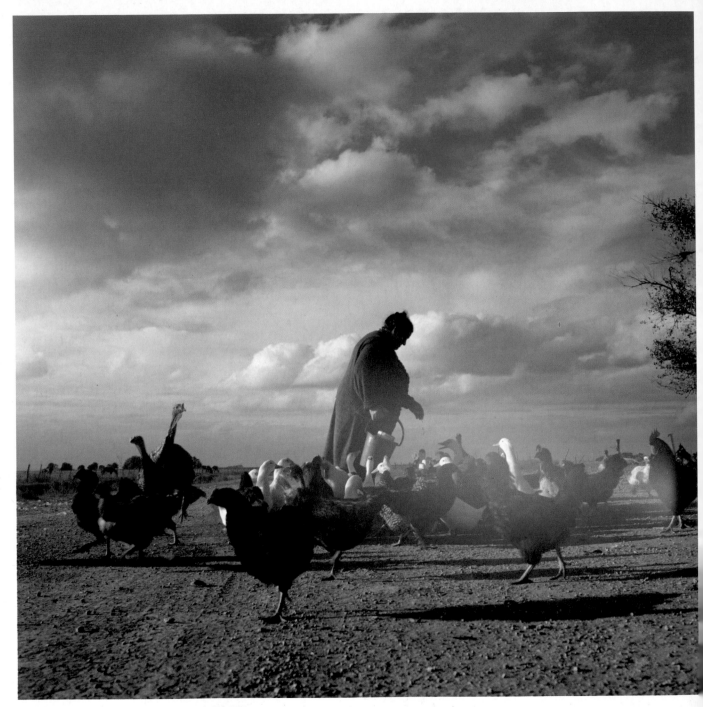

Untitled *(LIII)*, from the series "On the Sixth Day," 1996–2004

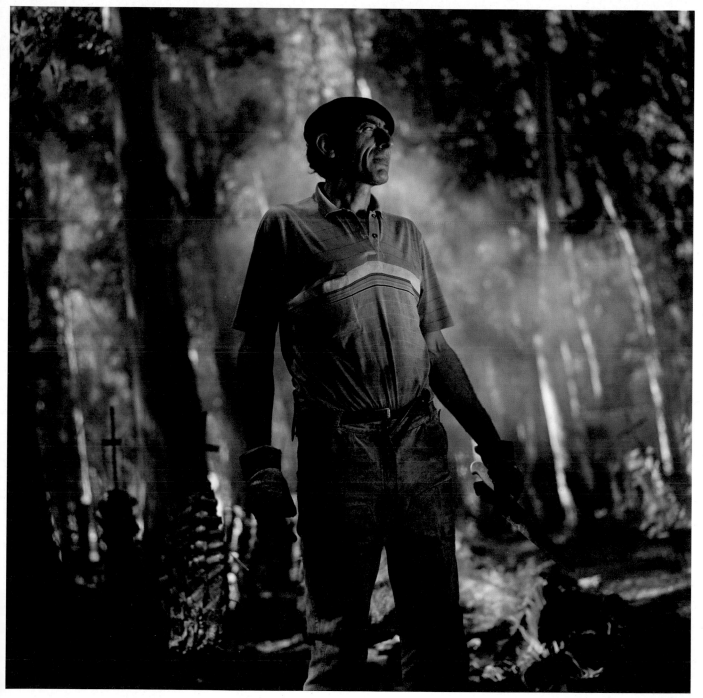

Untitled *(XXXVI)*, from the series "On the Sixth Day," 1996–2004

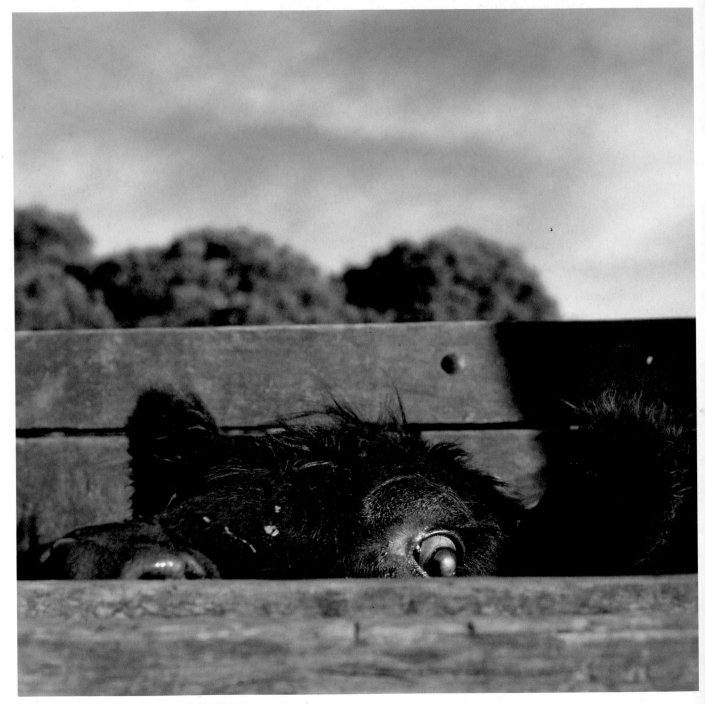

Untitled *(XIV)*, from the series "On the Sixth Day," 1996–2004

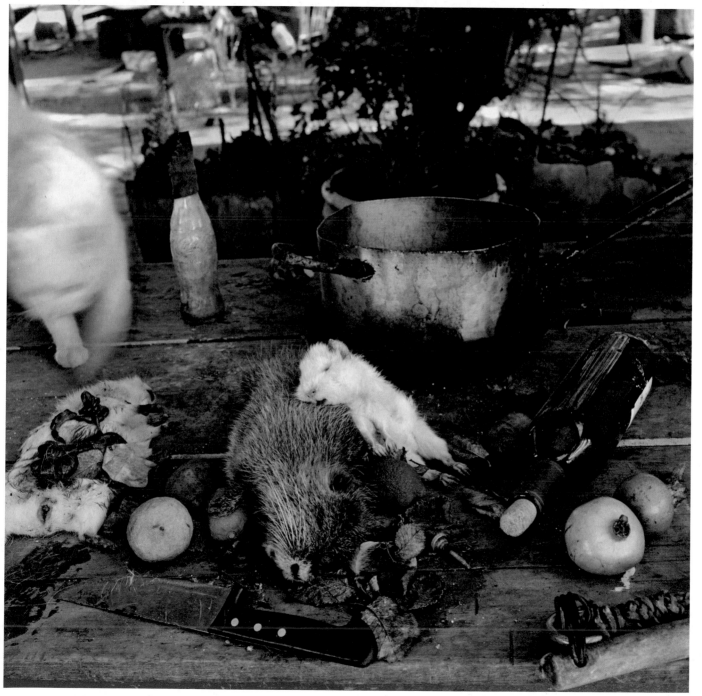

Untitled *(XLVIII)*, from the series "On the Sixth Day," 1996–2004

victor schrager

Over a seven-year period during the 1990s, Victor Schrager photographed more than 100 species of North American birds in intimate close-up. Given his background as an accomplished photographer of inanimate objects, one may be surprised to learn that Schrager has worked with some of nature's most fleet creatures. Yet far from forsaking the genre of still life, Schrager presents his avian subjects in a decidedly static fashion, as each bird is secured before a slashed fabric scrim by the disembodied hands of an ornithologist.

Collectively titled "Bird Hand," this ambitious series of platinum prints possesses taxonomic breadth and specificity. Indeed, by isolating different species and plainly labeling each image with the bird's common name, Schrager invokes the work of John James Audubon and other naturalists who visually documented flora and fauna throughout the eighteenth and nineteenth centuries. Though Audubon often drew from life and typically pictured his birds within summary renderings of their natural habitats, it is also well known that he shot, wired, and variously manipulated many of his specimens to better showcase their field marks and other distinguishing characteristics. Rather than disguise such physical coercion, Schrager's photographs render it transparent and emphasize visual dialogues between human hands and avian form.

These relationships shift as frequently as the varied species under Schrager's lens. Large, predatory birds like owls, hawks, and falcons tend to surmount and clutch the thick gloves beneath their tethered talons. The smaller finches and warblers, by contrast, are often cupped inside human hands, or gently pinched by naked fingers. The precise choreography of the changing grips tends to assure us that professional handlers stand behind the curtains, as does the unruffled calm of each bird. Yet despite their presentation as hand-held evidence, as immobilized avian fact, these birds have obviously been robbed of their defining ability to fly. While lending a note of irony to these photographs, this neutralization also speaks to the limits of our knowledge of the natural world.

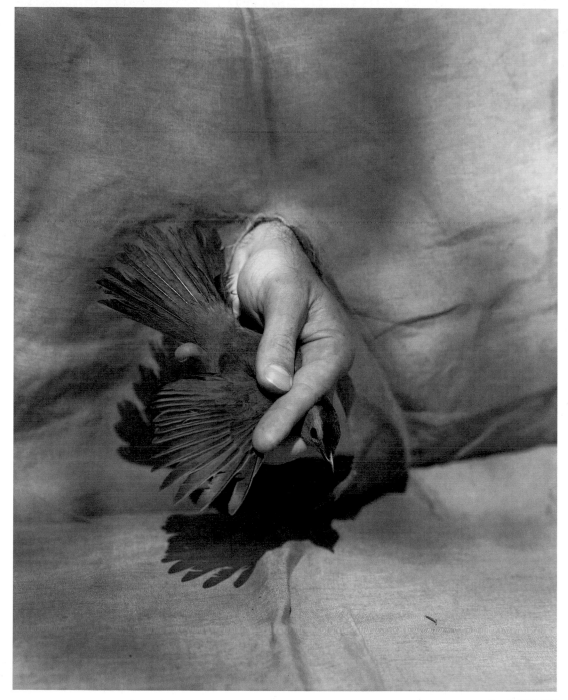

Grey Catbird, 1996

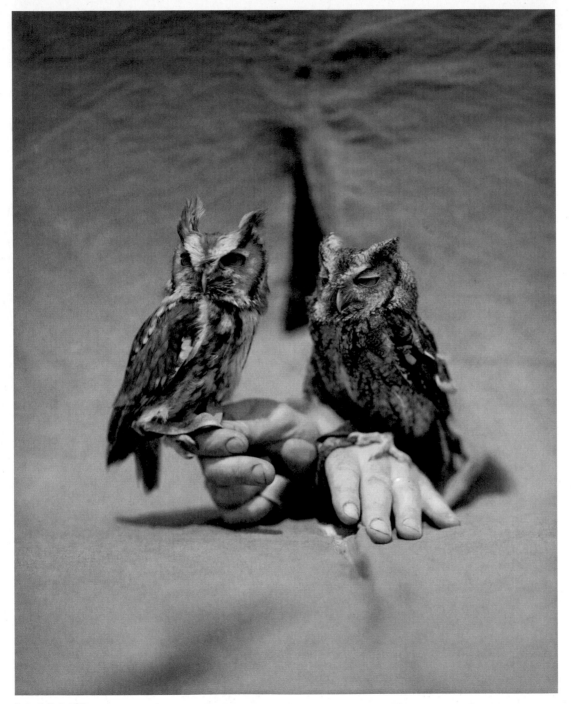

Screech Owls, 1995

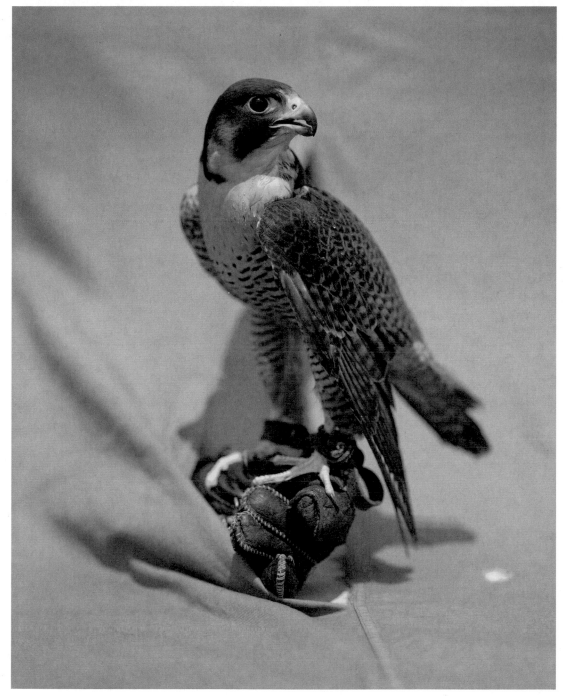

Peregrine Falcon, 1995

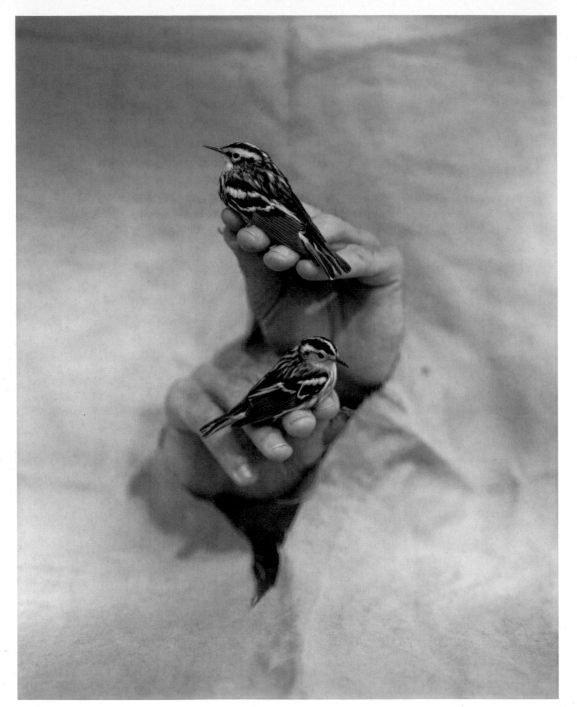

Black and White Warblers, 1996

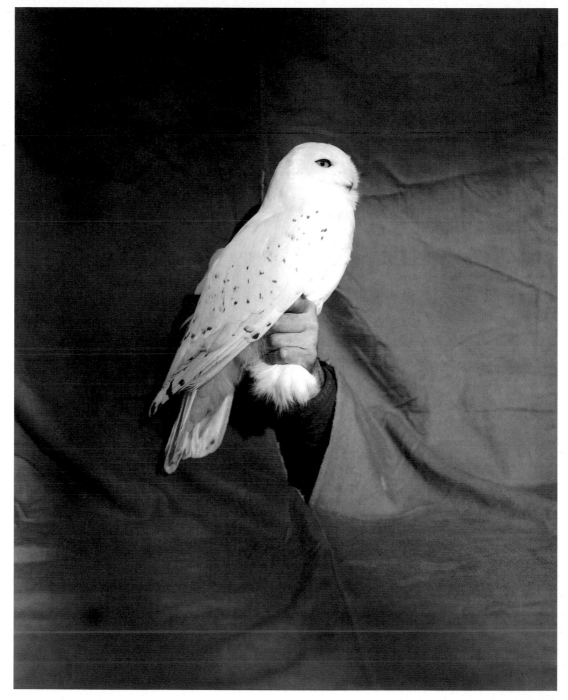

Snowy Owl, 1996

simon starling

The art of Simon Starling privileges the journey over the destination. His multimedia, process-oriented work gained wide exposure in 2005, when he was awarded the Turner Prize in London and much attention was focused on *Shedboatshed (Mobile Architecture no. 2)* (2005). This sculpture began its life as a small wooden shed on the banks of the Rhine. Starling dismantled the abandoned structure to build a functional boat, which he then paddled downriver to Basel, where the shed was reconstructed and exhibited in a museum.

The circular logic of *Shedboatshed* is quite typical of Starling's work, and underscores his abiding interest in ecologically sound creative practices. Yet to describe his art as an extended essay in recycling would be an oversimplification. Indeed, Starling has fabricated many objects from scratch over the past several years. But his finished works consistently reveal evidence of their own origins, asking us to consider the complex networks of historical, economic, and geopolitical forces that help bring them into existence, and ultimately deflating the popular notion that art can emerge from an insular, creative bubble.

Starling's resistance to this artistic model is demonstrated by *One Ton, II*, a group of five identical platinum prints that the artist made by hand in 2005. The title refers to the fact that one ton of ore was needed to produce the few precious ounces of platinum that were used to make these five prints. While this gross imbalance of raw material and final product could be effectively dramatized by any image, Starling provokes additional thought by depicting the very South African quarry from which these photographs derive, as well as numerous South African miners who can be seen toiling on the site. The repetition of this image reminds spectators of the geographic displacement of resources that preceded their appreciation of these photographs in New York, London, or another far-flung location, and the anonymous, alienated labor that also contributed to their viewing pleasure.

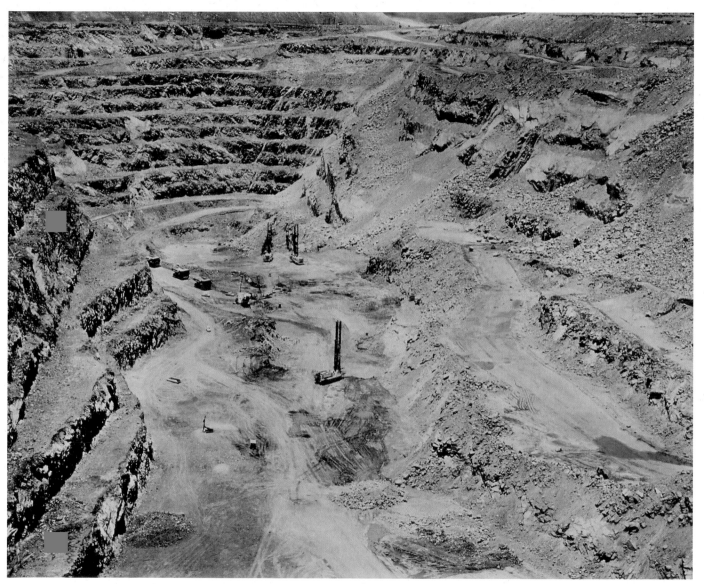

One Ton II, 2005 (detail)

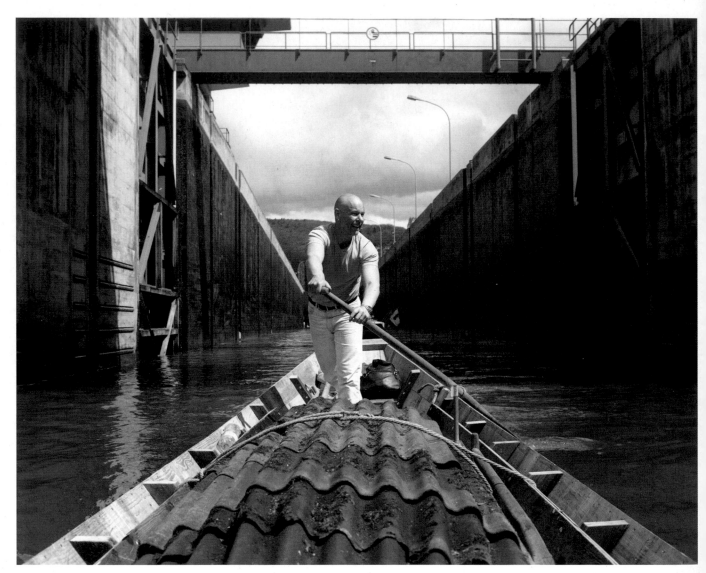

Shedboatshed (Mobile Architecture no. 2), 2005

Trinidad Tree House, 2001–2003 (details)

Trinidad Tree House, 2001–2003

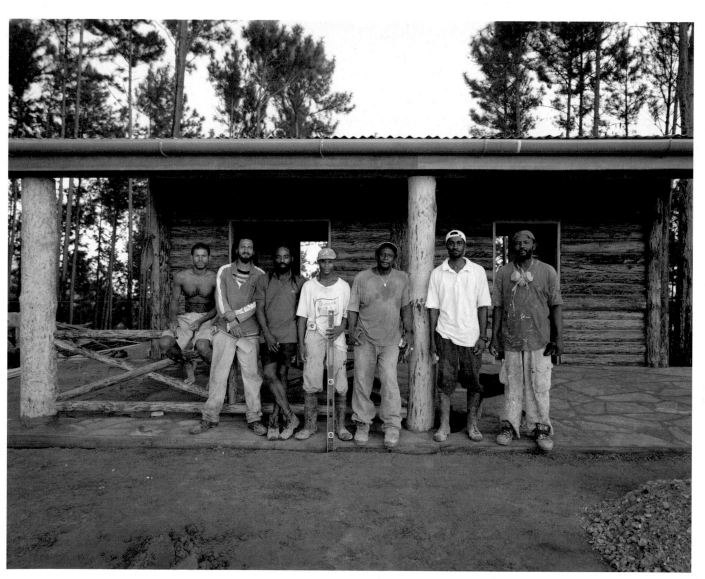

Trinidad Tree House, 2001–2003

kim stringfellow

At the turn of the twentieth century, entrepreneurial developers diverted a portion of the Colorado River to a dry, desert basin in southeastern California. Their efforts to generate fertile land for agriculture were initially successful, attracting thousands of settlers to this newly productive area. But the same irrigation system soon fostered unprecedented flooding of the basin in 1905, when a rain-swollen Colorado River coursed through the manmade canals to create the Salton Sea, an enormous body of water that has sometimes covered close to 400 square miles of the Imperial Valley.

Since her first visit to the Salton Sea in 1995, Kim Stringfellow has documented its troubled waters in striking color photographs, scavenged the surrounding area for natural and manmade artifacts, and studied the sea's ecological and cultural histories. She has compiled this research into an interactive website and a recently published book, both of which use text and images to chronicle the fluctuating fortunes of the Salton Sea over the past one hundred years. Her work illuminates the sea's mid-century identity as a recreational oasis, when developers lured tourists to golf courses, maritime diversions, and planned resort communities. But as Stringfellow informs us, the Salton Sea was largely abandoned by the 1980s, after years of unpredictable flooding and contamination from agricultural runoff rendered its waters and shoreline highly toxic.

Though Stringfellow's work partially functions as an indictment of human folly and environmental mismanagement, her multimedia study of the Salton Sea is not simply an exercise in fingerpointing. Despite its artificial origins, the sea has become a vital sanctuary for certain endangered fishes and migratory birds, and Stringfellow clarifies how their survival hinges on active remediation of their habitat. She also outlines several recent proposals to restore the Salton Sea to an ecologically sound state, succinctly contrasting their goals and feasibility. For a world in which human encroachments on nature are all but inevitable, Stringfellow presents the history of the Salton Sea as a case study to avoid, and looks forward to its future as a potential model of environmental reclamation and sustainable living.

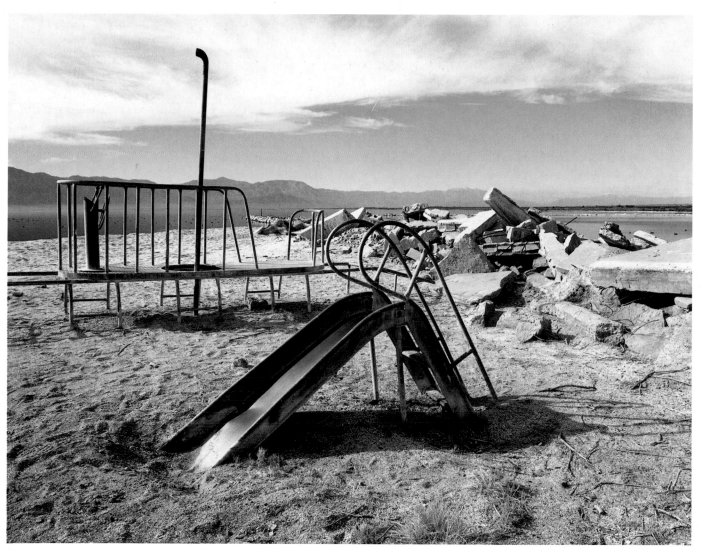

Playground, North Shore, 2004

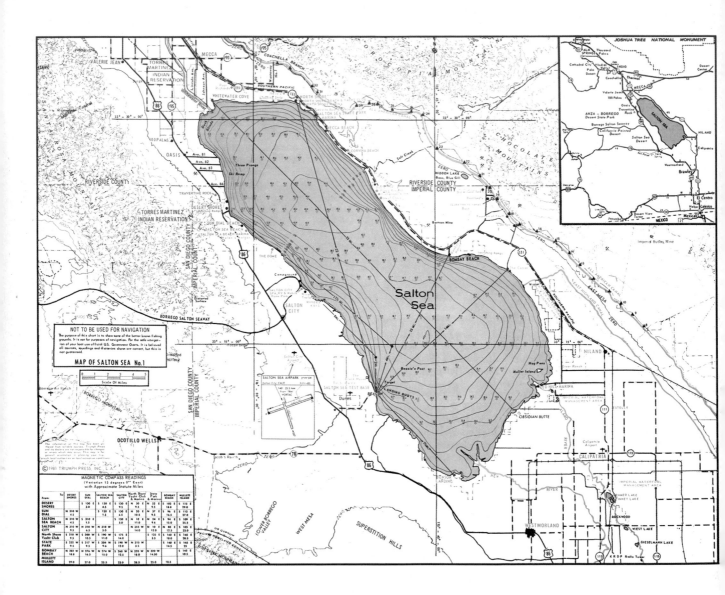

MAP OF SALTON SEA No.1

NOT TO BE USED FOR NAVIGATION

Salton Sea

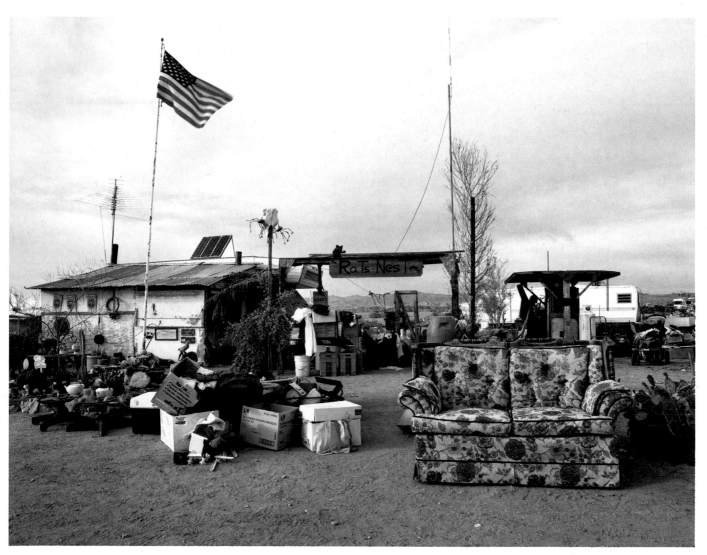

Rat's Nest, Slab City, 2004

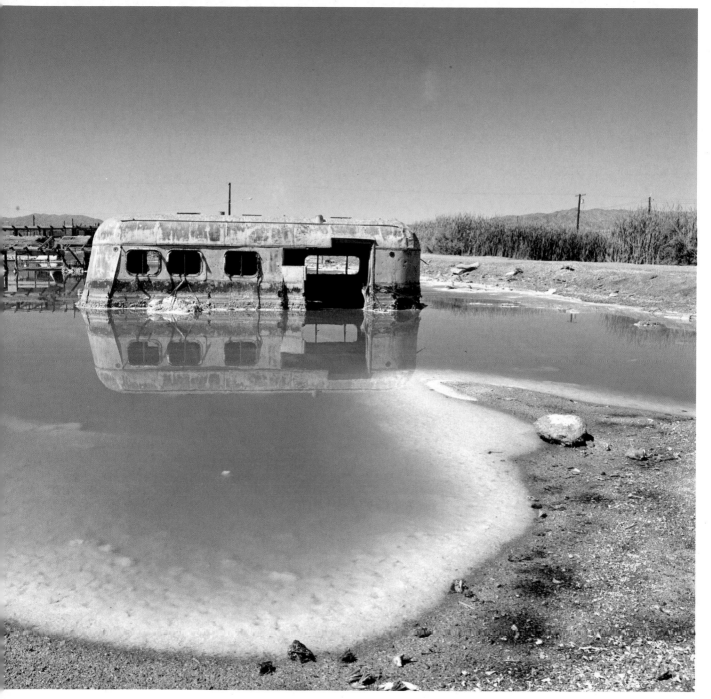

Abandoned Trailer, Bombay Beach, 2000

diana thater

Since the early 1990s, Diana Thater has garnered increasing acclaim for her distinctive use of film and video technologies. Responding to specific architectural settings, Thater tends to project multiple, layered, moving pictures across walls, floors, ceilings, and windows, and often displays additional imagery on monitors dispersed throughout the same rooms. Unlike conventional single-screen projections, which typically encourage imaginary displacement into illusionistic narratives, Thater's work incorporates viewers into more comprehensive environments that demand a phenomenological experience of the here and now.

Thater's work is also distinguished by its unique perspective on the natural world. The wolves, dolphins, chimpanzees, and other creatures that appear in her videos are usually tame or domesticated animals that the artist locates on sanctuaries, thus underscoring our mediated relationship to nature and the increasing disappearance of genuine wildlife on our planet. Such is the case in *Perfect Devotion*, a group of video installations from 2005 that capture three tigers playing in a swimming pool on the grounds of a California rescue compound. Working from an overhead crane, Thater shoots the animals from above with 35mm film and sometimes employs double exposure. Her use of obsolescent materials and techniques parallels the almost certain extinction of wild tigers in the near future.

Thater extends this metaphor by projecting these videos onto old-fashioned, freestanding movie screens. But unlike much of her work, which is normally spread throughout architectural spaces, here the screens confine the imagery to neat rectangles, transforming the aerial views of orange tigers, red balls, and green grounds into flat, abstract compositions of contrasting colors. This atypical presentation generates a binary opposition between the viewing subject and the pictorial object, perhaps alluding to the hierarchical distance we prefer to keep from the animal kingdom. Yet Thater ultimately extrapolates the green hue of the projected grass, and diffuses it through the gallery as an ethereal light. This nearly palpable tint connects the screened world of the tiger compound to our own space, and seems to encourage a more relational, empathetic dialogue between man and beast.

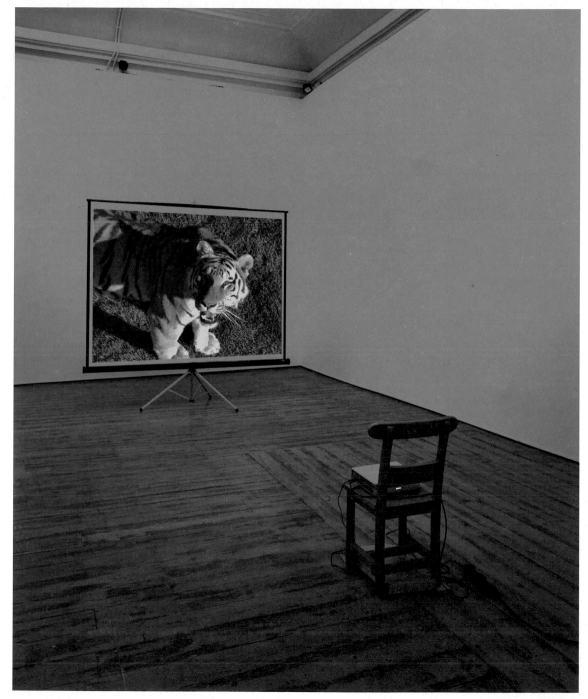

Perfect Devotion Two, 2005

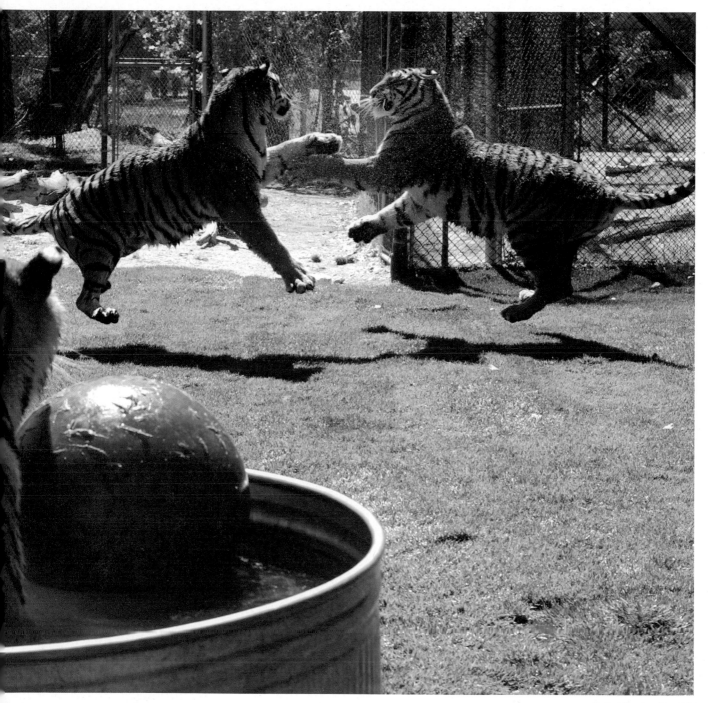

Perfect Devotion Five, 2005

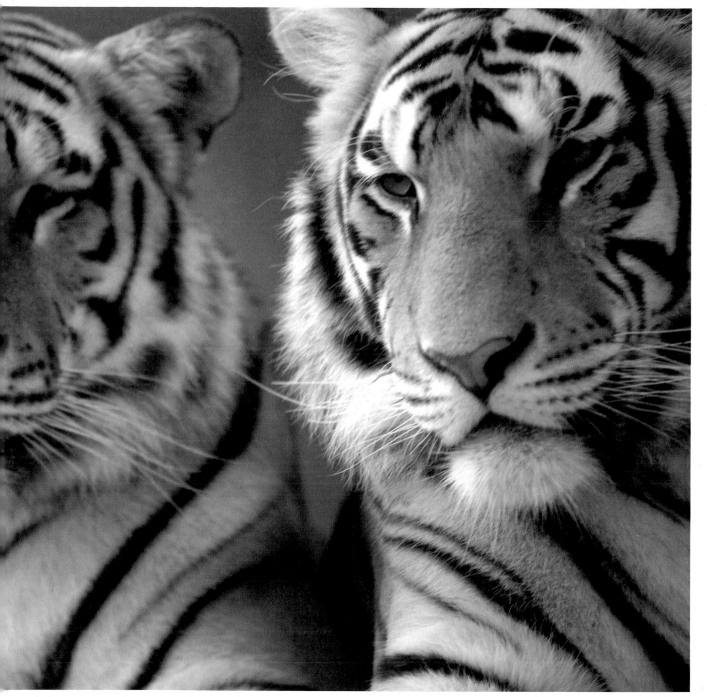

Perfect Devotion Five, 2005

tsunami

The tsunami that struck Southeast Asia on December 26, 2004, caused deaths estimated at over 200,000, and displaced well over a million people. Occasioned by a massive earthquake in the Indian Ocean, the magnitude of which was estimated at between 9.1 and 9.3 on the Richter Scale, the tsunami devastated the shores of southern India, Sri Lanka, Thailand, and Indonesia, with related deaths reported as far as Port Elizabeth, South Africa, 5,000 miles from the earthquake's epicenter. The aftermath of the tsunami was documented in thousands of harrowing photographs by countless photojournalists, but like many unforeseen cataclysms in recent years, images taken by amateurs with digital cameras, video cameras, and photo-enabled mobile phones were the first to provide the world a glimpse of the disaster's impact.

On the morning of the earthquake, Joanne Davis, a Hong Kong–based British national, was on holiday in Phuket, Thailand, when she made a sequence of photos of the encroaching surf from her hotel balcony before realizing the gravity of the situation and fleeing. The waves reached 100 feet high. In another series of photographs taken on the Thai beach of Hat Rai Lay, an anonymous amateur photographer documented the eerie recession of the tide, which retreated a mile and a half as the tsunami gathered force. Curious tourists, unfamiliar with these warning signs, are seen walking further out to sea before attempting to outrun the wave.

These images, a small sampling of the hundreds of amateur snaps available from photo agencies following the event, document with certain immediacy the devastation of the Indian Ocean earthquake. Their ubiquity points to the increased authority given to amateur image makers in capturing the events of our times.

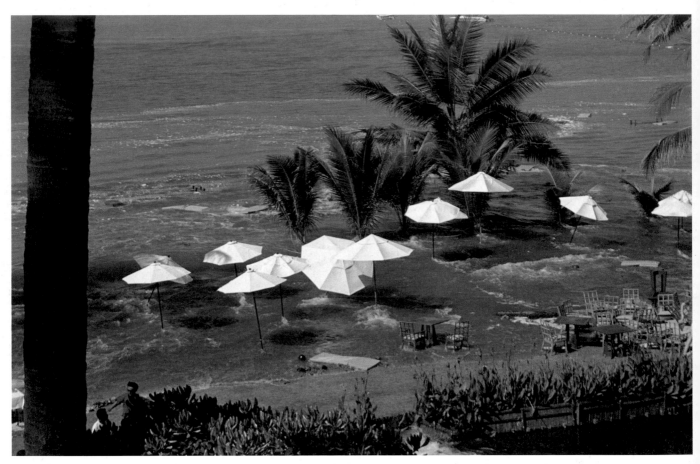

Courtesy Polaris Images

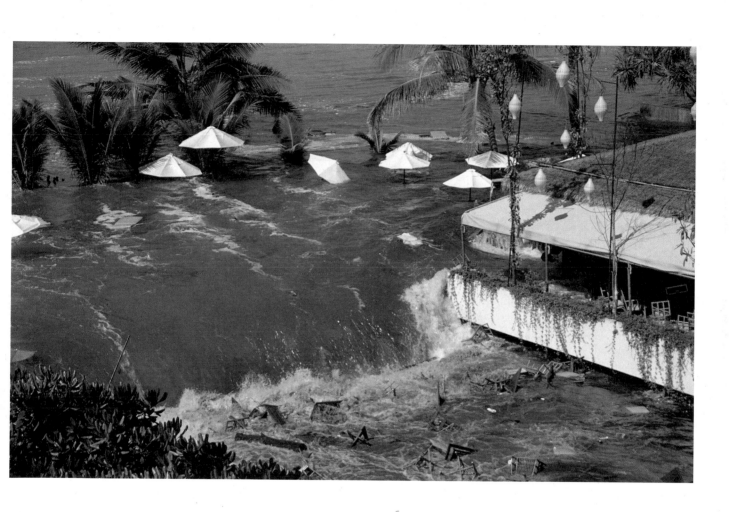

wang qingsong

In "Come!, Come!" (2005) Wang Qingsong critically examines the implications of China's rapid social transformations with this staged "demonstration." On the left, the protestors carry signs bearing slogans from past political campaigns, ranging from early confrontations with the West during the Opium War to the familiar rhetoric of socialist campaigns promoting reproductive policies and nation building. As they march away, the reverse of their signs reveal advertising slogans that have become commonplace since market liberalization in the 1980s—slogans promoting foreign and Chinese products alike, including the ubiquitous McDonald's and Coca-Cola, as well as bottled water, women's lingerie, and hard alcohol. In between is an image of the debris the protestors have left behind.

Beijing-based artist Wang Qingsong is best known for his elaborate tableau-style photographs featuring wry contemporary twists on images from Chinese popular culture. He directs dozens of "models" (often migrant labor crews hired for the occasion) in rented film studio lots, sometimes for weeks at a time. With this work Wang ventures out of doors, and in some sense raises the stakes of his critique. By juxtaposing these disparate slogans, Wang is questioning the radical and seemingly arbitrary ideological shift away from collective political action to the unchecked pursuit of consumerist desires, and the state that has promoted and enabled both paths for the nation. Commenting on these changes, Wang asks, "What is coming? ... Why is it coming? ... [and] Why is it happening on the same road?" With the deserted, polluted scene left in their wake, Wang seems to be implying that the downside of this transition has yet to be imagined, as the damage literally and metaphorically covers national landscape.

As usual, Wang places himself within the scene as an ambiguous participant-observer, hardly exempt from the processes he is critiquing. Here he can be found trailing behind the consumer-demonstrators, camera poised, next to a small and rather forlorn black and white sign demanding "Art Forever."

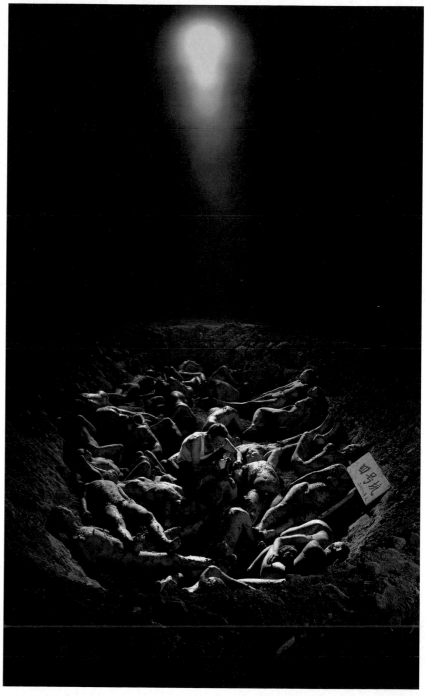

Archaeologist, 2004

Follow Me, 2003

250

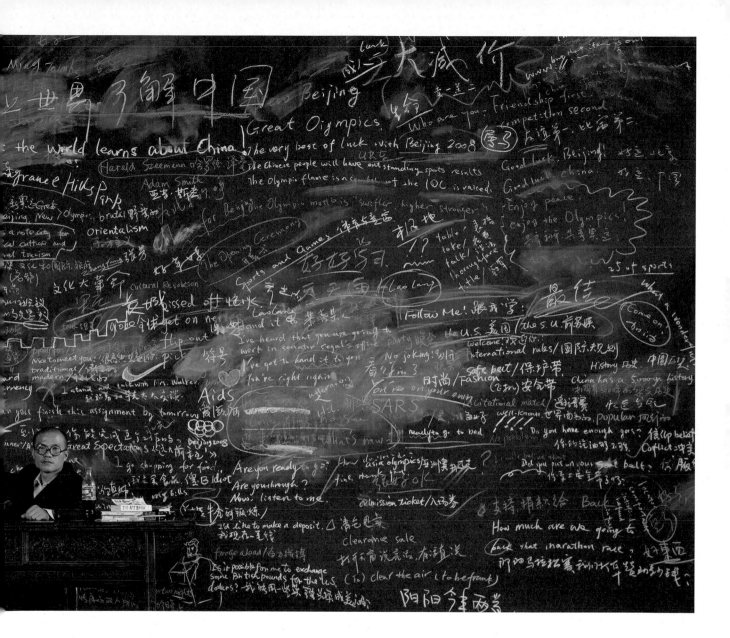

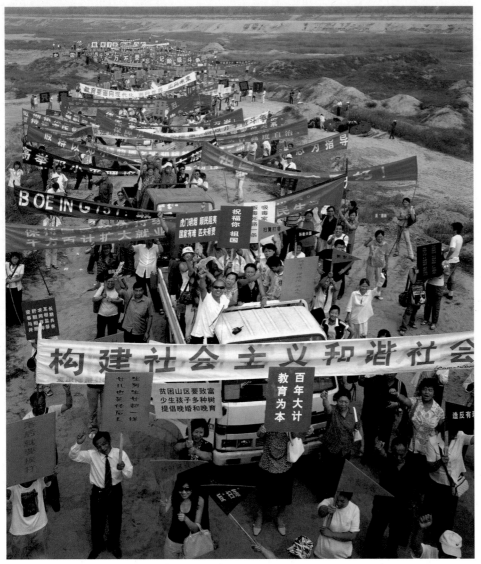
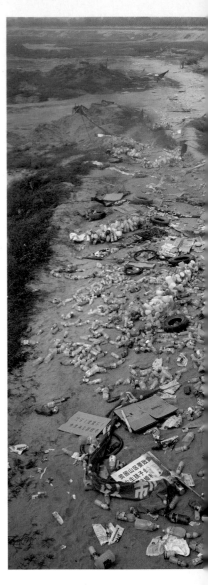

Come! Come!, 2005

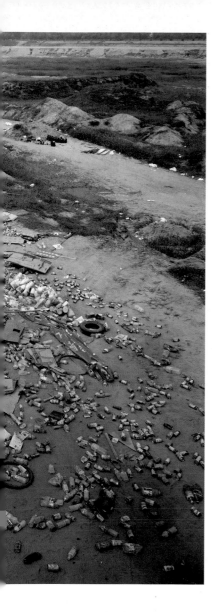

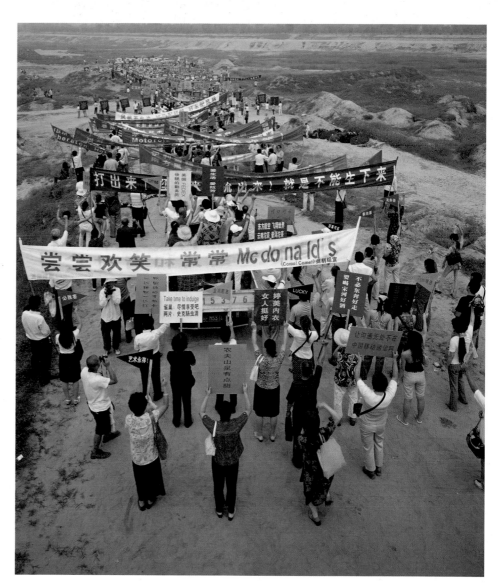

Checklist of the Exhibition as of July, 2006

robert adams
From the series "Turning Back," 1999–2003
– *Coos County, Oregon*, 1999
Gelatin silver print
14 x 11 in. (35.6 x 27.9 cm)
Courtesy Fraenkel Gallery, San Francisco,
and Matthew Marks Gallery, New York
– *Clatsop County, Oregon*, 2001
15 gelatin silver prints
11 x 14 in. (27.9 x 35.6 cm) and 14 x 11 in.
(35.6 x 27.9 cm)
Courtesy Fraenkel Gallery, San
Francisco, and Matthew Marks Gallery,
New York

doug aitken
– *Plateau*, 2002
Fujitrans print in lightbox
52 1/4 x 122 x 14 in. (132.7 x 309.9 x 35.6 cm)
Private collection, courtesy the Fabric
Workshop and Museum, Philadelphia

allora & calzadilla
– *Amphibious (Login-Logout)*, 2005
Video, color, sound, 6:17 min.
Courtesy Galerie Chantal Crousel, Paris,
and Lisson Gallery, London

wout berger
– *Ruigoord 3*, 2002
Chromogenic print
47 x 59 in. (119.4 x 149.9 cm)
Courtesy Galerie Van Kranendonk,
The Hague

adam broomberg and oliver chanarin
– *Rabin Park*, 2005
Chromogenic print
48 x 67 in. (121.9 x 170.2 cm)
Courtesy the artists
– *The Saints Forest*, 2005
Chromogenic print
48 x 67 in. (121.9 x 170.2 cm)
Courtesy the artists

patrick brown
– *Black Market: The Trafficking of
Endangered Species in Asia*, 2002–5
Digital image projection
Courtesy Patrick Brown/Panos Pictures

catherine chalmers
– *Safari*, 2006
Video, color, sound, appr. 7:00 min.
Courtesy the artist

stéphane couturier
– *Proctor Valley, San Diego*, 2004
Chromogenic print
49 x 67 in. (124.5 x 170.2 cm)
Courtesy Laurence Miller Gallery, New
York, and Galerie Polaris, Paris

lou dematteis and kayana szymczak
– *Crude Reflections*, 2003
Digital image projection
Courtesy the artists

yannick demmerle
From the series "*Les Nuits Étranges*," 2004
– *Untitled (#6)*, 2004
Chromogenic print
74 x 92 in. (188.9 x 233.7 cm)
Courtesy Arndt & Partner, Berlin/Zürich
– *Untitled (#14)*, 2004
Chromogenic print
74 x 92 in. (188.9 x 233.7 cm)
Courtesy Arndt & Partner, Berlin/Zürich

goran dević
– *Imported Crows*, 2004
Video, color, sound, 21:15 min.
Courtesy the artist

mark dion
– *The Bureau of Remote Wildlife
Surveillance*, 2006
Installation, including office furniture,
photo equipment, maps, bulletin boards,
archival boxes, and 4 x 6 in. chromogenic
prints
Dimensions variable
Courtesy Tanya Bonakdar Gallery,
New York

sam easterson
From the series "Animal Vegetable Video,"
1998–present
– *Sheep-Cam*, 1998
– *Deer-Cam*, 1999
– *Armadillo-Cam*, 2000
– *Scorpion-Cam*, 2000
– *Tarantula-Cam*, 2000
– *Tumbleweed-Cam*, 2000
– *Buffalo-Cam*, 2003
– *Cow-Cam*, 2004
– *Pig-Cam*, 2004
– *Wolf-Cam*, 2004
– *Fly-Cam*, 2005
– *Chick-Cam*, 2006
– *Falcon-Cam*, 2006
– *Turkey-Cam*, 2006
Video, color, sound, each appr. 1:00 min.
Courtesy Daniel Cooney Fine Art,
New York

mitch epstein
– *Amos Coal Power Plant, Raymond,
West Virginia*, 2004
Chromogenic print
70 x 92 in. (177.8 x 233.7 cm)
Courtesy Sikkema Jenkins & Co.,
New York
– *Biloxi, Mississippi*, 2005
Chromogenic print
70 x 92 in. (177.8 x 233.7 cm)
Collection Katie and Esme Brown,
courtesy Sikkema Jenkins & Co., New York

joan fontcuberta
– *Orogenesis: Brandt*, 2006
Gelatin silver print
30 x 40 in. (76 x 102 cm)

Courtesy Zabriskie Gallery, New York
– *Orogenesis: Man Ray/Duchamp*, 2006
Gelatin silver print
30 x 40 in. (76 x 102 cm)
Courtesy Zabriskie Gallery, New York
– *Orogenesis: Stieglitz*, 2006
Gelatin silver print
30 x 40 in. (76 x 102 cm)
Courtesy Zabriskie Gallery, New York

noriko furunishi
– *Untitled (Grey Dry Stream)*, 2005
Chromogenic print
91 1/2 x 48 in. (232 x 122 cm)
Courtesy Murray Guy, New York
– *Untitled (Tecopa L)*, 2005
Chromogenic print
101 1/2 x 48 in. (258 x 122 cm)
Courtesy Murray Guy, New York

marine hugonnier
– *Last Tour*, 2004
16mm film transferred to DVD, color,
sound, 14:17 min.
Courtesy Max Wigram Gallery, London

francesco jodice
– *Natura: Il Caso Montemaggiore*, 2003
Film, color, sound, 20:00 min.
Courtesy Photo & Contemporary, Turin

harri kallio
– *Domain du Chasseur #1, Mauritius*, 2001
Chromogenic print
29 1/2 x 35 in. (74.9 x 88.9 cm)
Courtesy Bonni Benrubi Gallery, New York
– *Lion Mountain #1, Mauritius*, 2001
Chromogenic print
29 1/2 x 35 in. (74.9 x 88.9 cm)
Courtesy Bonni Benrubi Gallery, New York
– *Lion Mountain #5, Mauritius*, 2004
Chromogenic print
37 x 76 in. (94 x 193 cm)
Courtesy Bonni Benrubi Gallery, New York
Installation, including two dodo recon-
structions, books, photographic copy
prints

Dimensions variable
Courtesy Bonni Benrubi Gallery, New York

vincent laforet
– *Hurricane Katrina*, 2005
Digital image projection
Courtesy Vincent Laforet/*The New York
Times*

christopher lamarca
– *Forest Defenders*, 2002–5
Digital image projection
Courtesy Christopher LaMarca/Redux

an-my lê
– *29 Palms*, 2005
35mm film, transferred to DVD, two-chan-
nel projection, black and white, 7:00 min.
Courtesy Murray Guy, New York

david maisel
– *Surveillance 976–8*, 2005
Chromogenic print
49 1/2 x 49 1/2 in. (126 x 126 cm)
Courtesy the artist and Von Lintel Gallery,
New York
– *Surveillance 983–9*, 2005
Chromogenic print
49 1/2 x 49 1/2 in. (125.7 x 125.7 cm)
Courtesy the artist and Von Lintel Gallery,
New York
– *Surveillance 973–10*, 2005
Chromogenic print
49 1/2 x 49 1/2 in. (125.7 x 125.7 cm)
Courtesy the artist and Von Lintel Gallery,
New York

mary mattingly
– *The New Mobility of Home (The Nobility
of Mobility)*, 2004
Chromogenic print
30 x 40 in. (76.2 x 101.6 cm)
Courtesy Robert Mann Gallery, New York
– *Travel and Lifestraw*, 2005
Chromogenic print
30 x 30 in. (76.2 x 76.2 cm)
Courtesy Robert Mann Gallery, New York

– *Seven Firm Oligopoly*, 2006
Chromogenic print
20 x 40 in. (50.8 x 101.6 cm)
Courtesy Robert Mann Gallery, New York
<www.marymattingly.com>
Website
Courtesy the artist

gilles mingasson
– *The End of Shishmaref: Global Warming*,
2005
Digital image projection
Courtesy Gilles Mingasson/Getty Images

simon norfolk
From the series "Scenes from a Liberated
Iraq," 2003
– *Date Grove, Atifya, Northern Baghdad*, 2003
Chromogenic print
20 x 24 in. (50.8 x 60.9 cm)
Courtesy Bonni Benrubi Gallery, New York
– *The North Gate of Baghdad (After Corot)*,
2003
Chromogenic print
40 x 50 in. (101.6 x 127 cm)
Courtesy Bonni Benrubi Gallery, New York
– *Surface to Surface Missile System,
Orange Grove, Northern Baghdad*, 2003
Chromogenic print
20 x 24 in. (50.8 x 60.9 cm)
Courtesy the Los Angeles County
Museum of Art

the otolith group
– *Otolith*, 2003
Video, color, sound, 22:20 min.
Courtesy the artists

sophie ristelhueber
– *Iraq*, 2001
Three chromogenic prints
Each 47 1/2 x 70 7/8 in. (120.7 x 177.8 cm)
Courtesy the artist

clifford ross
– *Mountain XIII*, 2006
Chromogenic print

71 1/2 x 130 in. (181.6 x 330.2 cm)
Courtesy Sonnabend Gallery, New York

thomas ruff
– *jpeg bo02*, 2004
Chromogenic print
74 x 95 1/2 in. (188 x 243 cm)
Private collection, courtesy David
Zwirner, New York

carlos and jason sanchez
– *Natural Selection*, 2005
Chromogenic print
24 x 96 in. (61 x 244 cm)
Courtesy the artists, Claire Oliver Fine
Art, New York, and Torch Gallery,
Amsterdam
– *Rescue Effort*, 2006
Chromogenic print
42 x 72 in. (107 x 183 cm)
Courtesy the artists, Claire Oliver Fine
Art, New York, and Torch Gallery,
Amsterdam

alessandra sanguinetti
From the series "On the Sixth Day,"
1996–2004
– *(Untitled) XVII*
Chromogenic print
30 x 30 in. (76.2 x 76.2 cm)
Courtesy Yossi Milo Gallery, New York
– *(Untitled) XIX*
Chromogenic print
30 x 30 in. (76.2 x 76.2 cm)
Courtesy Yossi Milo Gallery, New York

– *(Untitled) XXXVI*
Chromogenic print
30 x 30 in. (76 x 76.2 cm)
Courtesy Yossi Milo Gallery, New York
– *(Untitled) XLI*
Chromogenic print
30 x 30 in. (76.2 x 76.2 cm)
Courtesy Yossi Milo Gallery, New York
– *(Untitled) XLVIII*
Chromogenic print
30 x 30 in. (76.2 x 76.2 cm)
Courtesy Yossi Milo Gallery, New York
– *(Untitled) LIII*
Chromogenic print
30 x 30 in. (76.2 x 76.2 cm)
Courtesy Yossi Milo Gallery, New York

victor schrager
From the series "Bird Hand," 1994–2001
– *Zebra Finch*, 1994
Platinum print
8 x 10 in. (20.32 x 25.4 cm)
Courtesy Edwynn Houk Gallery, New York
– *Peregrine Falcon*, 1995
Platinum print
8 x 10 in. (20.3 x 25.4 cm)
Courtesy Edwynn Houk Gallery, New York
– *Two Screech Owls*, 1995
Platinum print
8 x 10 in. (20.3 x 25.4 cm)
Courtesy Edwynn Houk Gallery, New York
– *Black and White Warblers*, 1996
Platinum print
8 x 10 in. (20.3 x 25.4 cm)
Courtesy Edwynn Houk Gallery, New York

– *Grey Catbird*, 1996
Platinum print
8 x 10 in. (20.3 x 25.4 cm)
Courtesy Edwynn Houk Gallery, New York
– *Snowy Owl*, 1996
Platinum print
8 x 10 in. (20.3 x 25.4 cm)
Courtesy Edwynn Houk Gallery, New York

simon starling
– *One Ton, II*, 2005
Five platinum/palladium prints
Each 33 1/2 x 25 1/2 in. (85.1 x 65 cm)
Courtesy the artist and The Modern
Institute/Toby Webster Ltd., Glasgow

kim stringfellow
– *Greetings from the Salton Sea*, 2004
Website: www.greetingsfromsaltonsea.com
Courtesy the artist

diana thater
– *Perfect Devotion Five*, 2005
Installation, including digital projector,
DVD player, DVD, wooden chair, tripod-
mounted projection screen, Lee filters,
and existing architecture
Dimensions variable
Courtesy David Zwirner, New York

wang qingsong
– *Come! Come!*, 2005
Three chromogenic prints
Each 90 x 72 in. (230 cm)
Courtesy Salon 94, New York, and Pékin
Fine Arts, Beijing

Artist Biographies

robert adams

Born Orange, New Jersey, 1937
Lives in Astoria, Oregon

Education

B.A., English, University of Redlands,
California

Ph.D., English, University of Southern
California, Los Angeles

Selected Solo Exhibitions

2006

Deutsche Börse Photography Prize 2006,
The Photographers' Gallery, London
*Robert Adams: Landscapes of Harmony and
Dissonance*, J. Paul Getty Museum, Los
Angeles
Turning Back, Matthew Marks Gallery,
New York; Center for Creative
Photography, Tucson

2005

Circa 1970, Fraenkel Gallery, San
Francisco
Turning Back, San Francisco Museum of
Modern Art; Haus der Kunst, Munich

2004

The Paradise, Douglas Hyde Gallery,
Trinity College, Dublin
Robert Adams: From the Missouri West,
Princeton University Art Museum
Robert Adams: The New West, Joseph
Albers Museum, Bottrop, Germany

2003

Commercial, Residential, Roth Horowitz,
New York
No Small Journeys, Matthew Marks
Gallery, New York
Summer Nights, Fraenkel Gallery, San
Francisco

2002

*Robert Adams: What We Bought, The New
World*, Yale University Art Gallery, New
Haven

2001

Reinventing the West, Addison Gallery of
American Art, Andover, Massachusetts
Robert Adams: Places—People, National
Museum of Contemporary Art, Oslo
*Robert Adams: Sunlight, Solitude,
Democracy*, Douglas F. Cooley Memorial
Art Gallery, Reed College, Portland,
Oregon
Robert Adams: True West, Amon Carter
Museum, Fort Worth, Texas

2000

California, Fraenkel Gallery, San
Francisco
*Robert Adams: What We Bought The New
World, and California*, Matthew Marks
Gallery, New York

1998

To the Mouth of the Columbia, Princeton
University Art Museum

Selected Group Exhibitions

2006

Tiefenschärfe—Bilder vom Menschen,
Staatliche Kunsthalle Baden-Baden
Twilight: Photography in the Magic Hour,
Victoria and Albert Museum, London

2005

Bilanz in zwei Akten, Kunstverein
Hannover, Germany

2004

Citigroup Photography Prize 2004, The
Photographers' Gallery, London; Stiftung
Museum Kunst Palast, Düsseldorf
Glorious Harvest: Photographs from the

Michael E. Hoffman Tribute Collection,
Philadelphia Museum of Art
*Super Hits of the '70s: Photographs from
the Collection*, Milwaukee Art Museum
Wide Open Spaces, P.S.1 MoMA, Long
Island City, New York

2003

*Cruel and Tender: The Real in the Twentieth-
Century Photograph*, Tate Modern, London;
Museum Ludwig, Cologne
Enchanted Evening, Yancey Richardson
Gallery, New York
Jede Fotografie ein Bild, Pinakothek der
Moderne, Munich
Unreal Estate Opportunities, pkm gallery,
Seoul

2002

Regarding Landscape, Museum of
Contemporary Canadian Art, Toronto
Visions from America, Whitney Museum of
American Art, New York

2001

Amerikanische Fotografie ca. 1970, Mai 36
Galerie, Zürich
Nature in Photography, Galerie nächst St.
Stephan–Rosemarie Schwarzwälder,
Vienna
*Settings and Players: Theatrical Ambiguity
in American Photography*, White Cube,
London

2000

How You Look at It, Sprengel Museum
Hannover, Germany
*No Absolutes: Contemporary Art from the
Region*, Arizona State University Art
Museum, Tempe
*Open Ends: MoMA 2000, Seasons and
Moments*, Museum of Modern Art, New York
The West Since Yesterday, Denver Art
Museum

1999
The American Century: Art and Culture, 1950–2000, Whitney Museum of American Art, New York
Photography: A Measure of Nature, Art Institute of Chicago
Pure Products of America, Matthew Marks Gallery, New York
Sea Change, International Center of Photography, New York
Waterproof: Water in Photography Since 1852, Centro Cultural de Belém, Lisbon

Awards
2006
Deutsche Börse Photography Prize, The Photographers' Gallery, London

1995
Spectrum International Prize for Photography

1994
John D. and Catherine T. MacArthur Foundation Award

Selected Collections
Addison Gallery of American Art, Andover, Massachusetts
Albright-Knox Art Gallery, Buffalo, New York
Amon Carter Museum, Fort Worth, Texas
Arizona State University, Tempe
Art Institute of Chicago
Baltimore Museum of Art
Bowdoin College, Brunswick, Maine
Canadian Centre for Architecture, Montréal
Cincinnati Art Museum
Colgate University, Hamilton, New York
Denver Art Museum
Fonds National d'Art Moderne, Paris
Fonds Régional d'Art Contemporain (FRAC) Champagne-Ardennes, France
Fonds Régional d'Art Contemporain (FRAC) Lorraine, Metz, France
Fonds Régional d'Art Contemporain

(FRAC) Rhône-Alps, France
George Eastman House, Rochester, New York
Israel Museum, Jerusalem
J. Paul Getty Museum, Los Angeles
Los Angeles County Museum of Art
Madison Art Center, Madison, Wisconsin
Metropolitan Museum of Art, New York
Milwaukee Art Museum
Musée des Beaux-Arts du Canada, Ottawa
Museum of Fine Arts, Houston
Museum of Fine Arts, Santa Fe
Museum of Modern Art, New York
Museum of Photographic Arts, San Diego
National Gallery of Art, Washington, D.C.
National Gallery of Australia, Canberra
Nevada Museum of Art, Reno
New Mexico State University, Las Cruces
Oakland Museum of California
Philadelphia Museum of Art
Portland Art Museum, Portland, Oregon
Princeton University Art Museum
San Francisco Museum of Modern Art
Seattle Art Museum
Sheldon Memorial Art Gallery, Lincoln, Nebraska
Sprengel Museum Hannover, Germany
Staatsgalerie Stuttgart
Tokyo Metropolitan Museum of Photography
University of Colorado, Boulder
Victoria and Albert Museum, London
Whitney Museum of American Art, New York
Williams College, Williamstown, Massachusetts
Yale University Art Gallery, New Haven

Selected Publications
Adams, Robert. *Alders*. Tucson: Nazraeli Press, 2002.
_____. *Along Some Rivers: Photographs and Conversations*. New York: Aperture, 2006.
_____. *Bodhisattva: A Gandharan Face*. Tucson: Nazraeli Press, 2001.

_____. *California: Views by Robert Adams of the Los Angeles Basin, 1978–1983*. San Francisco: Fraenkel Gallery; New York: Matthew Marks Gallery, 2000.
_____. *Eden*. New York: Roth Horowitz, 1999.
_____. *Interiors: 1973–1974*. Tucson: Nazraeli Press, 2006.
_____. *The New West: Landscapes along the Colorado Front Range*. New ed. Cologne: Walther König, 2000.
_____. *No Small Journeys: Across Shopping Center Parking Lots, Down City Streets, 1979–1982*. New York: Matthew Marks Gallery, 2003.
_____. *Pine Valley*. Tucson: Nazraeli Press, 2005.
_____. *A Portrait in Landscapes*. Tucson: Nazraeli Press, 2005.
_____. *Turning Back: A Photographic Journal of Re-exploration*. San Francisco: Fraenkel Gallery; New York: Matthew Marks Gallery, 2005.
_____. *West from the Columbia: Views at the River Mouth*. New York: Aperture, 1995.
_____. *What We Bought—The New World: Scenes from the Denver Metropolitan Area, 1970–1974*. Hannover: Stiftung Niedersachsen, 1995.
Fillin-Yeh, Susan, and Leo Rubinfien. *Sunlight, Solitude, Democracy, Home: Photographs by Robert Adams*. Portland, OR: Douglas F. Cooley Memorial Art Gallery, Reed College, 2001.
Weinberg, Adam D., et al. *Reinventing the West: The Photographs of Ansel Adams and Robert Adams*. Andover, MA: Addison Gallery of American Art, 2001.

doug aitken
Born Redondo Beach, California, 1968
Lives in Los Angeles

Education
1987–91
B.F.A., Art Center College of Design, Pasadena, California

258

1986–87
Marymount College, Palos Verdes,
California

Selected Solo Exhibitions
2006
A Photographic Survey, Aspen Art
Museum, Aspen, Colorado

2005
Doug Aitken, Regen Projects, Los Angeles
Interiors, Henry Art Gallery, University of
Washington, Seattle
Sell yourself for nothing, Galerie Eva
Presenhuber, Zürich
Ultraworld, Musée d'Art Moderne de la
Ville de Paris

2004
Doug Aitken, Sala Rekalde, Bilbao, Spain
Doug Aitken, Sammlung Goetz, Munich
This Moment Is the Moment, Taka Ishii
Gallery, Tokyo
We're safe as long as everything is moving,
CalxaForum—Fundació la Caixa,
Barcelona

2003
Doug Aitken, Kunsthalle Zürich
I don't exist, Victoria Miro Gallery, London
New Ocean, Fondazione Sandretto Re
Rebaudengo, Turin
The New Yorkers (with Bang on a Can),
Brooklyn Academy of Music

2002
Doug Aitken, Louisiana Museum for
Moderne Kunst, Humlebaek, Denmark
Doug Aitken, 303 Gallery, New York
Interiors, Fabric Workshop and Museum,
Philadelphia
New Ocean, Kunsthaus Bregenz, Austria;
Tokyo Opera City Art Gallery
Rise, Le Magasin, Grenoble, France

2001
I AM IN YOU, Kunst-Werke, Berlin

Metallic Sleep, Kunstmuseum Wolfsburg,
Germany
New Ocean, Serpentine Gallery, London

2000
Glass Horizon, Wiener Secession, Vienna
Hysteria, Taka Ishii Gallery, Tokyo
I AM IN YOU, Galerie Hauser & Wirth &
Presenhuber, Zürich
Matrix 185|Into the Sun, Berkeley Art
Museum, University of California

1999
*Concentrations 33: Doug Aitken, Diamond
Sea*, Dallas Museum of Art
Diamond Sea, Lannan Foundation, Santa
Fe
Doug Aitken, Doug Lawing Gallery,
Houston
Doug Aitken, Pitti Immagine, Florence,
Italy
Into the Sun, Victoria Miro Gallery, London

1998
Diamond Sea, Jiri Svestka Gallery, Prague
Me Amour, Gallery Side 2, Tokyo
The Mirror, Taka Ishii Gallery, Tokyo

Selected Group Exhibitions
2006
Fuori Pista, La Capanna Mollino, Turin
Outside Europe, Stadtgalerie Kiel,
Germany
Sip My Ocean, Louisiana Museum for
Moderne Kunst, Humlebaek, Denmark
Strange Days, Samuel P. Harn Museum of
Art, Gainesville, Florida

2005
Best of Festivals #2, Médiathèque José
Cabanis, Toulouse, France
Beyond, 2nd Guangzhou Triennial,
Guangdong Museum of Art
The Jumex Collection, Glasgow
International Festival of Contemporary
Visual Art
Now's the Time, Kunsthaus Graz, Austria

*Universal Experience: Art, Life, and the
Tourist's Eye*, Museum of Contemporary
Art, Chicago; Hayward Gallery, London

2004
Canarias Media Fest, Las Palmas de Gran
Canaria, Spain
Hard Light, P.S.1 MoMA, Long Island City,
New York
Paisaje y memoria, La Casa Encendida,
Madrid; Centro Atlántico de Arte
Moderno, Las Palmas de Gran Canaria,
Spain
3', Schirn Kunsthalle, Frankfurt
Treasure Island, Kunstmuseum Wolfsburg,
Germany
Uses of the Image, Malba Colección
Costantini, Buenos Aires

2003
*Defying Gravity: Contemporary Art and
Flight*, North Carolina Museum of Art,
Raleigh
Fast Forward, Zentrum für Kunst und
Medientechnologie, Karlsruhe, Germany
Imperfect Innocence, Contemporary
Museum, Baltimore
Liquid Sea, Museum of Contemporary Art,
Sydney
New York Film and Video Festival
Nueva Film Festival, LaForet Museum
Harajuku, Tokyo
Spiritus, Magasin 3, Stockholm
Then all the world would be upside down,
Tina Kim Fine Art, New York
Tribeca Film Festival, New York
World Rush, National Gallery of Victoria,
Melbourne

2002
Impaktfestival, Utrecht, The Netherlands
Remix, Tate Liverpool
ResFest, New York, Los Angeles, San
Francisco
Screen Memories, Mito Contemporary Art
Center, Mito, Japan
Sonic Process, Museu d'Art

Contemporani, Barcelona; Centre Pompidou, Paris
Telluride Film Festival, Telluride, Colorado

2001
Ars 01—Unfolding Perspective, Museum of Contemporary Art Kiasma, Helsinki
Form Follows Fiction, Castello di Rivoli, Turin
International Short Film Festival, Oberhausen, Germany
London Film Festival
Media Connection, Palazzo delle Esposizioni, Rome
Moving Pictures, Villa Merkel, Esslingen, Germany
Urban Pornography, Artists Space, New York

2000
Biennale of Sydney
Future Identities: Reflections from a Collection, ARCO 2000, Madrid
Hypermental, Kunsthaus Zürich
International Short Film Festival, Oberhausen, Germany
Let's Entertain: Life's Guilty Pleasures, Kunstmuseum Wolfsburg, Germany; Walker Art Center, Minneapolis; Portland Art Museum, Portland, Oregon
Regarding Beauty in Performance and Media Arts, Haus der Kunst, Munich
Whitney Biennial 2000, Whitney Museum of American Art, New York

1999
Clues: An Open Scenario Exhibition, Monte Video, Amsterdam
dAPERTutto, 48th Venice Biennale
EXTRAetORDINAIRE, Le Printemps de Cahors, Saint-Cloud, France
Two Doors—True Value, Mai 36 Galerie, Zürich
Video Cult|ures, Zentrum für Kunst und Medientechnologie, Karlsuhe, Germany

1998
International Film Festival Rotterdam

L.A. Times, Fondazione Sandretto Re Rebaudengo, Turin
portrait—human figure, Galerie Peter Kilchmann, Zürich
Unfinished History, Walker Art Center, Minneapolis
La Voie Lactée, Alleged, New York

Awards
2000
Aldrich Award, Aldrich Contemporary Art Museum, Ridgefield, Connecticut

1999
Golden Lion (Leone d'Oro), Venice Biennale

Selected Publications
Aitken, Doug. *A–Z Book (Fractals)*. Philadelphia: Fabric Workshop and Museum, 2002.
_____. *New Ocean*. Bregenz: Kunsthaus Bregenz, 2002.
_____. *Notes for New Religions, Notes for No Religions*. Ostfildern-Ruit: Hatje Cantz, 2001.
_____. *Rise*. Humlebaek: Louisiana Museum for Moderne Kunst, 2002.
_____. *We're safe as long as everything is moving*. Barcelona: Fundació La Caixa, 2004.
Birnbaum, Daniel, et al. *Doug Aitken*. London: Phaiden, 2001.
Daniel, Noel, ed. *The Broken Screen: 26 Conversations with Doug Aitken*. London: Thames & Hudson, 2005.

allora & calzadilla
Jennifer Allora, born Philadelphia, 1974
Guillermo Calzadilla, born Havana, 1971
Live in New York and Puerto Rico

Education
Jennifer Allora
2001–3
M.S., Massachusetts Institute of Technology, Cambridge

1998–99
Whitney Independent Study Program, New York

1996
B.A., University of Richmond, Virginia
Guillermo Calzadilla

2001
M.F.A., Bard College, Annandale-on-Hudson, New York

1998
Skowhegan School of Painting and Sculpture, Skowhegan, Maine

1996
B.F.A., Escuela de Artes Plásticas, San Juan, Puerto Rico

Selected Solo Exhibitions
2006
Allora & Calzadilla, Galerie Chantal Crousel, Paris
Jennifer Allora & Guillermo Calzadilla, Stedelijk Museum voor Actuele Kunst, Ghent

2004
Allora & Calzadilla: Chalk, Institute of Contemporary Art, Boston
Ciclonismo, Galerie Chantal Crousel, Paris
Radio Revolt: One Person, One Watt, Walker Art Center, Minneapolis
Unstable Atmospheres, Lisson Gallery, London

2003
Land Mark, Escuela de Artes Plásticas, San Juan, Puerto Rico
Puerto Rican Light, Americas Society Art Gallery, New York

2002
Allora & Calzadilla, Institute of Visual Arts, University of Wisconsin, Milwaukee

2001
Alora & Calzadilla, Museo de Arte de Puerto Rico, Santurce

2000
Other Worlds, ARCO Project Rooms, ARCO 2000, Madrid

Selected Group Exhibitions
2006
Day for Night, Whitney Biennial, Whitney Museum of American Art, New York
Group Therapy, Museion, Bolzano, Italy
2nd Festival de Photo et Vidéo de Biarritz, France
Wrong, Klosterfelde, Berlin

2005
Always a Little Further, 51st Venice Biennale
Beyond, 2nd Guangzhou Triennial, Guangdong Museum of Art
Beyond Green: Toward a Sustainable Art, Smart Museum of Art, Chicago
Contemporaneo liquido, Franco Soffiantino Arte Contemporanea, Turin
Dedicated to you, but you weren't listening, The Power Plant, Toronto
Dialectics of Hope, 1st Moscow Biennale of Contemporary Art
Expérience de la durée/Experiencing Duration, Biennale d'art contemporain de Lyon
Irreducible: Contemporary Short Form Video, CCA Wattis Institute for Contemporary Arts, San Francisco; Miami Art Central; Bronx Museum of the Arts
Land Marks, Galerie Chantal Crousel, Paris
Material Time/Work Time/Life Time, Reykjavik Arts Festival
Monuments for the USA, CCA Wattis Institute for Contemporary Arts, San Francisco; White Columns, New York
Ninguna de las Anteriores, Museo de Arte de Puerto Rico, Santurce
No Convenient Subway Stops, Art in

General, New York
T1 Torino Triennale Tremusei, Turin
That from a long way off look like flies, Platform Garanti Contemporary Art Center, Istanbul
Tropical Abstraction, Stedelijk Museum Bureau Amsterdam
Uncertain States of America, Astrup Fearnley Museum of Modern Art, Oslo

2004
Ailleurs, ici, Musée d'Art Moderne de la Ville de Paris
Dak'Art, Biennial of Contemporary African Art, Dakar
Island Nations, Museum of Art, Rhode Island School of Design, Providence
Gwangju Biennale, Gwangju, South Korea
None of the Above, Real Art Ways, Hartford, Connecticut
Para Sites, Museum Moderner Kunst–Stiftung Ludwig, Vienna
Ralentir vite, Le Plateau, Fonds Régional d'Art Contemporain (FRAC) Île-de-France, Paris
Situations construites, Attitudes—Espace d'Arts Contemporains, Geneva
Son et Lumière, MIT List Visual Arts Center, Cambridge, Massachusetts

2003
Away from Home, Wexner Center for the Arts, Columbus, Ohio
Common Wealth, Tate Modern, London
How Latitudes Become Forms: Art in a Global Age, Walker Art Center, Minneapolis
Only Skin Deep: Changing Visions of the American Self, International Center of Photography, New York
24/7: Wilno–Nueva York (visa para), Contemporary Art Center, Vilnius, Lithuania

2002
Coleccionismos Contemporáneos—Público/Privado, Museo de Arte y Diseño

Contemporáneo, San José, Costa Rica
Inter.Play, The Moore Building, Miami
3rd Bienal Iberoamericana, Lima

2001
Zoning, The Project, New York

2000
Distinctions, Center for Curatorial Studies, Bard College, Annandale-on-Hudson, New York
El Museo's Bienal: The (S) Files/The Selected Files, El Museo del Barrio, New York
7th Bienal de La Habana

1998
Caribe: Exclusión, fragmentación y paraíso, Museo Extremeño e Iberoamericano de Arte Contemporáneo, Badajoz, Spain
24th Bienal de São Paulo

Awards and Residencies
2004
Civitella Ranieri Fellowship, Umbertide, Italy
Headlands Center for the Arts Bridge Program, Sausalito, California
Korea Foundation Award, Gwangju Biennale (for the video *Returning a Sound*)

2003
Artist-in-Residence, Walker Art Center, Minneapolis
Penny McCall Foundation Grant, New York

2002
Joan Mitchell Foundation Grant, New York

2000
Cintas Foundation Fellowship, New York

1008
P.S.1 Contemporary Art Center National Studio Program, Long Island City, New York

Selected Publications

Allora & Calzadilla. New York: Americas Society, 2003.

Bossé Laurence, and Hans-Ulrich Obrist. *Ici: Didier Fiuza Faustino, Jennifer Allora & Guillermo Calzadilla, Oliver Payne & Nick Relph, Tino Sehgal, Francis Alÿs*. Göttingen: Steidl, 2004.

Morgan, Jessica, ed. *Common Wealth*. London: Tate Publishing, 2003.

wout berger

Born Ridderkerk, The Netherlands, 1941
Lives in Uitdam, The Netherlands

Selected Solo Exhibitions

2006
landscapes, Galerie Van Kranendonk, The Hague

2005
INward OUTward, FLACC—Casino Modern, Genk, Belgium

2004
Various Positions, Galerie Polaris, Paris
Wout Berger, Galerie Witteveen, Amsterdam

2003
no subject was specified, Galerie Van Kranendonk, The Hague

Selected Group Exhibitions

2006
L'esprit du Nord: Netherlands Now, Maison Européenne de la Photographie, Paris

2005
Collection 2, Fondation Salomon, Alex, France
Constructed Moment, KW14, 's-Hertogenbosch, The Netherlands
In Sight: Contemporary Dutch Photography, Art Institute of Chicago
Paris Photo, with Galerie Van Kranendonk, The Hague

2004
Human Conditions, Intimate Portraits, Kortárs Müvészeti Intézet, Dunaújváros, Hungary
L'Insensé, Maison Louis Vuitton, Roppongi (store), Tokyo
Paris Photo, with Galerie Van Kranendonk, The Hague
Photography Biennale Conches, Musée du Verre, Conches, France
Pictura, Dordrecht, The Netherlands
Soleil vert, Musée des Beaux-Arts, Clermont-Ferrand, France
Zomertentoonstelling, Galerie Le Besset, Ardèche, France

2003
Art Rotterdam, with Galerie Van Kranendonk, The Hague
Link: Proposal for Municipal Acquisitions Photography, 2002–2003, Stedelijk Museum, Amsterdam
Paris Photo, with Galerie Van Kranendonk, The Hague

2002
Cultivated in the Open, Huis Marseille, Amsterdam
Fotografen in Nederland: 1852–2002, Fotomuseum, The Hague
Paris Photo, with Galerie Van Kranendonk, The Hague
Paris Photo 2002: Photography in the Netherlands, Institut Néerlandais, Paris
Rencontres de la Photographie, Arles, France

2001
Ambiance magasin, Centre d'Art Contemporain, Abbaye Saint-André, Meymac, France
Intimate Spaces, Galerie Van Kranendonk, The Hague
Paris Photo, with Galerie Van Kranendonk, The Hague
Re: Mote, The Photographers' Gallery, London

Trade: Commodities, Communication, and Consciousness in World Trade Today, Fotomuseum Winterthur, Switzerland

2000
Foto Biënnale, Nederlands Fotomuseum, Rotterdam
KunstRAI Amsterdam, Galerie Van Kranendonk, The Hague
Paris Photo, with Galerie Van Kranendonk, The Hague

1999
Constructing Identity, Nederlands Foto Instituut, Rotterdam
Human Conditions, Intimate Portraits, Mois de la Photo, Montréal

1998
Admissions of Identity, City Museum and Mappin Art Gallery, Sheffield, UK
Rencontres de la Photographie, Arles, France
Stockholm Art Fair, Galerie Van Kranendonk, The Hague

Selected Collections

ABN/AMRO, Amsterdam
Academisch Medisch Centrum (AMC), Amsterdam
Akzo Nobel Art Foundation, Arnhem, The Netherlands
Centrum voor Beeldende Kunst (CBK), Dordrecht, The Netherlands
Erasmus Universiteit, Rotterdam
Huis Marseille, Amsterdam
KLM, Schiphol, The Netherlands
Ministry of Foreign Affairs, The Hague
Ministry of Internal Affairs, The Hague
Museum Boijmans van Beuningen, Rotterdam
Stedelijk Museum, Amsterdam
Stedelijk Museum de Lakenhal, Leiden, The Netherlands
Tokyo Metropolitan Museum of Photography
Universitair Medisch Centrum (UMC), Utrecht, The Netherlands

Selected Publications

Berger, Wout. *Giflandschap: Vervuilde locaties en landschappen in Nederland/Poisoned Landscape*. Amsterdam: Fragment, 1992.

Gauret, Gabriel, et al. *Est-ce ainsi que les hommes vivent*. Paris: Éditions du Chêne, 2005.

Haijtema, Arno. *Sand Water Peat/Harena Aqua Palus*. Amsterdam: De Verbeelding, 2001.

Huis, Edwin van, et al. *Het eeuwige moment/The Eternal Moment*, by W_nanda Deroo, Mirjam de Zeeuw, and Wout Berger. Amsterdam: Fragment, 1992.

Wout Berger. The Hague: Galerie Van Kranendonk, 2003.

broomberg & chanarin

Adam Broomberg, born South Africa, 1970
Oliver Chanarin, born England, 1971
Live in London

Selected Solo Exhibitions

2006
Chicago, Q Arts, Derby Photography Festival, Derby, UK; Steven Kasher Gallery, New York

2005
Defying Distance, National Portrait Gallery, London

2004
Mr. Mkhize's Portrait & Other Stories from the New South Africa, The Photographers' Gallery, London

2003
Trusting the Truth, Johannesburg Art Gallery

2000
Trust/Ex-Voto, Hasselblad Center, Göteborg, Sweden

Selected Group Exhibitions

2006
1+1=3: Collaboration in Recent British Portraiture, Fremantle Arts Centre, Western Australia
So Now Then, Courtyard Arts Centre, Hereford Photography Festival, Hereford, UK

2005
The Face of Madness, Palazzo Magnani, Reggio Emilia, Italy
Ghetto, PhotoEspaña 2005, Aranjuez, Spain
New Photographers 2006, FotoMuseum, Antwerp, Belgium
Unsettled: 8 South African Photographers, Durban Art Gallery; Reykjavik Museum of Photography; The Regional Museum, Kristianstad, Sweden; Nationale Fotomuseum, Copenhagen

2004
History in the Making, PhotoEspaña 2004, Círculo de Bellas Artes, Madrid

2002
It's Wrong to Wish on Space Hardware, Gardner Arts Centre, Brighton, UK
Stepping In and Out: Contemporary Documentary Photography, Victoria and Albert Museum, London

2001
In a Lonely Place, National Museum of Photography, Film & Television, Bradford, UK

Filmography

Going Under (2000)
Mr. Mkhize's Portrait (2004)

Awards

2005
Arts Council England Grant

2004
Best Documentary Book (for *Mr. Mkhize's Portrait*), Golden Light Awards, Rockport, Maine

First Prize (for *Ghetto*), GRIN (Gruppo Redattori Iconografici Nazionale) Awards, Italy
Vic Odden Award, Royal Photographic Society, Bath, UK

2003
Open Society Institute/Soros Foundation Grant, New York

Collections

National Portrait Gallery, London
Victoria and Albert Museum, London

Selected Publications

Broomberg, Adam, and Oliver Chanarin. *Chicago: Everything That Happened, Happened Here First*. Göttingen: Steidl, 2006.

_____. *Ghetto*. London: Trolley, 2003.

_____. *Mr. Mkhize's Portrait & Other Stories from the New South Africa*. London: Trolley, 2004.

_____. *Trust*. London: Westzone, 2000.

patrick brown

Born Sheffield, England, 1969 (arrived Australia 1982)
Lives in Perth, Australia, and Bangkok, Thailand

Education

1991–94
Internship, Rear Studio, Perth, Western Australia

Solo Exhibitions

2006
Black Market, FotoFreo 2006, Fremantle Prison, Western Australia
Poaching in Asia, 10th Chroniques Nomades Festival, Honfleur, France

Group Exhibitions

2005
Angkor Photo Festival, Siem Reap, Cambodia

Project Reminds, Tokyo Metropolitan Museum of Photography
Reportage Festival, Sydney and Melbourne
World Press Photo, Felix Meritis, Amsterdam

2004
Reportage Festival, Sydney and Melbourne
Visa pour l'Image, Perpignan, France

2002
FotoFreo 2002, Perth, Western Australia

2001
Reportage Festival, Sydney

Professional Experience
In recent years, Patrick Brown has worked for international companies and publications including: *Time*, *Asiaweek*, *Year Zero*, *The Guardian*, *The Australian*, *The West Australian*, *The West Magazine*, BBC, *Sunday Times Magazine*, *Japan Times*, *South China Morning Post*, UNICEF International, United Nations Development Program (UNDP), *Foto8*, *Horizonte*, *Stern*, *Der Spiegel*, *The Observer*, *Liberation*, *The Nation*, and *Mother Jones*.

Awards
2005
Days Japan International Photojournalism Award
Pictures of the Year International: Third Place, Issue Reporting Picture Story (for "Black Market")
World Press Photo Award: Second Place

2003
World Press Photo: Joop Swart Masterclass Nominee

Selected Collections
City of Perth Photographic Collection

Panos Pictures, London
Photography Gallery of Western Australia
Royal Perth Hospital Art Collection

Publication
Davies, Ben. *Black Market: Inside the Endangered Species Trade in Asia*. Photography by Patrick Brown. San Rafael, CA: Earth Aware Editions, 2005.

catherine chalmers
Born San Mateo, California, 1957
Lives in New York

Education
1984
M.F.A., Royal College of Art, London

1979
B.S., Engineering, Stanford University

Selected Solo Exhibitions
2004
American Cockroach, Galerie im Park, Burgdorf, Switzerland
Executions, Galerie im Park, Zürich

2003
American Cockroach, RARE, New York; Grand Arts, Kansas City, Missouri
Food Chain, Oakville Galleries, Oakville, Ontario

2002
The Birds and the Bees, Imago Galleries, Palm Desert, California; Staton-Greenberg Gallery, Santa Barbara
Bug and Squish Drawings, RARE, New York
Food Chain, Peggy Notebaert Nature Museum, Chicago
Genetically Engineered Mice, Sun Valley Center for the Arts, Sun Valley, Idaho

2001
Catherine Chalmers + Robert Ziebell, d berman gallery, Austin, Texas
Prey and Eat, California State University Art Museum, Long Beach

2000
Food Chain, Kunsthalle, Vienna; Blue Sky Gallery, Portland, Oregon; Corcoran Gallery of Art, Washington, D.C.
Impostors, Cathedral of Saint John the Divine, New York
Pinkies, RARE, New York

1998
Food Chain, P.S.1 Contemporary Art Center, Long Island City, New York; Magazin 4 Vorarlberger Kunstverein, Bregenz, Austria
Food Chain: Encounters Between Mates, Predators & Prey, CoCA—Center on Contemporary Art, Seattle

Selected Group Exhibitions
2006
Bug Out of the Box, Berkshire Museum, Pittsfield, Massachusetts
Going Ape: Confronting Animals in Contemporary Art, DeCordova Museum, Lincoln, Massachusetts

2005
Animal Nature, Regina Gouger Miller Gallery, Carnegie Mellon University, Pittsburgh
Bug City, Winnipeg Art Gallery
Margaret Mead Film & Video Festival, American Museum of Natural History, New York

2004
Bug-Eyed: Art, Culture, Insects, Turtle Bay Exploration Park, Redding, California
Cleanliness, Sara Meltzer Gallery, New York
Earthly Delights, Bakalar Gallery, Massachusetts College of Art, Boston
Metamorphosis, John Michael Kohler Arts Center, Sheboygan, Wisconsin

2003
How Human: Life in the Post-Genome Era, International Center of Photography, New York

Photosynthesis, Anne Reed Gallery, Sun Valley, Idaho
Swarm, Glendale College Art Gallery, Glendale, California

2002
Constructed Realities, Grand Arts, Kansas City, Missouri
Gene(sis): Contemporary Art Explores Human Genomics, Henry Art Gallery, University of Washington, Seattle; Berkeley Art Museum, University of California; Frederick R. Weisman Art Museum, University of Minnesota, Minneapolis; Mary and Leigh Block Museum of Art, Northwestern University, Evanston, Illinois
OPEN2002, Venice Film Festival
PhotoGENEsis: Opus 2, Artists' Response to the Genetic Information Age, Santa Barbara Museum of Art

2001
The Gravity of the Immaterial, Museum of Contemporary Art, Taipei, Taiwan; Kaohsiung Museum of Fine Arts, Kaohsiung, Taiwan
Natural Histories: Artists Forage in Science and Nature, Florida Atlantic University Galleries, Boca Raton
A Natural Subject: Photographs from the Permanent Collection, Norton Museum of Art, West Palm Beach, Florida
New Ideas, Old Tricks, hARTware projekte, Dortmund, Germany
New Work: Contemporary Figuration, Hosfelt Gallery, San Francisco

2000
Deep Distance, Kunsthalle Basel
Life Cycles, Southeastern Center for Contemporary Art, Winston-Salem, North Carolina
Millennium Bugs, Islip Art Museum, East Islip, New York
Multiple Sensations, Yerba Buena Center for the Arts, San Francisco

Significant Other: The Hand of Man in Animal Imagery, Photographic Resource Center, Boston University
Unnatural Science, MASS MoCA, North Adams, Massachusetts

1999
Animal Artifice, Hudson River Museum, Yonkers, New York
In the Unlikely Event, Anne Reed Gallery, Sun Valley, Idaho
The New Natural History, National Museum of Photography, Film & Television, Bradford, UK; Hasselblad Center, Göteborg, Sweden
Phenomena: The Poetics of Science, The Friends of Photography, Ansel Adams Center, San Francisco
Photo Synthesis, RARE, New York
Summer Reading, Yancey Richardson Gallery, New York
Wohin kein Auge reicht, Deichtorhallen, Hamburg

1998
Back to Back, De Chiara/Stewart Gallery, New York
Formication, Laurence Miller Gallery, New York
Hot Spots, Nassauischer Kunstverein, Wiesbaden, Germany
Photography's Multiple Roles: Art, Document, Market, Science, Museum of Contemporary Photography, Chicago
Prime Focus, Illinois State University Galleries, Normal, Illinois
The Selective Eye, Anne Reed Gallery, Sun Valley, Idaho

Awards
2002
Robert Lehman Foundation, New York

2000
Alfred Eisenstaedt Award

1998
New York Foundation for the Arts Fellowship

1995
Mid-Atlantic Regional Fellowship, National Endowment for the Arts

Selected Bibliography
Chalmers, Catherine. *American Cockroach*. Essay by Tan Lin. Kansas City, MO: Grand Rapids, 2003.
_____. *American Cockroach*. New York: Aperture, 2004.
_____. *Foodchain: Encounters Between Mates, Predators, and Prey*. New York: Aperture, 2000.
Eskin, Blake. "The Roaches That Came in from the Cold." *Artnews* (February 2001), pp. 140–43 and cover.

stéphane couturier
Born Neuilly-sur-Seine, France, 1957
Lives in Paris

Selected Solo Exhibitions
2006
Melting Point, Laurence Miller Gallery, New York
Stéphane Couturier, Photobiennale 2006, Moscow House of Photography

2005
Melting Point, Galerie Polaris, Paris
Stéphane Couturier, Image/Imatge, Orthez, France

2004
Oeuvre, Galerie Van Kranendonk, The Hague
Stéphane Couturier, Rena Bransten Gallery, San Francisco
Stéphane Couturier, Forum für Fotografie, Cologne
Stéphane Couturier, Bibliothèque Nationale de France, Paris

2003

In Residence, University Art Gallery, University of California, San Diego
Landscaping, Laurence Miller Gallery, New York

2002

Landscaping, Galerie Polaris, Paris
Stéphane Couturier, Galerie Conrads, Düsseldorf

2001

Generic City, Centre Céramique, Maastricht, The Netherlands
Rencontres de la Photographie, Arles, France
Stéphane Couturier, Galerie Pennings, Eindhoven, The Netherlands
Stéphane Couturier, Galerie Sollertis, Toulouse, France

2000

Monument(s), Galerie Polaris, Paris
Stéphane Couturier, FIAC 2000, Galerie Polaris, Paris
Stéphane Couturier, Laurence Miller Gallery, New York
Urban Archaeology, Lowe Art Museum, University of Miami

1999

Stéphane Couturier, Fonds Régional d'Art Contemporain (FRAC) Auvergne, Clermond-Ferrand, France
Stéphane Couturier Photographs: Urban Archeology, Cleveland Museum of Art
Urban Archaeology, Galerie Fotohof, Salzburg, Austria

Selected Group Exhibitions

2006

Suburban Escape: The Art of California Sprawl, San Jose Museum of Art

2005

Collection de la Société Générale, Musée d'Art Moderne et Contemporain,
Strasbourg
Image & Paysage, Palais des Arts de Lviv, Ukraine
Objectif Paris 2, Pavillon des Arts, Paris
Paysage international, Fonds Régional d'Art Contemporain (FRAC) Auvergne, Clermond-Ferrand, France
2nd Seoul Photo Triennale

2004

Conditions urbaines, Galerie Donzé van Saanen, Lausanne
De leur temps, Musée des Beaux-Arts, Tourcoing, France
Surface, Laurence Miller Gallery, New York
Visages, lieux, traces, Musée des Beaux-Arts du Canada, Ottawa [*The World in Five Steps*, Galerie Van Kranendonk, The Hague
Yet Untitled, Nationale Fotomuseum, Copenhagen

2003

Archetypen, Landesgalerie am Oberösterreichischen Landesmuseum, Linz, Austria
Oases, Laurence Miller Gallery, New York
Photographing Architecture, Galerie Clairefontaine, Luxembourg
Le Prix Marcel Duchamp 2003, Musée National d'Art Moderne, Paris
Qui a peur du rouge, du jaune et du bleu?, Communs du Château de Tanlay, France
Rencontres photographiques Orthez-Pau, Image/Imatge, Orthez, France
The Spirit of Globalisation, Photographic Centre of Skopelos, Greece

2002

Art Downtown, Wall Street Rising, New York
Le Bâti et le Vivant (The Built and Living), Chapelle du Rham, Luxembourg
Biennale d'Art Contemporain, Nouméa, New Caledonia
Camere con vista, Centro Sperimentale per le Arti Contemporanee, Caraglio, Italy
De singuliers débordements, Maison de la
Culture, Amiens, France
Same same—different and identic, Galerie Conrads, Düsseldorf
Vues d'architectures, Musée de Grenoble, France

2001

Collection 3, Fonds Régional d'Art Contemporain (FRAC) Alsace, Sélestat, France
A Family Album: Brooklyn Collects, Brooklyn Museum
A well placed helmet is a secure gaze, Kunsthalle, Nuremberg

2000

Das Haus in der Kunst, Deichtorhallen, Hamburg
L'invitation à la ville, Brussels Centrum Photobiennale 2000, Moscow House of Photography
Photography Now, Contemporary Arts Center, New Orleans
Photopolis, ADIAF-Kanal 20, Brussels
Le temps déborde, Le Forum, Le Blanc-Mesnil, France
Vue imprenable sur la scène, Écuries de Chazerat, Clermont-Ferrand, France

1999

Berlin: Renaissance d'une capitale, CAUE 92, Sceaux, France
Building Representation: Photography and Architecture, Fogg Art Museum, Cambridge, Massachusetts
New Voices/New Visions, University Art Gallery, University of California, San Diego
Perfect, Galerie Polaris, Paris
Souvenir–Dokument–Utopie, Stadthaus Ulm, Germany
A Tale of Three Cities, SF Camerawork, San Francisco
Tomorrow For Ever, Kunsthalle Krems, Austria; Küppersmühle Museum, Duisburg, Germany
Under Construction, Milwaukee Art Museum

Selected Collections

Art Institute of Chicago
Artothèque, Hôtel d'Escoville, Caen, France
Artothèque Municipale, Auxerre, France
Caisse d'Épargne, Luxembourg
Cleveland Museum of Art
De Pont Foundation, Amsterdam
Fondation CCF pour la Photographie, Paris
Fondation Société Générale, Paris
Fonds Départemental d'Art Contemporain, Bobigny, France
Fonds Municipal d'Art Contemporain, Paris
Fonds National d'Art Contemporain, Paris
Fonds Régional d'Art Contemporain (FRAC) Alsace, Sélestat, France
Fonds Régional d'Art Contemporain (FRAC) Auvergne, Clermond-Ferrand, France
Gemeentemuseum, The Hague
Los Angeles County Museum of Art
Lowe Art Museum, University of Miami
Maison Européenne de la Photographie, Paris
Musée Carnavalet, Paris
Musée d'Art Moderne et Contemporain, Strasbourg
Musée d'Art Moderne Grand-Duc Jean, Luxembourg
Musée de Charleroi, France
Musée de La Roche-sur-Yon, France
Musée de l'Élysée, Lausanne
Musée des Beaux-Arts du Canada, Ottawa [
National Gallery of Art, Washington, D.C.
Saint Louis Art Museum
Santa Barbara Museum of Art
University Art Gallery, University of California, San Diego

Selected Publications

Berlin: Mutations urbaines. Text by Vincent Von Wroblewsky. Paris: Édition Archipress, 1997.
Piguet, Philippe. "Stéphane Couturier—Vistas." In *Imago 99: Encuentros de fotografía y video*. Salamanca: Centro de Fotografía de la Universidad de Salamanca, 1999.
Poirier, Matthieu. *Stéphane Couturier, photographies*. Paris: A. Biro, 2004.
Stéphane Couturier. Clermont-Ferrand: FRAC Auvergne, 1999.
Stéphane Couturier: Landscaping. Paris: Édition Ville Ouverte, 2002.
Stéphane Couturier: Mutations. Paris: Bibliothèque Nationale, 2004.
Stéphane Couturier, photographies. Paris: L'Insolite, 2005.

lou dematteis and kayana szymczak

Lou Dematteis, born Palo Alto, California, 1948
Kayana Szymczak, born Chicago, 1974
Live in San Francisco

lou dematteis
Education

1972–73
Photography, De Young Museum Art School, San Francisco

1966–70
B.A., Political Science, University of San Francisco

Selected Exhibitions

"Crude Reflections: Chevron Texaco's Rainforest Legacy"
Bolívar House, Center for Latin America Studies, Stanford University, Palo Alto, California (2006)
St. Mary's College, Moraga, California (2006)
Mudd's Environmental Center, San Ramon, California (2005)
San Francisco Arts Commission Gallory (2005)

"A Portrait of Viet Nam"
Hemphill Gallery, Washington, D.C. (2002)
Gallery Saigon, Ho Chi Minh City, Viet Nam (1999)
Foreign Correspondents Club of Thailand, Bangkok (1999)

"War on Nicaragua"
The Photographers' Gallery, London (1991)
Ansel Adams Center, San Francisco (1990)
Alternative Museum, New York (1988)
Eye Gallery, San Francisco (1987)

Professional Experience

1990–present
Contract Photographer, Reuters News Pictures, San Francisco
Freelance Photographer, images filed with Image Works, Woodstock, New York, and Corbis, New York

1986–90
Staff Photographer, Reuters News Pictures, Managua, Nicaragua

1985
Freelance Photographer, Managua, Nicaragua

1981–84
United Press International, San Francisco

Awards

1994
Media Alliance Meritorious Achievement Award for Photography

1986
Citation, World Press Photo
National Press Photographers Association Pictures of the Year, Spot News
New York Times Pictures of the Year

Selected Publications

Dematteis, Lou. *A Portrait of Viet Nam*. New York: W. W. Norton, 1996.

_____, ed. Nicaragua: A Decade of Revolution. New York: W. W. Norton, 1991.

kayana szymczak

Education
1994
B.A., University of Illinois, Chicago

Selected Solo Exhibitions

2006
Crude Reflections, Bolívar House, Center for Latin America Studies, Stanford University, Palo Alto, California; St. Mary's College, Moraga, California

2005
Crude Reflections, Mudd's Environmental Center, San Ramon, California; San Francisco Arts Commission Gallery

Selected Group Exhibitions
2005
Art Not Oil, The Bongo Club, London
Ghosts of a Little Boy: Artists for Peace, National Japanese American Historical Society, San Francisco

Award
2005
Titcomb Foundation Grant

Collection
Kelingrove Art Gallery and Museum, Glasgow

yannick demmerle
Born Sarreguemines, France, 1969
Lives in Dresden, Germany

Education
École Supérieure des Arts Décoratifs, Strasbourg (class of Manfred Sternjakob)

Selected Solo Exhibitions
2006
Fotografie + Skulptur, Kunstverein Lingen Kunsthalle, Lingen, Germany

2005
Yannick Demmerle, Arndt & Partner, Zürich
Yannick Demmerle, Leonhardi-Museum Dresden
Yannick Demmerle, Sint-Lukasgalerie, Brussels

2004
Yannick Demmerle, Haunch of Venison, London

2003
Portraits de paysages, Château d'Oiron, France
Yannick Demmerle, Fonds Régional d'Art Contemporain (FRAC) Alsace, Sélestat, France
Yannick Demmerle, Arndt & Partner, Berlin
Yannick Demmerle: Photographs, Vedanta Gallery, Chicago

2002
Yannick Demmerle, Galerie Aline Vidal, Paris

2001
Xavier Chevalier et Yannick Demmerle, La Chaufferie, Strasbourg
Yannick Demmerle & Roland Fischer, Galerie Aline Vidal, Paris

Selected Group Exhibitions
2005
Nature cultivée, Centre Photographique d'Île-de-France, Pontault-Combault
Through the Lens, C. Grimaldis Gallery, Baltimore
wunderkammer II: paisajes, Galería Nina Menocal, Mexico City

2004
Made in Berlin, Art Forum Berlin

2003
Oases, Laurence Miller Gallery, New York

2002
L'Image—La Vision—L'Imagination, Musée d'Art Moderne et Contemporain, Strasbourg
Les Lauréats du CEAAC 1987–2001, Centre Européen d'Actions Artistiques Contemporaines, Strasbourg

2001
Saison française de la photographie, 8th Noorderlicht Photofestival, Groningen, The Netherlands
Sense of Space, 8th Noorderlicht Photofestival, Groningen, The Netherlands

2000
Collections II, Fonds Régional d'Art Contemporain (FRAC) Alsace, Sélestat, France

Awards
2002
Centre Européen d'Actions Artistiques Contemporaines, Strasbourg

2001
Conseil Général de la Moselle, Metz, France

2000
Villa Médicis Hors les Murs, Paris

1999
Deutsch-Französisches Jugendwerk, Bad Honnef
Kulturamt, Dresden

Selected Collections
Caisse des Dépôts et des Consignations, Paris
Collection du Centre des Monuments Nationaux, Château d'Oiron, France
Fonds Régional d'Art Contemporain (FRAC) Alsace, Sélestat, France
Frederick R. Weisman Art Foundation, Los Angeles

Kunstsammlung des Deutschen
Bundestages, Berlin
Münchener Rückversicherungs-
Gesellschaft, Munich
Musée d'Art Moderne et Contemporain,
Strasbourg

Selected Publications
Yannick Demmerle. Frankfurt am Main:
Revolver, 2005.
Yannick Demmerle. Sélestat: FRAC;
Berlin: Arndt & Partner, 2003.

goran dević

Born Sisak, Croatia, 1971
Lives in Zagreb

Education
Studied law, archaeology, and film at the
Academy for Dramatic Art, Zagreb

Filmography
Jesam li se zajebo? (*Did I Fuck Up?*), 2004,
documentary, ADU, 17 min.
Knin 2004, 2004, documentary, HTV, 30 min.
Nemam ti _ta re_' ljepo (*Nothing Nice to
Say*), 2006, documentary, FACTUM, 30 min.
Uvozne vrane (*Imported Crows*), 2004,
documentary, ADU, 22 min.

**Exhibitions, Festivals, and
Awards**
(for the documentary film *Imported
Crows*)

2006
Normalisation, Rooseum Center for
Contemporary Art, Malmö, Sweden

2005
Belgrade International Film Festival
Cork Film Festival, Ireland
Dubrovnik Film Festival, Croatia
Helsinki International Film Festival
Kansas International Film Festival
Rotterdam International Film Festival
Solothurn Film Festival, Switzerland

2004
Astra Film Fest, Albania
Croatian Film Festival: Grand Prix, Best
Script and Best Director; Octavian Award,
Best Short Documentary Film (awarded by
Croatian Association of Film Critics)
Motovun Film Festival: Jameson Short
Film Award
Sarajevo Film Festival: Human Rights
International Award

mark dion

Born New Bedford, Massachusetts, 1961
Lives in Beach Lake, Pennsylvania

Education
2003
Ph.D., School of Art, University of
Hartford, Connecticut

1986
B.F.A., School of Art, University of
Hartford, Connecticut

1984–85
Independent Study Program, Whitney
Museum, New York

1982–84
School of Visual Arts, New York

Selected Solo Exhibitions
2006
Neotropic (with Bob Braine), Galerie
inSITU, Paris

2005
*The Brazilian Expedition of Thomas
Ender—Reconsidered*, Akademie der
Bildenden Künste, Vienna
*Bureau of the Centre for the Study of
Surrealism and Its Legacies*, Manchester
Museum, Manchester, UK
The Curiosity Shop, Tanya Bonakdar
Gallery, New York
*Dungeon of the Sleeping Bear, the Phantom
Forest, the Birds of Guam, and Other Fables

of Ecological Mischief*, Château d'Oiron,
France
Memento Mori (My Glass Is Run), Aldrich
Contemporary Art Museum, Ridgefield,
Connecticut
Microcosmographia, South London
Gallery
Salon de la Chasse, Musée de la Chasse et
de la Nature, Château de Chambord,
France

2004
Mark Dion: Drawings and Printed Works,
Goodwater, Toronto
Projects 82: Rescue Archaeology, Museum
of Modern Art, New York

2003
Full House, Aldrich Contemporary Art
Museum, Ridgefield, Connecticut
*L'ichthyosaure, la pie et autres merveilles
du monde naturel* (The Ichthyosaurus, the
Magpie, and Other Marvels of the Natural
World), Musée Gassendi and Réserve
Géologique de Haute-Provence, Digne,
France; Centro Sperimentale per le Arti
Contemporanee, Caraglio, Italy
*RN: The Past, Present and Future of the
Nurses' Uniform* (with J. Morgan Puett),
Fabric Workshop and Museum,
Philadelphia

2002
Mark Dion: Encyclomania, Villa Merkel,
Esslingen, Germany; Kunstverein
Hannover, Germany; Kunstverein, Bonn
Urban Wildlife Observation Unit, Public
Art Fund, Madison Square Park, New York
Ursus Maritimus, Goodwater, Toronto
Vivarium, Tanya Bonakdar Gallery, New
York

2001
Cabinet of Curiosities, Frederick R.
Weisman Art Museum, University of
Minnesota, Minneapolis
New England Digs, Fuller Museum of Art,

Brockton, Massachusetts; David Winton Bell Gallery, Providence, Rhode Island; University of Massachusetts, Dartmouth

2000
The Museum of Poison, Tanya Bonakdar Gallery, New York
Nature Bureaucracies, American Fine Arts Co., New York

1999
The Ladies' Field Club of York (with J. Morgan Puett), National Railway Museum, York, UK
Two Banks (Tate Thames Dig), Tate Britain, London
Where the Land Meets the Sea, Yerba Buena Center for the Arts, San Francisco

1998
Adventures in Comparative Neuroanatomy, Deutsches Museum, Bonn

Selected Group Exhibitions
2006
Birdspace: A Post-Audubon Artists Aviary, Tucson Museum of Art
Rare Specimen: The Natural History Museum Show, Arsenal Gallery, Central Park, New York

2005
Becoming Animal: Contemporary Art in the Animal Kingdom, MASS MoCA, North Adams, Massachusetts
Controlled, Tanya Bonakdar Gallery, New York
Drawing from the Modern, 1975–2005, Museum of Modern Art, New York
Gotik und Moderne im Dialog, Fränkische Galerie, Kronach, Germany
Odd Lots: Revisiting Gordon Matta-Clark's Fake Estates, Queens Museum of Art, New York
Our Surroundings, Dundee Contemporary Arts, Dundee, Scotland
ShowCASe: Contemporary Art for the UK,

City Art Centre and Talbot Rice Gallery, Edinburgh

2004
Animals & Us: The Animal in Contemporary Art, Galerie St. Etienne, New York
Field: Science, Technology, and Nature, Socrates Sculpture Park, Long Island City, New York
For the Birds, Artspace, New Haven
Interventions, Bowling Green State University Galleries, Bowling Green, Ohio
Past Presence: Contemporary Reflections on the Main Line, Main Line Art Center, Haverford, Pennsylvania
26th Bienal de São Paulo

2003
De l'homme et des insectes: Jean-Henri Fabre, 1823–1915, L'Espace EDF Electra, Paris
Global Priority, Herter Gallery, University of Massachusetts, Amherst
A Short History of Performance, Part II, Whitechapel Art Gallery, London

2002
Concrete Jungle, Gorney Bravin + Lee, New York
Hell-Gruen, Hofgarten, Düsseldorf
The House of Fiction, Sammlung Hauser und Wirth, St. Gallen, Switzerland
Museutopia, Karl Ernst Osthaus–Museum der Stadt Hagen, Germany
Nach der Nature, Kunstverein Wolfsburg, Germany

2001
Fresh Kills, Snug Harbor Cultural Center, Staten Island, New York
Lateral Thinking: Art of the 1990s, Museum of Contemporary Art San Diego
Museum as Subject, National Museum of Art, Osaka, Japan

2000
American Art Today: Fantasies and Curiosities, Art Museum at Florida

International University, Miami
Crossing the Line, Queens Museum of Art, New York
Ecologies, Smart Museum of Art, Chicago
InSITE 2000, organized by the Installation Gallery, San Diego
Small World: Dioramas in Contemporary Art, Museum of Contemporary Art San Diego

1999
Carnegie International 99/00, Carnegie Museum of Art, Pittsburgh
The Museum as Muse, Museum of Modern Art, New York

Award
2001
9th Annual Larry Aldrich Foundation Award

Selected Publications
Blazwick, Iwona. "Mark Dion's 'Tate Thames Dig.'" *Oxford Art Journal* 24, no. 2 (2001), pp. 103–12.
Coles, Alex. "The Epic Archaeological Digs of Mark Dion." *A-R-C: Journal of Art Research and Critical Curating* (online) 1, no. 1 (March 2000).
Corrin, Lisa Graziose, et al. *Mark Dion*. London: Phaedon, 1997.
Dion, Mark. *Archaeology*. London: Black Dog, 1999.
_____. *Bureau of the Centre for the Study of Surrealism and Its Legacies*. London: Book Works, 2005.
_____. *Microcosmographia*. London: South London Gallery, 2005.
Klein, Richard, ed. *Mark Dion: Drawings, Journals, Photographs, Souvenirs, and Trophies, 1990–2003*. Ridgefield, CT: Aldrich Museum of Contemporary Art, 2003.

sam easterson
Born Hartford, Connecticut, 1972
Lives in Los Angeles

Education

1999
M.S., Landscape Architecture, University of Minnesota, Minneapolis

1994
B.F.A., Cooper Union, New York

Selected Solo Exhibitions

2005
Insects, Daniel Cooney Fine Art, New York

2003
Animal, Vegetable, Video: Where the Buffalo Roam, Grand Arts, Kansas City, Missouri
On the Farm, Center for Land Use Interpretation, Los Angeles

2002
Animal, Vegetable, Video: Swamp Sanctuary, RARE, New York

2001
Animal, Vegetable, Video: Swamp Sanctuary, Atlanta College of Art Gallery

2000
Animal, Vegetable, Video: Oasis, RARE, New York
Animal, Vegetable, Video: Memories of Manhattan from a Millennium Ago, Art in General, New York

1999
Sam Easterson/Matt Monahan, Archipel, Apeldoorn, The Netherlands

1998
Dialogues: Sam Easterson/T. J. Wilcox, Walker Art Center, Minneapolis

Selected Group Exhibitions, Screenings, and Festivals

2006
C.O.L.A. 2006, Los Angeles Municipal Art Gallery
Hybridity: The Evolution of Species and Spaces in 21st-Century Art, 21c Museum, Louisville, Kentucky

2005
Becoming Animal: Contemporary Art in the Animal Kingdom, Mass MoCA, North Salem, Massachusetts
Media Test Wall: Critters, MIT List Visual Arts Center, Cambridge, Massachusetts

2004
Bug-Eyed: Art, Culture, Insects, Turtle Bay Museum, Redding, California
Entropie: Über das Verschwinden des Werkes, AR/GE Kunst Galerie Museum, Bolzano, Italy

2003
American Dream, Ronald Feldman Fine Arts, New York
Animal Magnetism, The Exploratorium, San Francisco
International Environmental Film and Video Festival, Planet in Focus, Toronto
Occurrences: The Performative Space of Video, School of the Art Institute of Chicago
Through the Eye of the Wolf, Beall Center for Art + Technology, University of California, Irvine

2002
Dogs: Wolf, Myth, Hero & Friend, Natural History Museum of Los Angeles County; San Diego Natural History Museum; National Geographic Explorers Hall, Washington, D.C.
Media Field: Old New Technologies, Williams College Museum of Art, Williamstown, Massachusetts

2001
Ann Arbor Film Festival, Ann Arbor, Michigan
Athens Film Festival, Athens, Georgia
Chain Reaction: Rube Goldberg and Contemporary Art, Williams College Museum of Art, Williamstown, Massachusetts; Tang Teaching Museum, Saratoga Springs, New York
Chicago Filmmakers
Dallas Video Festival
Impaktfestival, Utrecht, The Netherlands
Many Moons, Hammond Museum, North Salem, New York
Natural Histories: Artists Forage in Science and Nature, Florida Atlantic University Galleries, Boca Raton
Panic, Julie Saul Gallery, New York
Science et Cité, Centre pour l'Image Contemporaine, Geneva
3rd Pandaemonium Festival, LUX Centre, London
Video Jam, Palm Beach Institute of Contemporary Art, Lake Worth, Florida
Video Marathon, Art in General, New York
The World According to the Newest and Most Exact Observations, Tang Teaching Museum, Saratoga Springs, New York

2000
Artcinema Off-Off, Copenhagen
Centre d'Art Santa Mònica, Barcelona
Cinema Digitaal, Paradiso, Amsterdam
Eat Carpet, Australian TV, Sydney
European Media Art Festival, Kunsthalle Dominikanerkirche, Osnabrück, Germany
Instituto Cubano de Arte e Industria Cinematográficos, Havana
International Artists' Museum, Lodz, Poland
Kasseler Dokumentarfilm und Videofest, Kassel, Germany
Royal Danish Academy of Fine Arts, Copenhagen
Statens Kunstakademi, Oslo
Sydney Film Festival
Transmitter Festival, Vorarlberg, Austria

1999
Animal, Magic, Centre d'Art Contemporain/Transat Vidéo, Hérouville Saint-Clair, France
CyberArts Festival, Massachusetts

Insitute of Technology, Cambridge
Franconia Sculpture Park, Shafer,
Minnesota
Hallwalls Contemporary Arts Center,
Buffalo, New York
Impakt Festival, Amsterdam
Offener Kanal Berlin
Paradise 8, Exit Art/The First World, New
York
17th World Wide Video Festival, Stedelijk
Museum, Amsterdam
VIDARTE, Barranca del Muerto, Mexico

1998
Attack of the Art Films, 911 Media Arts
Center, Seattle
Dissolving the Walls, Art in General, New
York
Niet de Kunstvlaai, Sandberg Institute,
Amsterdam
Pandaemonium Festival, LUX Centre,
London
PARK 4D TV, Amsterdam
Scope, Artists Space, New York

Collections
Altoids Collection
Walker Art Center, Minneapolis

Awards
2004
Durfee Prize, Durfee Foundation, Los
Angeles

2003
Margaret Hall Silva Award, Kansas City,
Missouri

2002
Community Redevelopment Grant, City of
Los Angeles

2001
Creative Capital Foundation Grant, New
York
Minnesota State Arts Board Award, St.
Paul

2000
Peter S. Reed Foundation Award, New
York

1999
Louis Comfort Tiffany Prize, New York

Selected Publications
Dialogues: Sam Easterson/T. J. Wilcox.
Minneapolis: Walker Art Center, 1998.
Thompson, Nato, ed. *Becoming Animal:
Contemporary Art in the Animal Kingdom*.
North Adams, MA: MASS MoCA, 2005.

mitch epstein
Born Holyoke, Massachusetts, 1952
Lives in New York

Education
1972–74
Cooper Union, New York

1971–72
Rhode Island School of Design,
Providence

1970–71
Union College, Schenectady, New York

Selected Solo Exhibitions
2006
Mitch Epstein, Galerie Rodolphe Janssen,
Brussels
Mitch Epstein: WORK—Eine Retrospektive,
Photographische Sammlung/SK Stiftung
Kultur, Cologne
Recreation, Jackson Fine Art, Atlanta

2005
*Recreation: American Photographs
1973–1988*, Sikkema Jenkins & Co., New
York

2004
Family Business, Yancey Richardson
Gallery, New York
Mitch Epstein, BrancoliniGrimaldi,

Florence
Mitch Epstein, Jackson Fine Art, Atlanta

2003
Family Business, Power House, Memphis

2002
Onefront Gallery, New York

2001
Brent Sikkema, New York
Photographs from the City, Rose Gallery,
Santa Monica

1999
Brent Sikkema, New York

1998
Vietnam: A Book of Changes, Center for
Documentary Studies, Durham, North
Carolina

Selected Group Exhibitions
2006
*Current: River Photography from the
Monsen Collection*, Henry Art Gallery,
University of Washington, Seattle
Shooting the Family, CCA Wattis Institute
for Contemporary Arts, San Francisco

2005
*Garry Winogrand and the American Street
Photographers*, Foam Fotografiemuseum,
Amsterdam; Städtische Galerie,
Wolfsburg, Germany

2004
History in the Making, PhotoEspaña 2004,
Círculo de Bellas Artes, Madrid
The Open Book, Hasselblad Center,
Göteborg, Sweden
Rencontres de la Photographie, Arles,
France
Seventies Color Photography, Kennedy
Boesky Photographs, New York

2002
New York après New York, Musée de l'Ély-
sée, Lausanne

2001
Blind Spot #17, Bakalar Gallery,
Massachusetts College of Art, Boston
Overnight to Many Cities, 303 Gallery, New
York
Sense of Space, 8th Noorderlicht
Photofestival, Groningen, The
Netherlands

2000
New York Now, Museum of the City of New
York

1999
William Eggleston and the Color Tradition,
J. Paul Getty Museum, Los Angeles

1998
In Country: Vietnam Revisited, Laurence
Miller Gallery, New York
*Photography after Modernism: Extensions
into Contemporary Art*, San Francisco
Museum of Modern Art
The Sound of One Hand, Apex Art, New
York

Filmography
Dad, 2003, short, director and producer
India Cabaret, 1985, documentary, director
of photography
Mississippi Masala, 1992, feature, co-pro-
ducer, production designer, and second
unit cinematographer
Salaam Bombay!, 1988, feature, co-produ-
cer, production designer, and second unit
cinematographer
So Far from India, 1982, documentary,
director of photography

**Awards and Professional
Experience**
2004
Kraszna-Krausz Book Award (for *Family
Business*)
Visiting Lecturer, Graduate Photography
Program, School of Visual Arts,
New York

2002
John Simon Guggenheim Memorial
Foundation Fellowship

1999, 2001
Associate Professor of Photography,
School of the Arts, Bard College,
Annandale-on-Hudson, New York

1997
American Institute of Graphic Artists, 50
Best Books of the Year

Selected Collections
Art Institute of Chicago
Baltimore Museum of Art
Bibliothèque nationale de France, Paris
Brooklyn Museum
Corcoran Gallery of Art, Washington, D.C.
Gilman Paper Collection, New York
Henry Art Gallery, University of
Washington, Seattle
J. Paul Getty Museum, Los Angeles
Joseph E. Seagram and Sons Collection,
New York
Los Angeles County Museum of Art
Metropolitan Museum of Art, New York
Museum of Contemporary Photography,
Chicago
Museum of Fine Arts, Boston
Museum of Fine Arts, Houston
Museum of Modern Art, New York
National Gallery of Australia, Canberra
Philadelphia Museum of Art
Saint Louis Art Museum
San Francisco Museum of Modern Art
Santa Barbara Museum of Art
Tokyo Metropolitan Museum of
Photography
Vassar College Art Museum,
Poughkeepsie, New York
Whitney Museum of American Art, New York

Selected Publications
Epstein, Mitch. *The City*. New York:
powerHouse, 2001.
_____. *Family Business*. Göttingen: Steidl, 2003.

_____. *Fraternity*. Paris: Toluca, 2006.
_____. *Recreation: American Photographs
1973–1988*. Göttingen: Steidl, 2005.
_____. *Vietnam: A Book of Changes*. New
York: W. W. Norton/DoubleTake, 1996.
_____. *Work*. Göttingen: Steidl, 2006.

joan fontcuberta
Born Barcelona, 1955
Lives in Barcelona

Education
1972–77
Communications, Universitat Autònoma,
Barcelona

Selected Solo Exhibitions
2006
Datascapes, Artcore, Toronto
Googlegrams, Zabriskie Gallery, New York
Landscapes without Memory, Aperture
Foundation, New York

2005
Googlegramas, Instituto Cervantes, Paris
Joan Fontcuberta, Galería Bacelos, Vigo,
Spain
Orogenese: Landschaften ohne Gedächtnis,
Photoforum PasquArt, Biel, Switzerland
Sciences-Friction, Musée de l'Hôtel Dieu,
Mantes-la-Jolie, France

2004
Fauna, Sala Municipal de San Benito,
Valladolid, Spain
Joan Fontcuberta, Galería Forum Chantal
Grande, Tarragona, Spain
Joan Fontcuberta, Galería Senda,
Barcelona
Mazzeri, Instituto Francés, Barcelona
Mission photographique sur la Corse,
Centre Méditerranéen de la Photographie,
Ville di Pietrabugno, France
OROGÉNESIS: Dalí, Galería Vanguardia,
Bilbao, Spain
Ping Zhuang, Zabriskie Gallery,
New York

2003
Imaginary Gardens, Salvador Dalí Museum, St. Petersburg, Florida
Miracles & Co., Zabriskie Gallery, New York
Mission photographique sur la Corse, Centre Méditérranéen de la Photographie, Ville di Pietrabugno, France

2002
Paysages encryptés, Galerie Nathalie Parienté, Paris
Securitas, Galeria Filomena Soares, Lisbon

2001
Contranatura, Museo de la Universidad de Alicante, Spain

Selected Group Exhibitions
2006
Catarsis: Rituales de purificación, Artium, Vitoria-Gasteiz, Spain
Contact: 10th Annual Toronto Photography Festival
Fictions Abound, Ffotogallery, Cardiff, Wales
Images d'un territoire: 10 ans de comman-des photographique en Corse, Château d'Eau, Toulouse, France; Centre Culturel Français de Damas, Syria
My Collection, Museo di Fotografia Contemporanea Ken Damy, Brescia, Italy
150 años de fotografía en España, Hungarian House of Photography, Budapest
Troubles du cadre, Château d'Eau, Toulouse, France

2005
Un autre monde, 6th Rencontres Africaines de la Photographie, Bamako, Mali
Experimentação na Colecção de Fotografia do IVAM, Centro Português de Fotografia, Porto, Portugal; Muzeul Na_ional de Art_ Contemporan_, Bucharest

Insensé Espagne, Colette, Paris
Rencontres de la Photographie, Arles, France
Vidas Privadas, Sala Municipal de San Benito, Valladolid, Spain

2004
Agua al desnudo, Fundación Canal de Isabel II, Madrid
Colecção Fotográfica do Concello de Vigo, Centro Portugues de Fotografia, Porto, Portugal
Géneros y tendencias en los albores del siglo XXI, Sala Municipal de San Benito, Valladolid, Spain
Nueva tecnología, nueva iconografía, nueva fotografía, Museu d'Art Espanyol Contemporani, Palma, Spain; Museo de Arte Abstracto Español, Cuenca, Spain
Rencontres de la Photographie, Arles, France
Supernatural, Galerie Zürcher, Paris
Variacións en España: Fotografía e arte 1900–1980, Museo de Arte Contemporánea, Vigo, Spain; PhotoEspaña 2004, Madrid
Vidas Privadas, Fundación Foto Colectania, Barcelona
Wirklich wahr! Realitätsversprechen von Fotografien, Ruhrlandmuseum, Essen, Germany

2003
Entdecken, Fördern, Handeln, Württembergischer Kunstverein Stuttgart
Ficciones, Galeria Esther Montoriol, Barcelona
How Human: Life in the Post-Genome Era, International Center of Photography, New York
Microcòsmics, Metrònom, Barcelona
Realidad y representación: Coleccionar paisaje hoy, Fundación Foto Colectania, Barcelona
Realities: Collections Without Frontiers II, Zach_ta—National Gallery of Art, Warsaw
Vigovisións 1986–2000, Museo de Arte

Contemporánea, Vigo, Spain
La vita delle forme: Fotografie, disegni e grafiche, Galleria Civica Modena, Italy

2002
Melodrama: Lo excesivo en la imaginación posmoderna, Artium, Vitoria-Gasteiz, Spain

2001
A B See D, Anthony Reynolds Gallery, London
Realidad construida, Galería Helga de Alvear, Madrid

Awards and Professional Experience
2005
Visiting Professor, Newport School of Art, Media, and Design, University of Wales

2003
Visiting Professor, Department of Visual and Environmental Studies, Harvard University

1998
National Award for Photography, Ministry of Culture, Spain

1997
Year of Photography and Electronic Image Award, Arts Council of England

1994
Chevalier dans l'Ordre des Arts et des Lettres, Ministry of Culture, France

1993–present
Faculty of Audiovisual Communication, Universitat Pompeu Fabra, Barcelona

1988
David Octavius Hill Medal, Gesellschaft Deutscher Lichtbildner, Mannheim, Germany

Collections

Fundación Foto Colectania, Barcelona
MIT List Visual Arts Center, Cambridge, Massachusetts
Musée des Beaux-Arts du Canada, Ottawa
Museum of Contemporary Photography, Chicago
National Museum of Photography, Film & Television, Bradford, UK
San Francisco Museum of Modern Art

Selected Publications

Caujolle, Christian. *Joan Fontcuberta*. London: Phaidon, 2001.
Fontcuberta, Joan. *Le baiser de Judas: Photographie et verité*. Arles: Actes Sud, 2005.
_____. *Euskaldunen uhartea/La isla de los vascos*. Vitoria-Gasteiz: Artium, 2003.
_____. *Googlegramas*. Paris: Instituto Cervantes, 2005.
_____. *Joan Fontcuberta habla con Cristina Zelich*. Madrid: La Fábrica, 2001.
_____. *Karelia, Milagros & Co.* Madrid: Fundación Telefónica, 2002.
_____. *Landscapes without Memory*. New York: Aperture, 2005.
_____, ed. *Photography: Crisis of History*. Barcelona: Actar, 2004.
_____. *Sciences-Friction*. Paris: Somogy, 2005.
_____. *Securitas*. Barcelona: G. Gili, 2001.
_____. *Sputnik*. Madrid: Fundación Arte y Tecnología, 1997.
_____. *Twilight Zones*. Barcelona: Actar, 2000.
Grande, Chantal. *Joan Fontcuberta*. Madrid: La Fábrica, 2000.
Jarauta, Francisco, et al. *Contranatura: Joan Fontcuberta*. Barcelona: Museo de la Universidad de Alicante, 2001.
Jeffett, William. *Joan Fontcuberta: Imaginary Gardens: Mapping Dalí's Landscapes*. St. Petersburg, FL: Salvador Dalí Museum, 2003.
Pujade, Robert, et al. *Du réel á la fiction:*

La vision fantastique de Joan Fontcuberta. Paris: Édition Isthme, 2005.

noriko furunishi

Born Kobe, Japan, 1966
Lives in Los Angeles

Education

2005
M.F.A., University of California, Los Angeles

1993
B.F.A., Pratt Institute, Brooklyn

Selected Solo Exhibitions

2005
Landscapes, Murray Guy, New York

2004
Two Eyes: Photographs by Maximilian Canepa and Noriko Furunishi, Hayworth Gallery, Los Angeles

Selected Group Exhibitions

2006
Landscape: Recent Acquisitions, Museum of Modern Art, New York
Super Vision, Institute of Contemporary Art, Boston

2005
Supersonic, L. A. Design Center, Los Angeles

2004
Pareidolia, Orange County Center for Contemporary Art, Santa Ana, California

2002
Now Serving, Art in General, New York

Collections

Institute of Contemporary Art, Boston
Museum of Modern Art, New York

marine hugonnier

Born Paris, 1969
Lives in London

Education

1993–95
M.S., Anthropology, Université Paris X–Nanterre

1991–93
B.S., Philosophy, Université Tolbiac, Paris

Selected Solo Exhibitions

2006
Marine Hugonnier, Max Wigram Gallery, London
Travelling Amazonia, Galería NoguerasBlanchard, Barcelona

2005
Marine Hugonnier, Center for Curatorial Studies, Bard College, Annandale-on-Hudson, New York

2004
The "Last Chance to See" Tour, Haunch of Venison, Zürich; Kunst-Werke, Berlin; Magazzino d'Arte Moderna, Rome
Marine Hugonnier, Dundee Contemporary Arts, Dundee, Scotland

2003
Ariana, MWprojects, London; Chisenhale Gallery, London; Spacex Gallery, Exeter, UK
Marine Hugonnier, Galerie Yvon Lambert, Paris

2002
Anna Hanusova, TRANS>area, New York
Marine Hugonnier & Bernard Joisten, Fonds Régional d'Art Contemporain (FRAC) Languedoc-Roussillon, Montpellier, France
Towards Tomorrow, MWprojects, London

2001

Anna Hanusova, Engholm Galerie, Vienna
Marine Hugonnier, Annet Gelink Gallery, Amsterdam
Marine Hugonnier, Centre d'Art Neuchâtel, Switzerland
Marine Hugonnier, Centro Galego de Arte Contemporánea, Santiago de Compostela, Spain

2000
Art Unlimited, Art Basel
Interlude, Galerie Chantal Crousel, Paris

Selected Group Exhibitions
2006
Around the World in Eighty Days, Institute of Contemporary Arts, London
Culture Bound, Courtauld Institute of Art, London
Nature Attitudes, T-B A21 Thyssen-Bornemisza Art Contemporary, Vienna
Pusan Biennial, Pusan, South Korea
Uchronies et autres fictions, Fonds Régional d'Art Contemporain (FRAC) Lorraine, Metz, France

2005
British Art Show 6, BALTIC, Gateshead, UK
Cine y Casi Cine 2005, Museo Nacional Centro de Arte Reina Sofía, Madrid
Documentary Creations, Kunstmuseum, Lucerne, Switzerland
Invisible Script, W139, Amsterdam
Leaps of Faith, Nicosia, Cyprus
Quand les latitudes deviennent suisses, Fonds Régional d'Art Contemporain (FRAC) Lorraine, Metz, France
T1 Torino Triennale Tremusei, Turin
This Peaceful War, Glasgow International Festival of Contemporary Art
Universal Experience: Art, Life, and the Tourist's Eye, Museum of Contemporary Art, Chicago

2004
Britannia Works, Ileana Tounta Contemporary Art Centre, Galerie Xippas,
and The Breeder, Athens
Fade In, Contemporary Arts Museum, Houston
Landscape and Memory, La Casa Encendida, Madrid
Nine Points of the Law, Neue Gesellschaft für Bildende Kunst e.V., Berlin
Teatro della memoria, Galleria Comunale d'Arte Contemporanea, Bologna
Territories, Malmö Konsthall, Malmö, Sweden
Todo va a estar bien, Museo Tamayo Arte Contemporáneo, Mexico City
Utopia Station, Haus der Kunst, Munich

2003
Cine y Casi Cine 2003, Museo Nacional Centro de Arte Reina Sofía, Madrid
Dialogues—Quand on pose une chose contre une autre, elles se touchent, Centre Régional d'Art Contemporain, Sète, France
Dreams and Conflicts: The Dictatorship of the Viewer, 50th Venice Biennale
Elephant Juice (o sexo entre amigos), Kurimanzutto, Mexico City
Spiritus, Magasin 3, Stockholm

2002
Confiture demain et confiture hier, mais jamais confiture aujourd'hui, Centre Régional d'Art Contemporain, Sète, France
Geographies #2, Galerie Chantal Crousel, Paris
Less Ordinary: French Contemporary Art, Artsonje Center, Seoul
The Mind Is a Horse, Bloomberg Space, London
Nuit Blanche, Les Pompes Funèbres, Paris
Post-VCR-Art, Tyneside Cinema, Newcastle-upon-Tyne, UK

2001
Beau Monde: Toward a Redeemed Cosmopolitanism, SITE Santa Fe's Fourth International Biennial

Movimientos inmóviles, Museo de Arte Moderno, Buenos Aires
My Generation, Atlantis Gallery, London
Presentness Is Grace: Experiencing the Suspended Moment, Arnolfini Gallery, Bristol, UK
Squatters/Ocupações, Fundação de Serralves, Porto, Portugal
Traversées, Musée d'Art Moderne de la Ville de Paris
Unreal Time Video, Korean Culture and Arts Foundation, Seoul

2000
Fig-1: 50 Projects in 50 Weeks, various venues in London
Permanencia voluntaria, Kurimanzutto, Mexico City
Projet réalisé pour la "TV Mobile" de Pierre Huyghe, Le Consortium, Dijon, France

Awards and Residencies
2003
Fellowship AFAA, Villa Médicis Hors les Murs, France

1999
Le Fresnoy, Studio National des Arts Contemporains, Lille, France
Residency, Delfina Studio Trust, London

Selected Collections
Arts Council of England
Centro Galego de Arte Contemporánea, Santiago de Compostela, Spain
Fondazione Sandretto Re Rebaudengo, Turin
Fonds National d'Art Contemporain, Paris
Fonds Régional d'Art Contemporain (FRAC) Lorraine, Metz, France
Fundação de Serralves, Porto, Portugal
Jumex Collection, Mexico City
Musée d'Art Moderne de la Ville de Paris
Sammlung Goetz, Munich
T-B A21 Thyssen-Bornemisza Art Contemporary, Vienna

Selected Publications

Marine Hugonnier. Texts by Michael Newman and Jeremy Miller; interview by Lynne Cooke. Dundee: Dundee Contemporary Arts, 2004.
Marine Hugonnier. Texts by Miguel Fernández-Cid, Martin Herbert, and Angeline Scherf. Santiago de Compostela: CGAC, 2001.

francesco jodice

Born Naples, 1967
Lives in Milan

Selected Solo Exhibitions

2006
Crossing, Maison Européenne de la Photographie, Paris
Rear Window (broadcast), Canal+ Spain

2004
Natura, Liverpool Biennial 2004, Open Eye Gallery
I nuovi segni del territorio, Palazzo dei Giureconsulti, Milan
Private Investigations, Galerie Davide Di Maggio–Mudimadue, Berlin

2003
The Crandell Case, Galleria Photo & Contemporary, Turin
What We Want, Galería Marta Cervera, Madrid

2001
What We Want, Galleria Dryphoto, Prato, Italy; Galleria Le Bureau des Esprits, Milan

1999
Cartes postales d'autre espaces, Centre Culturel "Les Chiroux," Liège, Belgium
The Phantom Limb (video installation with Stefano Boeri), Film+Arc Biennale, Graz, Austria

1998
Cartoline dagli altri spazi, Galleria Carla Sozzani, Milan

Selected Group Exhibitions

2006
Un été italien—Une histoire privée, Maison Européenne de la Photographie, Paris
Metropolitanscape: Paesaggi urbani nell'arte contemporanea, Palazzo Cavour, Turin
27th Bienal de São Paulo

2005
Beyond Media 05, International Festival of Architecture and Media, Stazione Leopolda, Florence, Italy
Gli occhi della città, artandgallery, Milan
Italian Camera, Venezia Immagine, Isola di San Servolo, Venice
A Journey Around My House, PhotoEspaña 2005, Círculo de Bellas Artes, Madrid
I luoghi e l'anima, Palazzo Reale, Milan
Napoli Presente: Posizioni e prospettive dell'arte contemporanea, Palazzo delle Arti, Naples
6 x Torino, Galleria Civica d'Arte Moderna e Contemporanea, Turin
Urbana: La città in trasformazione, Festival di Fotografia, Biella, Italy

2004
Empowerment/Cantiere Italia, Villa Croce Museo d'Arte Contemporanea, Genoa
Neutrality, FRI-ART—Centre d'Art Contemporain, Fribourg, Switzerland
Sguardi contemporanei: 50 anni di architettura italiana, 9th Mostra Internazionale di Architettura, Venice
Suburbia, Chiostri di San Domenico, Reggio Emilia, Italy

2003
Arte pubblica in Italia (Multiplicity), Fondazione Pistoletto, Biella, Italy
Atlante Italiano 2003, Museo Nazionale delle Arti del XXI Secolo, Rome
Colección Sandretto Re Rebaudengo, IVAM (Institut Valencià d'Art Modern), Valencia, Spain
14th Quadriennale di Roma, Palazzo Reale, Naples

Going Public (Multiplicity), Bologna
L'idea di paesaggio nella fotografia italiana dal 1850 ad oggi, Modena per la Fotografia 2003, Modena, Italy
In Natura, 10th Biennale Internazionale di Fotografia, Turin
International Film Festival Rotterdam (Multiplicity)
ManifesTO, Galleria Civica d'Arte Moderna e Contemporanea, Turin
Sogni e conflitti (Multiplicity), 50th Venice Biennale
Villes vues, villes vécues, FNAC Forum des Halles, Paris

2002
Da Guarene all'Etna 2002, Padiglione Italia, Venice
documenta 11 (Multiplicity), Kassel, Germany
Idea di metropoli, Museo Fotografia Contemporanea, Villa Ghirlanda, Milan
Perth International Arts Festival (Multiplicity), Perth, Australia
Side Effects, Triennale di Milano
Space World—A Void Workshop (Multiplicity), Center for Contemporary Art, Kitakyushu, Japan
USE: Uncertain States of Europe (curated by Multiplicity), Triennale di Milano
VOID (Multiplicity) Rice Gallery/G2, Tokyo

2001
Il Dono, Palazzo delle Papesse, Siena; Centro Culturale Candiani, Venice
Instant City, Museo Pecci, Prato, Italy
Poetics of Vision, Italian Landscapes 1971/2001, Galleria Photo & Contemporary, Turin
Revolving Doors, Galleria Spazio Erasmus, Milan
Strategies, Kunsthalle zu Kiel, Kiel, Germany; Museion, Bolzano, Italy; Rupertinum, Salzburg, Austria
Urban Pornography, Artists Space, New York

2000
Mutations, arc en rêve–centre d'architecture, Bordeaux, France
Raccolta della fotografia contemporanea: Nuove acquisizioni 1997–2000, Galleria Civica Modena, Italy
7th International Architecture Exhibition, Venice Biennale

Selected Collections
arc en rêve–centre d'architecture, Bordeaux, France
Fondazione Sandretto Re Rebaudengo, Turin
Fonds National d'Art Contemporain, Paris
Galleria Civica Modena, Italy

Selected Publications
Boeri, Stefano, et al. *Multiplicity: USE: Uncertain States of Europe: A Trip Through a Changing Europe*. Milan: Skira, 2003.
Jodice, Francesco. *Cartoline dagli altri spazi*. Milan: Motta, 1998.
Koolhaas, Rem, et al. *Mutations.* Photographs by Francesco Jodice et al. Bordeaux: arc en rêve–centre d'architecture; Barcelona: ACTAR, 2000.
Molinari, Luca, ed. *Francesco Jodice: What We Want: Landscape as a Projection of People's Desires*. Milan: Skira, 2004.

harri kallio
Born Salla, Finland, 1970
Lives in New York

Education
2002
M.F.A., Photography, University of Art and Design, Helsinki

1999
B.F.A., Photography, University of Art and Design, Helsinki

1998–99
Publishing and Music, School of Art, Oxford Brookes University

Selected Solo Exhibitions
2006
The Dodo and Mauritius Islands, Bonni Benrubi Gallery, New York

2004
Institute of Systematic Zoology and Evolutionary Biology, Jena, Germany

2003
Finnish Museum of Natural History, Helsinki

Selected Group Exhibitions
2006
The Earth, FotoFest, Houston
Fotofinlandia, Victor Barsokevitsch Photographic Centre, Kuopio, Finland

2005
Obiettivo Uomo Ambiente 2005, Viterbo, Italy

2004
Ausgezeichnet—15. BFF-Förderpreis und Reinhart-Wolf-Preis 2003, Gruner+Jahr Pressehaus, Hamburg; Design Center, Stuttgart

2003
Libris, Galleria Uusitalo, Helsinki

2000
Profounders Gallery, Helsinki

1999
Galleria Hippolyte, Helsinki

Awards
2006
Finnish Cultural Foundation Grant
Fotofinlandia Prize

2004
Finnish Art Council Grant
European Publishers Award for Photography

2003
BFF Promotion Award
Finnish Cultural Foundation Grant

2002
Finnish Cultural Foundation Grant

2000
Finnish Art Council Grant

1996
Images of Europe 1996, European Cultural Foundation Award

Selected Publications
Kallio, Harri. *The Dodo and Mauritius Island: Imaginary Encounters*. London: Dewi Lewis, 2004.
_____. "Dodo Redux." *Aperture* 183 (Summer 2006).

vincent laforet
Born Saanen, Switzerland, 1975
Lives in New York

Education
B.S., Journalism, Northwestern University, Evanston, Illinois

Professional Experience
Laforet Visuals, Inc., New York
New York Times, National Contract Photographer, 2005–present
New York Times, Staff Photographer, 2000–2005
Agence France-Presse, Chicago, Freelance Photographer, 1994–present
Adjunct Professor, Columbia School of Journalism, New York

Awards
2003
Photographer of the Year, National Press Photographers Association

2002
Photographer of the Year, National Press

Photographers Association
Pulitzer Prize in Feature Photography

2001
Photographer of the Year, New York Press
Photographers Association

christopher lamarca
Born New York, 1975
Lives in Brooklyn

Professional Clients
The Fader
National Geographic Online
Newsweek
Volvo

Awards
2006
Best of Photojournalism 2006 (2nd place
for "Forest Defenders")
Photo District News 30 Emerging
Photographers

2004
Golden Light Award, Documentary and
Photojournalism category (for the series
"Pool Hustlers")

an-my lê
Born Saigon, Vietnam, 1960
Lives in New York

Education
1993
M.F.A., Yale University School of Art

1985
M.S., Stanford University

1981
B.S., Stanford University

Selected Solo Exhibitions
2006
Small Wars: Photographs by An-My Lê,
Marion Center for Photographic Arts,
College of Santa Fe

2004
29 Palms, Murray Guy, New York

2002
Small Wars, P.S.1 MoMA, Long Island City,
New York

2000
*Documents, Perceptions, and Perspectives:
The Landscape Photography of An-My Lê
and Brent Phelps*, Bannister Gallery,
Rhode Island College, Providence

1999
Vietnam, Scott Nichols Gallery, San
Francisco

Selected Group Exhibitions
2006
*Beautiful Suffering: Photography and the
Traffic in Pain*, Williams College Museum
of Art, Williamstown, Massachusetts
Landscape: Recent Acquisitions, Museum
of Modern Art, New York

2005
Art of Aggression, The Moore Building,
Miami
In Words and Pictures, Murray Guy, New
York
Stages of Memory: The War in Vietnam,
Museum of Contemporary Photography,
Chicago
T1 Torino Triennale Tremusei, Turin

2004
The Freedom Salon, Deitch Projects,
New York

2002
Fiona Banner, An-My Lê, Ann Lislegaard,
Murray Guy, New York
Gravity Over Time, Galleria 1000 Eventi, Milan
Road Trip, Murray Guy, New York

2001
Photographs from the Permanent

Collection, Metropolitan Museum of Art,
New York

2000
Reconsidering Vietnam, Brush Art Gallery,
St. Lawrence University, Canton, New York

1999
Things They Carry, University of North
Texas Art Galleries, Denton

1998
In Country: Vietnam Revisited, Laurence
Miller Gallery, New York
Re-Imagining Vietnam, FotoFest, Houston

Awards and Professional
Experience
1998–present
Assistant Professor of Photography, Bard
College, Annandale-on-Hudson, New York

1997
John Simon Guggenheim Memorial
Foundation Fellowship

1996
New York Foundation for the Arts
Fellowship (photography)

1995
CameraWorks Fellowship

Selected Collections
Arthur M. Sackler Gallery, Washington,
D.C.
Bibliothèque Nationale de France, Paris
Metropolitan Museum of Art, New York
Museum of Fine Arts, Houston
Museum of Modern Art, New York
San Francisco Museum of Modern Art

Publication
Lê, An-My. *Small Wars*. Essay by Richard
B. Woodward; interview by Hilton Als.
New York: Aperture, 2005.

david maisel

Born New York, 1961
Lives in Sausalito, California

Education

1988–89
Graduate School of Design, Harvard University

1984
B.A., Princeton University

Selected Solo Exhibitions

2006
Black Maps, South East Museum of Photography, Daytona Beach, Florida
Black Maps: The Lake Project, Fotografie Forum International, Frankfurt

2005
Terminal Mirage, Von Lintel Gallery, New York; Paul Kopeikin Gallery, Los Angeles; Haines Gallery, San Francisco; Miller Block Gallery, Boston

2004
The Lake Project, James Nicholson Gallery, San Francisco; Blue Sky Gallery, Portland, Oregon

2003
Aerial Photography, Schneider Gallery, Chicago
The Lake Project, Von Lintel Gallery, New York; Paul Kopeikin Gallery, Los Angeles; Miller Block Gallery, Boston; Bolinas Art Museum, Bolinas, California
Treading Water, Society for Contemporary Photography, Kansas City, Missouri

Selected Group Exhibitions

2006
Frontiers: Collecting the Art of Our Time, Worcester Art Museum, Worcester, Massachusetts
Imaging a Shattering Earth, Museum of Contemporary Canadian Art, Toronto
Naturaleza, PhotoEspaña 2006, Madrid

2005
New Turf, Robert Hull Fleming Museum, University of Vermont, Burlington
Paradise Paved, Painted Bride Art Center, Philadelphia
Traces and Omens, 12th Noorderlicht Photofestival, Groningen, The Netherlands

2004
Contemporary Photographs from the Permanent Collection, Princeton University Art Museum
Diversions & Dislocations: California's Owens Valley, Center for Land Use Interpretation, Los Angeles
Frames of Reference: New Works by PhotoAlliance Founders, Center for Photographic Art, Carmel, California
Monument Recall: Public Memory and Public Spaces, SF Camerawork, San Francisco
No Man's Land: Contemporary Photographers and Fragile Ecologies, Halsey Institute of Contemporary Art, College of Charleston, South Carolina
Photolucida Critical Mass Project, Blue Sky Gallery, Portland, Oregon, and other venues
reGenerations: Environmental Art in California, Armory Center for the Arts, Pasadena, California
Water, Fotofest, Houston

2003
Abstraction in Photography, Von Lintel Gallery, New York
H20, Santa Fe Art Institute
Inaugural Exhibition, James Nicholson Gallery, San Francisco
Managing Eden, Center for Photography at Woodstock, New York

2002
New Acquisitions/New Work/New Directions 3, Los Angeles County Museum of Art

Photographs from the Peter C. Bunnell Collection, Princeton University Art Museum
Picturing the Wilderness: Photographs by David Maisel, Macduff Everton & Josef Muench, Wildling Art Museum, Los Olivos, California

Awards

2003
Nominee, John Guttman Photography Fellowship, San Francisco Foundation

1992
Photography Award, Opsis Foundation, New York

Selected Collections

Aldrich Contemporary Art Museum, Ridgefield, Connecticut
Bowdoin College Museum of Art, Brunswick, Maine
Brooklyn Museum
George Eastman House, Rochester, New York
Los Angeles County Museum of Art
Metropolitan Museum of Art, New York
Museum of Contemporary Photography, Chicago
Museum of Fine Arts, Houston
Portland Art Museum, Portland, Oregon
Princeton University Art Museum
Rose Art Museum, Waltham, Massachusetts
Santa Barbara Museum of Art

Selected Publications

Gaston, Diana. "Immaculate Destruction: David Maisel's Lake Project." *Aperture*, no. 172 (Fall 2003), pp. 39–43.
Maisel, David. *The Lake Project*. Tucson: Nazraeli Press, 2004.
_____. "Living in Oblivion." *Dwell Magazine* (January 2005), pp. 149–56.
_____. "Sanctuary and the Modern Metropolis." *Daylight Magazine*, no. 3 (Fall 2004).

_____. *Terminal Image.* New York: Von Lintel Gallery, 2005.

No Man's Land: Contemporary Photographers and Fragile Ecologies: Edward Burtynsky, Emmet Gowin, David Maisel. Charleston: Halsey Institute of Contemporary Art, 2004.

Olson, Marisa S. "The Abstract Aerial Landscape Photography of David Maisel." *CameraArts* (April–May 2003), pp. 8–11.

Rosner, Hillary. "Ghost Lake." *Audubon* (May 2004), pp. 48–53.

mary mattingly

Born Rockville, Connecticut, 1978
Lives in Brooklyn

Education

B.F.A., Pacific Northwest College of Art, Portland, Oregon

New School for Social Research, New York

Yale School of Art, Norfolk, Connecticut

Selected Solo Exhibitions

2006
Second Nature, Robert Mann Gallery, New York

2005
We Go Round and Round in the Night, Philip Feldman Gallery, Portland, Oregon

2004
Mattingly|Dedes, Duende Studios, Rotterdam

2003
The Stage, Lyons Wier Gallery, New York

2002
Lyons Wier Gallery, Scope Miami

2001
Puppets, Disjecta, Portland, Oregon
Valparaiso, Media Arts Gallery, Portland, Oregon

2000
Mary Mattingly, Higgins Gallery, Portland, Oregon

Selected Group Exhibitions

2005
Lifeboat—Hamptons (Microscope), Scope Hamptons, New York (curated by Mary Mattingly and Paul Middendorf)
Two Continents and Beyond: Waterways, 9th Istanbul Biennial
Waterways, Venice Biennale (curated by Mary Mattingly and Renée Vara)

2004
Blackmail Party Favors, Jupiter Art Fair, Disjecta, Portland, Oregon
Digital '04: Tomorrow, New York Hall of Science
DNA: Art & Science—The Double Helix, Contemporary Art Museum, Tampa, Florida
First Annual Photo New York Invitational, Lyons Wier Gallery, New York
LifeBoat, Art Basel Miami Beach (curated by Mary Mattingly and Paul Middendorf)
The Modern Zoo—East Versus West Coast, Disjecta, Portland, Oregon
Nineteeneighty—Art Show, RARE, New York
The Peekskill Project 2004, Hudson Valley Center for Contemporary Art, Peekskill, New York
Small Works X, RAM Foundation, Rotterdam
Transforming Home, RAM Foundation, Rotterdam

2003
Best of Show, Gallery 1401, Philadelphia University of the Arts
New Directions '03, Barrett Art Center, Poughkeepsie, New York
(R)evolution: Warface, Pamela Auchincloss Project Space, New York
Visual AIDS, Galerie Lelong, New York

2002
Affordable Art Fair, Lyons Wier Gallery, New York
Feast, Parsons School of Design, New York

2000
Deck the Walls, Portland Institute for Contemporary Art, Portland, Oregon

Awards

2004
London Photographic Awards

2001
Opal Filteau Photography Scholarship
Stephen Swirling Award for Digital Arts

gilles mingasson

Born Boulogne-Billancourt, France, 1965
Lives in Los Angeles

Selected Group Exhibitions

2005
10th Istanbul Slide-Show Days (*The End of Shishmaref*)

2004
9th Istanbul Slide-Show Days (*The Nascar Dads* and *La Reconquista: Latinos in Los Angeles*)

2001
Aesthetics, Perfect Exposure Gallery, Los Angeles

2000
Moments Between Millenniums (project organizer and co-curator), Paris Photo, Los Angeles; Gallery 478, San Pedro, California; Los Angeles Public Library (through 2003)
The World Is Round, Perfect Exposure Gallery, Los Angeles

Filmography

The Executioners, documentary, 52 min., for Capa and France2

The Nascar Dads, documentary, for
France2-Envoyé Spécial

Professional Clients
Discovery
Le Figaro
Fortune
Global Education Fund
Newsweek
Le Nouvel Observateur
Smithsonian
UNESCO
U. S. News & World Report

Award
2005
American Photography 21 Contest (1st
place, Web—Latino Essay)

simon norfolk
Born Lagos, Nigeria, 1963
Lives in Brighton, England

Education
1988–90
Gwent College, University of Wales,
Newport

1985–88
Bristol University

1984–85
Hertford College, Oxford

Selected Solo Exhibitions
2006
Et in Arcadia ego, Photobiennale 2006,
Zurab Tsereteli Art Gallery, Moscow
I'm sorry Dave, I'm afraid I can't do that,
AOP Gallery, London

2005
Bleed, Blue Sky Gallery, Portland, Oregon
Eastern Bosnia and Northern Normandy,
The Photographers' Gallery, London
Erzähl mir vom Krieg, Zephyr, Mannheim,
Germany

Et in Arcadia ego, Bonni Benrubi Gallery,
New York
Goaf, Side Photographic Gallery,
Newcastle-upon-Tyne, UK
Keeping Peace, Sirius Arts Centre, Cobh,
Ireland
Simon Norfolk, McBride Fine Art,
Antwerp, Belgium

2004
Afghanistan Chronotopia, Belfast Exposed
Conflicting Landscapes, The
Photographers' Gallery, London
Scenes from a Liberated Iraq, Gallery
Luisotti, Santa Monica, California
Utah, Omaha, Gold, Juno, Sword, Galerie
Martin Kudlek, Cologne

2003
Afghanistan Zero, Scuderie Aldobrandini
del Comune di Frascati, Rome
*For most of it I have no words: Genocide,
Landscape, Memory*, Society for
Contemporary Photography, Kansas City,
Missouri
Neither Here Nor There, Galerie Martin
Kudlek, Cologne

2002
Afghanistan Zero, Deutsches Architektur
Museum, Frankfurt
*For most of it I have no words: Genocide,
Landscape, Memory*, Holocaust Museum,
Houston; Photosynkyria 2002,
Thessaloniki; Minneapolis Center for
Photography
Simon Norfolk: Neue Photoarbeiten,
Galerie Martin Kudlek, Cologne

2000
*For most of it I have no words: Genocide,
Landscape, Memory*, Imperial War
Museum, London; Portland Art Museum,
Portland, Oregon

Selected Group Exhibitions
2006
Post.doc, Photosynkyria 2006, Thessaloniki

Museum of Photography
*Shifting Terrain: Contemporary Landscape
Photography*, Wadsworth Atheneum
Museum of Art, Hartford, Connecticut

2005
Coalfield Stories, Photofusion, London
Hereford Photography Festival, Courtyard
Arts Centre, Hereford, UK
Rencontres de la Photographie, Arles,
France
Srebrenica: Remembrance for the Future,
organized by the Heinrich Böll Stiftung,
Berlin; toured to Brussels, Belgrade,
Berlin, Athens, Washington, D.C.,
Strasbourg, and Sarajevo
Vital Signs, George Eastman House,
Rochester, New York

2004
Arti & Architettura (1900–2000), Palazzo
Ducale, Genoa
La dura bellezza, FotoGrafia Festival,
Istituto Nazionale per la Grafica, Rome
En Guerra, Centre de Cultura
Contemporània, Barcelona
57 on 57th Street, Bonni Benrubi Gallery,
New York
Water, FotoFest, Houston

2003
Citibank Photography Prize 2003, The
Photographers' Gallery, London; Museum
Kunst Palast, Düsseldorf; Fundación
Carlos de Amberes, Madrid
Dexia FotoFestival, Naarden, The
Netherlands
*Images Against War: A Visual Statement by
402 Artists*, Galerie Lichtblick, Cologne
In Natura, 10th Biennale Internazionale di
Fotografia, Turin
M_ARS: Kunst und Krieg/Art and War,
Neue Galerie Graz am Landesmuseum
Joanneum, Graz, Austria
3 Jahre, Galerie Martin Kudlek, Cologne
War, Centre de Cultura Contemporània,
Barcelona

2001
DarkLight, Galerie Martin Kudlek, Cologne

Awards and Residencies
2005
Artist-in-Residence, Irish Army, UN peacekeeping duties
Bursary, Association of Photographers (AOP), London
JGS Commission, Aperture Foundation, New York
Le Prix Dialogue de l'Humanité, Rencontres de la Photographie, Arles, France

2004
Infinity Award, International Center of Photography, New York

2003
Olivier Rebbot Award for Best International Reporting, Foreign Press Club of America
Stuttgart Fotobuchpreis

2002
European Publishers Award for Photography
Sani Prize, Photosynkyria, Thessaloniki

2001
Silver Award, Association of Photographers (AOP), London
World Press Award

Selected Collections
British Council Collection
Channel 4 TV, UK
Frederick R. Weisman Art Museum, University of Minnesota, Minneapolis
George Eastman House, Rochester, New York
Hayward Gallery, London
Museum of Fine Arts, Houston
Portland Art Museum, Portland, Oregon
Los Angeles County Museum of Art
San Francisco Museum of Modern Art

Selected Publications
Norfolk, Simon. *Afghanistan Chronotopia.* Stockport: Dewi Lewis, 2002.
_____. *Afghanistan Zero.* Heidelberg: Edition Braus, 2002.
_____. *Bleed.* Stockport: Dewi Lewis, 2005.
_____. *For most of it I have no words: Genocide, Landscape, Memory.* Introduction by Michael Ignatieff. Stockport: Dewi Lewis, 1998.

the otolith group
Founded London, 2002

Anjalika Sagar
Born London, 1968

Kodwo Eshun
Born London, 1967

Richard Couzins
Born London, 1967

Education
Anjalika Sagar
1993–96
School of Oriental and African Studies, London

Kodwo Eshun
1986–89
University College, Oxford

Richard Couzins
2001–3
Birkbeck College, London

1984–88
Duncan of Jordanstone College of Art and Design, University of Dundee

Selected Group Exhibitions
2006
New British Art, Tate Triennial 2006, London
Our House Is a House That Moves, Living Art Museum, Reykjavik

2005
Homeworks III, A Forum on Cultural Practice, Beirut
MIR: Dreams of Space, Stills Gallery, Edinburgh
Prologue, New Europe, New Feminism, Cornerhouse, Manchester, UK
Video Brasil, State of the Art, São Paulo

2004
Beyond Belief: Reading Utopia, Institute of Contemporary Arts, London
City of Women, 10th International Festival of Contemporary Arts, Ljubljana, Slovenia
Fly Utopia, transmediale 04, Berlin
Luggage, Nanjing Art Institute, Nanjing, China
Our House Is a House That Moves, Galerija _kuc, Ljubljana, Slovenia
Resonance FM, Frieze Art Fair, London

2003
Everything Normal: The Equipment Is Working Perfectly, Arts Catalyst, London
Festival of Art Outsiders, Maison Européenne de la Photographie, Paris
MIR: Art in Variable Gravity, Cornerhouse, Manchester, UK
MIR: Microgravity Interdisciplinary Research, V2—The Institute for Unstable Media, Rotterdam

sophie ristelhueber
Born Paris, 1949
Lives in Paris

Education
Studied at the Sorbonne and the École Pratique des Hautes Études, Paris

Selected Solo Exhibitions
2006
Eleven Blowups, Les Rencontres d'Arles, France

2005
Sophie Ristelhueber: Stitches, Blancpain

Stepczynski, Geneva
WB: West Bank, Musée d'Art Moderne et Contemporain, Geneva

2002
Le Luxembourg, Musée Zadkine, Paris

2001
L'air est à tout le monde (II), Camden Arts Centre, London
Dead Set, Blancpain Stepczynski, Geneva
Details of the World, Museum of Fine Arts, Boston

2000
La Liste, Hôtel des Arts, Toulon, France

1999
Trace, The 1st Liverpool Biennial of International Contemporary Art, Liverpool
The Edge of Awareness, PS I, New York

1998
Premises: Invested Spaces in Visual Arts from France, Guggenheim Museum Soho, New York

Selected Group Exhibitions
2006
Lieux de belligérance 1, Monum/In Visu, Salses, France
Un point c'est tout, Forum Culturel du Blanc-Mesnil, France
Rencontres de la Photographie, Arles, France

2005
After the Fact, 1st Berlin Photography Festival, Martin-Gropius-Bau
Big Bang, MNAM, Centre Pompidou, Paris
Blau: Der Erfindung der donau/Blue: Inventing the River Danube, Technisches Museum, Vienna
Hors circuits, Transphotographiques 2005, Lille

2004
Climats: Cyclothymie des paysages, Centre National d'Art et du Paysage, Vassivière, France
Paisatges després de la batalla, Centre d'Art La Panera, Lleida, Spain
Paysages invisibles, Musée Départemental d'Art Contemporain de Rochechouart, France
Témoins de l'histoire, Centre Photographique d'Île-de-France, Pontault-Combault

2003
De mémoires, Le Fresnoy, Tourcoing, France
Defying Gravity: Contemporary Art and Flight, North Carolina Museum of Art, Raleigh
M_ARS: Kunst und Krieg/Art and War, Neue Galerie Graz am Landesmuseum Joanneum, Graz, Austria
Nackt! Frauenansichten, Städelsches Kunstinstitut und Städtische Galerie, Frankfurt

2002
Iconoclash, ZKM Museum für Neue Kunst, Karlsruhe, Germany
Sans consentement, Centre d'Art Neuchâtel, Switzerland

2001
Le paysage comme Babel, Galerie les Filles du Calvaire, Paris

Selected Publications
Hindry, Ann. *Sophie Ristelhueber*. Paris: Hazan, 1998.
Ristelhueber, Sophie. *Details of the World*. Boston: MFA Publications, 2001.
_____. *La Liste*. Toulon: Hôtel des Arts, 2000.
_____. *Le Luxembourg*. Paris: Paris-Musées, 2002.
_____. *W(est) B(ank)*. London: Thames & Hudson, 2005.
_____. *Eleven Blowups*. Paris: Bookstorming, 2006

clifford ross
Born New York, 1952
Lives in New York

Education
1974
B.A., Art and Art History, Yale University

1973
Skowhegan School of Painting and Sculpture, Skowhegan, Maine

Selected Solo Exhibitions
2006
Clifford Ross, Galería Javier López, Madrid

2005
Clifford Ross, Sonnabend Gallery, New York
The Mountain Series, George Eastman House, Rochester, New York

2004
Clifford Ross, Sonnabend Gallery, New York
Jean Pagliuso & Clifford Ross, Evo Gallery, Santa Fe

2002
Sonnabend Gallery, New York

1999
Edwynn Houk Gallery, New York

Selected Group Exhibitions
2006
Art Basel

2005
Sonnabend Gallery, New York

2004
Recent Acquisitions: Framing the Collection, Parrish Art Museum, Southampton, New York
Sonnabend Gallery, New York

Visions of America, Sammlung Essl–Kunsthaus, Klosterneuberg, Austria

2003
Genomic Issue(s): Art and Science, Gallery of the City University of New York Graduate Center
Hot Summer in the City, Sean Kelly Gallery, New York
Summer Life, Alice Austen House Museum, Staten Island, New York

2002
The Beach, The Gallery at Windsor, Vero Beach, Florida
The Blurred Image, Winston Wächter Mayer Fine Art, New York
From Pop to Now: Selections from the Sonnabend Collection, Tang Teaching Museum, Saratoga Springs, New York; Wexner Center for the Arts, Columbus, Ohio; Milwaukee Art Museum
Photogenesis: Opus 2, Artists' Response to the Genetic Information Age, Santa Barbara Museum of Art
Visions from America, Whitney Museum of American Art, New York

2001
Sonnabend Gallery, New York
Kennedy Boesky Photographs, New York

1999
Souvenirs: Collecting, Memory, and Material Culture, Guild Hall Museum, East Hampton, New York
Surroundings: Responses to the American Landscape, San Jose Museum of Art

Awards
2004
U.S. Patent 6,795,648 for the R1 High-Resolution Camera System
Digital Innovator Award, American Photo Magazine

Selected Collections
Albright-Knox Art Gallery, Buffalo, New York

Corcoran Gallery of Art, Washington, D.C.
Guild Hall Museum, East Hampton, New York
International Center of Photography, New York
Metropolitan Museum of Art, New York
Museum of Fine Arts, Houston
Museum of Modern Art, New York
Parrish Art Museum, Southampton, New York
Rose Art Museum, Waltham, Massachusetts
Speed Art Museum, Louisville, Kentucky
Solomon R. Guggenheim Museum, New York
Wadsworth Atheneum, Hartford, Connecticut
Whitney Museum of American Art, New York
Yale University Art Gallery, New Haven

Selected Publications
Ross, Clifford. *Wave Music*. Text by Arthur C. Danto. New York: Aperture, 2005.
_____, and Karen Wilkin. *The World of Edward Gorey*. New York: Abrams, 1996.

thomas ruff

Born Zell am Harmersbach, Germany, 1958
Lives in Düsseldorf

Education
1977–82
Staatliche Kunstakademie, Düsseldorf (under Bernd Becher)

Selected Solo Exhibitions
2006
jpeg, Galerie Nelson, Paris
Sterne/Stars, Ben Brown Fine Art, London
Thomas Ruff, Arario Beijing
Thomas Ruff, Johnen Galerie, Berlin
Thomas Ruff: The Grammar of Photography, Fondazione Bevilacqua La Masa, Venice

2005
Neue jpegs, Mai 36 Galerie, Zürich
New Works, David Zwirner, New York

Thomas Ruff, Kunstverein Region Heinsberg, Germany

2004
neue Nudes—neue Substrate—neue Maschinen, Galerie Johnen & Schöttle, Cologne
Les oeuvres de la collection Pierre Huber, Musée d'Art Moderne et Contemporain, Geneva
Vis-à-vis Stelle & pianeti: Thomas Ruff e Oscar Turco, Studio d'Arte Contemporanea Pino Casagrande, Rome

2003
Nudes und Maschinen, kestnergesellschaft, Hannover, Germany
Thomas Ruff, Museu de Arte Contemporânea de Serralves, Porto, Portugal
Thomas Ruff: 1979 to the Present, Tate Liverpool

2002
l.m.v.d.r., Galería Estrany–De La Mota, Barcelona; Contemporary Fine Arts, Berlin
Identificaciones, Museo Tamayo Arte Contemporáneo, Mexico City

2001
Thomas Ruff, Galería Helga de Alvear, Madrid
Thomas Ruff: 1979 to the Present, Staatliche Kunsthalle Baden-Baden; Museet for Samtidskunst, Oslo; Tate Liverpool

2000
New Works, Galerie Wilma Tolksdorf, Frankfurt
Nudes, David Zwirner, New York; Contemporary Fine Arts, Berlin

Selected Group Exhibitions
2006
Click Doubleclick, Haus der Kunst,

Munich; Palais des Beaux-Arts, Brussels
Fallout: Cold War Culture, Mitchell-Innes &
Nash, New York
*Metropolitanscape: Paesaggi urbani nell'-
arte contemporanea*, Palazzo Cavour, Turin
Nature Attitudes, T-B A21 Thyssen-
Bornemisza Art Contemporary, Vienna
Paisajes (Landscapes), PhotoEspaña 2006,
Galería Arnés y Röpke, Madrid
Short Stories, Nationale Fotomuseum,
Copenhagen
Tokyo Blossoms, Hara Museum of
Contemporary Art, Tokyo
What's New, Pussycat?, Museum für
Moderne Kunst, Frankfurt

2005
Always a Little Further, 51st Venice
Biennale
Atlantic & Bukarest, Museum für
Gegenwartskunst, Basel; Kunstmuseum
Basel
Beautiful Cynicism, Arario Beijing
Beyond Delirious, Cisneros Fontanals Art
Foundation, Miami
Enchanté Château, Fondation Salomon,
Alex, France
The Enigma of Modernity, Ludwig Múzeum,
Budapest
Homage to the Square, Galerie Mezzanin,
Vienna
Re-Positioning Photography: Seduction,
Queensland Centre for Photography,
Brisbane
Rückkehr ins All, Kunsthalle, Hamburg
Sex ... in Art, Galerie Sho Contemporary
Art, Tokyo
Surfaces Paradise, Museum voor Moderne
Kunst, Arnhem, The Netherlands
*Zur Vorstellung des Terrors: Die RAF-
Ausstellung*, Kunst-Werke, Berlin; Neue
Galerie Graz am Landesmuseum
Joanneum, Graz, Austria

2004
Artéfacts: La vie secrète des choses,
Fondation Guerlain, Les Mesnuls, France

Cabinet photographique érotique, Galerie
Steinek, Vienna
Close By—Time Space Architecture, Mai 36
Galerie, Zürich
Contemporary Visions, Wäinö Aaltonen
Museum, Turku, Finland
In Focus: Themes in Photography,
Albright-Knox Art Gallery, Buffalo, New
York
Gwangju Biennale, Gwangju, South Korea
Making Faces: The Death of the Portrait,
Musée de l'Élysée, Lausanne
Metamorph, Trajectories, 9th International
Architecture Exhibition, Venice Biennale
*PILLish: Harsh Realities and Gorgeous
Destinations*, Museum of Contemporary
Art Denver
Relating to Photography, Fotografie Forum
International, Frankfurt
Take Five!, Huis Marseille, Amsterdam
What is, is now, Galerie van Gelder,
Amsterdam
Die Zehn Gebote, Deutsches Hygiene-
Museum, Dresden

2003
Cold Play, Fotomuseum Winterthur,
Switzerland
Cruel and Tender, Tate Modern, London;
Museum Ludwig, Cologne
Family Ties, Peabody Essex Museum,
Salem, Massachusetts
Female Turbulence, Aeroplastics
Contemporary, Brussels
Geometry of the Face, Nationale
Fotomuseum, Copenhagen
*Happiness: A Survival Guide for Art and
Life*, Mori Art Museum, Tokyo
Imperfect Innocence, Palm Beach Institute
of Contemporary Art, Lake Worth, Florida
M_ARS: Kunst und Krieg/Art and War,
Neue Galerie Graz am Landesmuseum
Joanneum, Graz, Austria
Pictures of You, Galería Estrany–De La
Mota, Barcelona
Realities: Collections Without Frontiers II,
Zach_ta—National Gallery of Art, Warsaw

Rencontres de la Photographie, Arles,
France
*Social Strategies: Redefining Social
Realism*, Santa Barbara Art Museum
Unreal Estate Opportunities, pkm gallery,
Seoul

2002
Art for Living Again, Galería Estrany–De La
Mota, Barcelona
Erotika, Riva Gallery, New York
*Herzog & de Meuron: Archaeology of the
Mind*, Canadian Centre for Architecture,
Montréal
Moving Pictures, Solomon R. Guggenheim
Museum, New York
Startkapital, K21 Kunstsammlung NRW,
Düsseldorf
25th Bienal de São Paulo
Vertigo, Leo Castelli Gallery, New York

2001
Close Up, Kunstverein Hannover, Germany
I Love NY, Zwirner & Wirth, New York
*The Inward Eye: Transcendence in
Contemporary Art*, Contemporary Arts
Museum, Houston
Mies in Berlin, Museum of Modern Art,
New York
Picturing Media, Metropolitan Museum of
Art, New York

2000
*Ansicht Aussicht Einsicht—
Architekturphotographie*, Galerie für
Zeitgenössische Kunst, Leipzig
La Arquitectura sin Sombra, Centro
Andaluz de Arte Contemporáneo, Seville,
Spain
L'Opéra: Un chant d'Étoiles, Théâtre
Royale de la Monnaie, Brussels

**Awards and Professional
Experience**
2006
Infinity Award for Art Photography,
International Center of Photography,
New York

2003
Hans-Thoma Prize, Hans-Thoma Museum,
Bernau, Germany

2000–present
Professor of Photography, Staatliche
Kunstakademie, Düsseldorf

Selected Collections
Albright-Knox Art Gallery, Buffalo,
New York
Centre Pompidou, Paris
Fondation Cartier pour l'Art
Contemporain, Paris
Fondazione Sandretto Re Rebaudengo,
Turin
Fotomuseum Winterthur, Switzerland
Hamburger Bahnhof, Berlin
Huis Marseille, Amsterdam
K21 Kunstsammlung NRW, Düsseldorf
Kunsthalle, Hamburg
Kunstmuseum Basel
Museum Abteiberg,
Mönchengladbach, Germany
Museum für Moderne Kunst, Frankfurt
Museum of Contemporary Art, Chicago
Museum of Fine Arts, Boston
Museum van Hedendaagse Kunst,
Antwerp, Belgium
Solomon R. Guggenheim Museum,
New York
Stedelijk Museum voor Actuele Kunst,
Ghent
T-B A21 Thyssen-Bornemisza Art
Contemporary, Vienna
Vancouver Art Gallery

Selected Publications
Drück, Patricia. *Das Bild des Menschen in
der Fotografie: Die Porträts von Thomas
Ruff*. Berlin: Reimer, 2004.
Flosdorff, Caroline, and Veit Görner, eds.
Thomas Ruff: Machines. Ostfildern: Hatje
Cantz, 2003.
Heynen, Julian, ed. *Thomas Ruff: l.m.v.d.r.*
Krefeld: Museum Haus Esters, 2000.
Houellebecq, Michael. *Thomas Ruff:*

Nudes. Munich: Schirmer/Mosel, 2003.
Ruff, Thomas. *Thomas Ruff: m.d.p.n.* Milan:
Charta, 2005.
Winzen, Matthias, ed. *Thomas Ruff: 1979
to the Present*. Cologne: Walther König,
2001.

carlos & jason sanchez
Carlos Sanchez, born Montréal, 1976
Jason Sanchez, born Montréal, 1981
Live in Montréal

Education
Carlos Sanchez
2001
B.F.A., Photography, Concordia
University, Montréal

Jason Sanchez
2000–2001
Interdisciplinary Studies, Concordia
University, Montréal

Selected Solo Exhibitions
2006
Carlos & Jason Sanchez, Claire Oliver Fine
Art, New York
Carlos & Jason Sanchez, Espace F, Matane,
Québec
Plan Large (public billboard installation),
Fonderie Darling, Montréal
The Sanchez Brothers: A Walk Through Life,
Foam Fotografiemuseum, Amsterdam
Septembre de la Photographie, Nice,
France

2005
Carlos & Jason Sanchez, Torch Gallery,
Amsterdam
*Dieter Mammel and Carlos & Jason
Sanchez*, Christopher Cutts Gallery,
Toronto

2004
Disruptions, Christopher Cutts Gallery,
Toronto

2003
Model Citizens, Khyber Centre for the
Arts, Halifax, Nova Scotia
The Young, Dazibao, Montréal

2002
Model Citizens, Espace 306, Montréal

Selected Group Exhibitions
2006
ARCO International Contemporary Art
Fair, Madrid
Art Brussels
Les Convertibles, Musée National des
Beaux-Arts du Québec
Darkness Ascends, Museum of
Contemporary Canadian Art, Toronto
18th Annual Works on Paper, Park Avenue
Armory, New York
Scope New York
20th Anniversary Group Show, Christopher
Cutts Gallery, Toronto

2005
ARCO International Contemporary Art
Fair, Madrid
Art Fair Cologne
Earthly Delights, Claire Oliver Fine Art,
New York
Future Perfect, Claire Oliver Fine Art, New
York
Oracle of Truth, Aeroplastics
Contemporary, Brussels
Paris Photo
Re-presenting Representation VII, Arnot
Art Museum, Elmira, New York
Scope Miami
Scope New York
Surface Tension, Gallery 500, Portland,
Oregon
La tierra desollada, Galería Begoña
Malone, Madrid
Toronto International Art Fair
*Zeitgenössische Fotokunst aus
Kanada/Contemporary Photographic Art in
Canada: The Space of Making*, Neuer
Berliner Kunstverein, Berlin; Städtisches

Museum, Zwickau, Germany; Städtische
Galerie, Waldkraiburg, Germany;
Kunstmuseum Heidenheim, Germany

2004
Fabulation, Vox—Centre de l'Image
Contemporain, Montréal
Scope Miami
Toronto International Art Fair

2003
Art Forum Berlin
ArtSutton, Sutton, Canada
Photo-Based Works, Christopher Cutts
Gallery, Toronto
Salon du Printemps, Montréal
Toronto International Art Fair

2002
The Armory Photography Show, New York
Scope Miami
Young Fiction, Galerie Trois Points,
Montréal

Awards
2005
Type B Grant, Conseil des Arts et des
Lettres du Québec

2004
Canada Council for the Arts Grant
Conseil des Arts et des Lettres du
Québec Grant

2003
Conseil des Arts et des Lettres du
Québec Grant
Du Maurier Arts Council Grant

2001
Du Maurier Arts Council Grant

Selected Collections
Canada Council Art Bank
Musée des Beaux-Arts du Montréal
Musée d'Art Contemporain de Montréal
Musée National des Beaux-Arts du Québec
Museum of Fine Arts, Houston

Selected Publications
Campbell, James D. *Disruptions:
Subversion and Provocation in the Art of
Carlos and Jason Sanchez*. Toronto:
Christopher Cutts Gallery, 2004.
Gollner, Adam, and Derek Webster.
"Young Bloods." *Maisonneuve*, January 10,
2004, pp. 66–71.
Nomblot, Javier Rubio. *La tierra desolla-
da/The Flayed Land*. Madrid: Galería
Begoña Malone; Toronto: Christopher
Cutts Gallery, 2005.
Zeitgenössische Fotokunst aus Kanada.
Berlin: Neuer Berliner Kunstverein, 2005.

alessandra sanguinetti
Born New York, 1968
Lives in Buenos Aires and New York

Selected Solo Exhibitions
2004
*The Adventures of Guille and Belinda and
the Enigmatic Meaning of Their Dreams*,
Yossi Milo Gallery, New York

2003
*The Adventures of Guille and Belinda and
the Enigmatic Meaning of Their Dreams*,
Museo de Arte Moderno, Buenos Aires;
Light Work, Syracuse, New York

2001
*Alessandra Sanguinetti: En el Sexto Día/On
the Sixth Day*, Ruth Benzacar Galería de
Arte, Buenos Aires

1998
Sweet Expectations, Fotogalería del Teatro
San Martín, Buenos Aires

Selected Group Exhibitions
2005
Beyond the Walls, Daniel Azoulay Gallery,
Miami
*El Museo's Bienal: The (S) Files/The
Selected Files*, El Museo del Barrio, New
York

5th Bienal do Mercosul, Porto Alegre,
Brazil
Play, Center for Photography at
Woodstock, New York
Rencontres de la Photographie, Arles,
France

2004
Colección del MAMbA II Fotografía,
Museo de Arte Moderno, Buenos Aires
We Are the World, Chelsea Art Museum,
New York
Wild Flowers, Ariel Meyerowitz Gallery,
New York

2003
Art Basel, Daniel Azoulay Gallery, Miami
Enchanted Evening, Yancey Richardson
Gallery, New York

2001
Premios Klemm, Galería Fundación
Klemm, Buenos Aires

Awards and Residencies
2002
Artist in Residence, Light Work, Syracuse,
New York

2001
Hasselblad Foundation Grant, Göteborg,
Sweden
National Fund for the Arts Grant,
Argentina

2000
John Simon Guggenheim Memorial
Foundation Fellowship
1st Prize, National Hall of the Arts,
Argentina

1998
Joop Swart Masterclass, Rotterdam

Selected Collections
International Center of Photography, New
York

Light Work, Syracuse, New York
Museo de Arte Moderno, Buenos Aires
Museum of Fine Arts, Boston
Museum of Fine Arts, Houston
Museum of Modern Art, New York
San Francisco Museum of Modern Art

Selected Publications
Alessandra Sanguinetti. Buenos Aires:
Ruth Benzacar Galería de Arte, 2001.
Sanguinetti, Alessandra. *On the Sixth Day*.
Tucson: Nazraeli Press, 2006.

victor schrager
Born Bethesda, Maryland, 1950
Lives in New York

Education
1975
M.F.A., Florida State University,
Tallahassee

1972
B.A., Harvard College

Selected Solo Exhibitions
2006
*Composition as Explanation: Pigment
Prints*, Edwynn Houk Gallery, New York

2005
Composition as Explanation, Adamson
Gallery, Washington, D.C.; Lexington Art
Gallery, Lexington, Virginia
Victor Schrager, HackelBury Fine Art
Limited, London
Victor Schrager, LongHouse Reserve, East
Hampton, New York

2004
Books, Robert Klein Gallery, Boston
Composition as Explanation, Edwynn Houk
Gallery, New York

2001
Botany, Edwynn Houk Gallery, New York

Selected Group Exhibitions
2005
Atelier David Adamson, Maison
Européenne de la Photographie, Paris
Bibliotheca, Stephen Bulger Gallery,
Toronto
Still Life and Stilled Lives, Ariel Meyerowitz
Gallery, New York

2004
*Animals & Us: The Animal in Contemporary
Art*, Galerie St. Etienne, New York
Still Life, Candace Perich Gallery,
Katonah, New York
Up to Now, Candace Perich Gallery,
Katonah, New York

2002
A Bird Show, Ricco-Mareska Gallery, New
York
Colour & Concept, National Gallery of
Australia, Canberra

2001
*Here Is New York: A Democracy of
Photographs*, national and international
locations, including New York, Washington,
D.C., Chicago, Berlin, London, Paris, and
Zürich
WTC Benefit Auction, Drive-in Studios,
New York, and House & Garden Magazine,
New York

2000
Botanical Photographs, Galerie Francoise
et ses Frères, Lutherville, Maryland
*Significant Other: The Hand of Man in
Animal Imagery*, Photographic Resource
Center, Boston University

1999
Fauna III, Candace Perich Gallery,
Katonah, New York

1998
Blind Spot Issue #11, Art Directors Club,
New York

Color, Edwynn Houk Gallery, New York
Fauna II, Candace Perich Gallery, Katonah,
New York
From the Heart: The Power of Photography,
South Texas Institute for the Arts, Corpus
Christi

Awards and Professional Experience
1993
John Simon Guggenheim Memorial
Foundation Fellowship

1987
Founder, MFA Program in Photography,
School of Visual Arts, New York

1978–86
Instructor in Photography, School of
Visual Arts, New York City

Selected Collections
Addison Gallery of American Art,
Andover, Massachusetts
Baltimore Museum of Art
Center for Creative Photography, Tucson
Cleveland Museum of Art
Cranbrook Academy of Art, Bloomfield
Hills, Michigan
Denver Art Museum
Florida State University, Tallahassee
George Eastman House, Rochester, New
York
High Museum of Art, Atlanta
International Center of Photography, New
York
Library of Congress, Washington, D.C.
Los Angeles County Museum of Art
Maison Européenne de la Photographie,
Paris
Metropolitan Museum of Art, New York
Museum of Fine Arts, Houston
Museum of Modern Art, New York
National Gallery of Australia, Canberra
Polaroid Collection
Princeton University Art Museum
San Francisco Museum of Modern Art

University of Colorado, Boulder
Whitney Museum of American Art,
New York

Selected Publications

Forley, Diane. *The Anatomy of a Dish*.
Photographs by Victor Schrager. New
York: Artisan, 2002.
Goldman, Amy. *Melons for the Passionate
Grower*. Photographs by Victor Schrager.
New York: Artisan, 2002.
Schrager, Victor. *Composition as
Explanation*. Göttingen: Steidl, 2006.
_____, and A. S. Byatt. *Bird Hand Book*.
New York: Graphis, 2001.

simon starling
Born Epsom, England, 1967
Lives in Glasgow

Education
1990–92
Glasgow School of Art

1987–90
Nottingham Polytechnic

1986–87
Maidstone College of Art

Selected Solo Exhibitions
2006
24 Hour Tangenziale, Galleria Franco
Noero, Turin

2005
Cuttings, Kunstmuseum Basel; Museum
für Gegenwartskunst, Basel

2004
Art Statements, Art Basel
One Ton, Neugerriemschneider, Berlin
Simon Starling, Casey Kaplan, New York
Simon Starling, Fundació Joan Miró,
Barcelona
Tabernas Desert Run, The Modern
Institute, Glasgow

2003
Djungel, South London Gallery
Inverted Retrograde Theme, Casey Kaplan,
New York; Hammer Museum, Los Angeles
Simon Starling, Museo d'Arte
Contemporanea, Rome
Simon Starling, Villa Arson, Centre d'Art
Contemporain, Nice, France

2002
Djungel, Dundee Contemporary Arts,
Dundee, Scotland
Flaga (1972–2000), Galleria Franco Noero,
Turin
Kakteenhaus, Portikus, Frankfurt
Mathew Jones/Simon Starling, Museum of
Contemporary Art, Sydney

2001
Burn Time, Neugerriemschneider, Berlin
CMYK/RGB, Fonds Régional d'Art
Contemporain (FRAC) Languedoc-
Roussillon, Montpellier, France
Inverted Retrograde Theme, Wiener
Secession, Vienna
Simon Starling/Poul Henningsen, Dundee
Contemporary Arts, Dundee, Scotland

2000
Simon Starling, Camden Arts Centre,
London

1999
Simon Starling, Blinky Palermo Prize,
Galerie für Zeitgenössische Kunst,
Leipzig
Simon Starling, Signal, Malmö, Sweden

1998
Project for a Modern Museum, Moderna
Museet, Stockholm

Selected Group Exhibitions
2006
Lichtkunst aus Kunstlicht, ZKM Museum
für Neue Kunst, Karlsruhe, Germany
*NowHere Europe: Trans:it: Moving Culture
Through Europe*, Muzeul Na_ional de Art_
Contemporan_, Bucharest
Transformation, Kunstmuseum
Liechtenstein, Vaduz

2005
Academy Remix, Portikus, Frankfurt
The Forest: Politics, Poetics, and Practice,
Nasher Museum of Art, Duke University,
Durham, North Carolina
Goodbye 14th Street, Casey Kaplan, New
York
Imágenes en movimiento/Moving Pictures,
Guggenheim Museum Bilbao
Paralleles Leben, Kunstverein, Frankfurt
ThickDesign05, Betty Rymer Gallery,
School of the Art Institute of Chicago
Turner Prize 2005, Tate Britain, London
*Universal Experience: Art, Life, and the
Tourist's Eye*, Museum of Contemporary
Art, Chicago

2004
Art Needs an Operation, Casey Kaplan,
New York
Strange I've Seen That Face Before, Gallery
of Modern Art, Glasgow; Museum
Abteiberg, Mönchengladbach, Germany
26th Bienal de São Paulo

2003
*Dreams and Conflicts: The Dictatorship of
the Viewer*, 50th Venice Biennale
Faking Real, Neiman Gallery, Columbia
University, New York
GNS (Global Navigation System), Palais de
Tokyo, Paris
Independence, South London Gallery
Lap Dissolve, Casey Kaplan, New York
The Moderns, Castello di Rivoli, Turin
New Space! Group Show!, Galleria Franco
Noero, Turin
Outlook International Art Exhibition, Athens
Skulptur Biennale Münsterland, Germany
Spécial Dédicace, Musée Départemental
d'Art Contemporain de Rochechouart,
France

2002

Der Globale Komplex—Continental Drift, Kunstverein, Graz, Austria

Inter.Play, The Moore Building, Miami

Manifesta 4, Kunstverein, Frankfurt

My Head Is on Fire But My Heart Is Full of Love, Charlottenborg Museum, Copenhagen

Sphere, Sir John Soane's Museum, London

Summer Cinema, Casey Kaplan, New York

Wrong Time, Wrong Place, Kunsthalle Basel

Zusammenhänge herstellen/Contextualize, Kunstverein, Hamburg

2001

Circles, ZKM Museum für Neue Kunst, Karlsruhe, Germany

G3NY, Casey Kaplan, New York

Here + Now: Scottish Art, 1990–2001, Dundee Contemporary Arts, Dundee, Scotland

Der Larsen Effekt, OK Centrum für Gegenwartskunst, Linz, Austria; Casino Luxembourg

Let's Get to Work, Susquehanna Art Museum, Harrisburg, Pennsylvania

Open Country: Contemporary Scottish Artists, Musée Cantonal des Beaux-Arts, Lausanne

The Silk Purse Procedure, Arnofini Gallery, Bristol, UK

Squatters 2, Witte de With, Rotterdam

Total Object Complete With Missing Parts, Tramway, Glasgow

Words and Things, Centre for Contemporary Arts, Glasgow

2000

Artifice, Deste Foundation, Athens

The British Art Show, various venues

Future Perfect, Centre for Visual Arts, Cardiff, Wales

If I Ruled the World, Living Art Museum, Reykjavik; Centre for Contemporary Arts, Glasgow

Manifesta 3, Moderna Galerija, Ljubljana, Slovenia

Micropolitique, Le Magasin, Grenoble, France

No Hortus Is Conclusus, Marres Centrum Beeldende Kunst, Maastricht, The Netherlands

Play-Use, Witte de With, Rotterdam

Spacecraft, Bluecoat, Liverpool

What If: Art on the Verge of Architecture and Design, Moderna Museet, Stockholm

The Work in This Space Is a Response to the Existing Conditions and/or Work Previously Shown within the Space, Neugerriemschneider, Berlin

1999

Fang den Hut, Galerie Eigen + Art, Leipzig

Fireworks, De Appel Foundation, Amsterdam

Tyrebagger Sculpture Project, Aberdeenshire, England

1998

Dummy, Catalyst Arts, Belfast

Family, Inverleith House, Edinburgh; Heide Museum of Modern Art, Melbourne

Reconstructions, Smart Project Space, Amsterdam

Thinking Aloud, Camden Arts Centre, London

Awards

2005

Turner Prize, Tate Britain, London

2004

Nominee, Hugo Boss Prize, Solomon R. Guggenheim Museum, New York

1999

Blinky Palermo Prize, Galerie für Zeitgenössische Kunst, Leipzig

Henry Moore Sculpture Fellowship, Duncan of Jordanstone College of Art and Design, Dundee, Scotland

Paul Hamlyn Foundation Award for Artists, London

Selected Collections

Arts Council of Great Britain

Fondazione Sandretto Re Rebaudengo, Turin

Fonds Régional d'Art Contemporain (FRAC) Languedoc-Roussillon, Montpellier, France

Scottish Arts Council

Solomon R. Guggenheim Museum, New York

Selected Publications

Eccher, Danilo, ed. *Simon Starling*. Milan: Electa, 2003.

Kaiser, Philipp, ed. *Simon Starling: Cuttings*. Ostfildern-Ruit: Hatje Cantz, 2005.

Kirkpatrick, Gail B., et al., eds. *Simon Starling*. Nice: Villa Arson, 2004.

Starling, Simon. *Djungel*. Dundee: Dundee Contemporary Arts, 2002.

_____. *Flaga (1972–2000)*. Text by Rob Tufnell. Turin: Franco Noero, 2002.

_____. *Front to Back*. London: Camden Arts Centre, 2000.

_____. *Inverted Retrograde Theme*. Vienna: Secession, 2001.

_____. *Kakteenhaus*. Text by Jochen Volz. Frankfurt: Portikus, 2003.

kim stringfellow

Born San Mateo, California, 1963

Lives in San Diego

Education

M.F.A., School of the Art Institute of Chicago

B.F.A., Academy of Art College, San Francisco

Selected Solo Exhibitions

2005

Greetings from the Salton Sea, Michael Dawson Gallery, Los Angeles

2003

Greetings from the Salton Sea, Circle Elephant Art, Los Angeles

2002

Safe as Mother's Milk, Henriette E. Woessner Alumni Gallery, Cornish College of the Arts, Seattle

2001

Greetings from the Salton Sea, Gallery 2, Washington State University, Pullman

Selected Group Exhibitions

2006

Invisible-5 (collaborative project), Southern Exposure, San Francisco

2005

Festival Internacional de Linguagem Eletrônica (FILE), São Paulo

2004

Painting/Sculpture/Photos, DeLeon White Gallery, Toronto
International Symposium on Electronic Art (ISEA), Tallinn City Gallery, Tallinn, Estonia
Speculative Terrain: Recent Views of the Southern California Landscape from San Diego to Santa Barbara, Carnegie Art Museum, Oxnard, California; Riverside Art Museum, Riverside, California; Laband Art Gallery, Loyola Marymount University, Los Angeles
Tender Landscape: Artists Respond to Human Involvement in the Natural World, Dalton Gallery, Agnes Scott College, Decatur, Georgia

2003

Digital State, SDSU Community Art Gallery, San Diego
Siggraph 2003 Web Graphics Expo, San Diego

2002

Paisajes Tóxicos, Biblioteca Nacional José Martí, Havana

2001

Toxic Landscapes: Artists Examine the

Environment, Rachel Carson Institute, Chatham College, Pittsburgh; Puffin Cultural Forum, Teaneck, New Jersey

1999

Rattling the Frame: The Photographic Space 1974–1999, SF Camerawork, San Francisco
7th New York Digital Salon, School of Visual Arts, New York; Círculo de Bellas Artes, Madrid
Siggraph 99 technOasis: ARTsite, Los Angeles
Immedia 99, University of Michigan, Ann Arbor

Selected Online Exhibits

2002

Safe as Mother's Milk: The Hanford Project (www.hanfordproject.com), commissioned by the Cornish College of the Arts, Seattle, ARTS | ACTIVISM 2002 Visiting Artists Series

2001

Salmon in the City (www.salmoncity.net), commissioned by the Seattle Arts Commission

2000

Greetings from the Salton Sea (www.greetingsfromsaltonsea.com/saltlaunch.html)

1998

The Charmed Horizon (www.thecharmedhorizon.com)

Awards, Residencies, and Professional Experience

2004

Creative Work Fund, San Francisco
Graham Foundation for Advanced Studies in the Fine Arts, Chicago

2002

Kodak Photo Educator Scholarship, Santa Fe Workshops

2001–present

Assistant Professor, School of Art, Design, and Art History, San Diego State University

2000

Residency, Civitella Ranieri Center, Umbertide, Italy
James Nelson Raymond Fellowship, School of the Art Institute of Chicago

1999

South by Southwest (SXSW) 2nd Annual Interactive Web Competition, Best Art-Related Site: *The Charmed Horizon*

Selected Collections

Polaroid Domestic Collection, Clarence Kennedy Gallery, Cambridge, Massachusetts
Polaroid International Collection, Offenbach, Germany

Publication

Stringfellow, Kim. *Greetings from the Salton Sea: Folly and Intervention in the Southern California Landscape, 1905–2005*. Santa Fe: Center for American Places, 2005.

diana thater

Born San Francisco, 1962
Lives in Los Angeles

Education

M.F.A., Art Center College of Design, Pasadena, California

B.A., Art History, New York University

Selected Solo Exhibitions

2006

Diana Thater, Casa Estudio Luis Barragán, Mexico City
Diana Thater, Casa ITESO Clavigero, Guadalajara, Jalisco, Mexico
Diana Thater, Haunch of Venison, London

2005
Continuous Contiguous, David Zwirner,
New York; Zwirner & Wirth, New York
Perpetual Motion Perfect Devotion,
Haunch of Venison, London
Pink Daisies, Amber Room, 1301PE, Los
Angeles

2004
*Keep the Faith! Videoinstallationen
1993–2003*, Museum für Gegenwartskunst
Siegen, Germany; Kunsthalle Bremen,
Germany

2003
*Diana Thater: Transcendence is expansion
and contraction at the same time,* Haunch
of Venison, London

2002
Bastard Pink, Galleria Emi Fontana, Milan
Diana Thater, Galerie Ghislaine Hussenot,
Paris

2001
Broken Circle, Museum für
Gegenwartskunst Siegen, Germany
Knots + Surfaces, Dia Center for the Arts,
New York
The Sky Is Unfolding Under You, David
Zwirner, New York; 1301PE, Los Angeles

2000
The Caucus Race, Galleria Emi Fontana,
Milan
Delphine, Galerie Hauser & Wirth, Zürich;
Wiener Secession, Vienna
Diana Thater, 1301PE, Los Angeles

1999
The best sense is the non-sense, Art
Gallery at York University, Toronto
The best space is the deep space, Carnegie
Museum of Art, Pittsburgh

1998
The best animals are the flat animals, MAK

Center for Art and Architecture, Los
Angeles; Museum of Modern Art, New
York
*Diana Thater: Electric Mind and Recent
Work*, The University Gallery, Amherst,
Massachusetts

Selected Group Exhibitions
2006
Ballerina in a Whirlpool, Staatliche
Kunsthalle Baden-Baden
Day for Night, Whitney Biennial 2006,
Whitney Museum of American Art,
New York
Projections: Beyond Cinematic Space,
Hamburger Bahnhof, Berlin
*Vom Pferd erzählen: Das Pferd in der zeit-
genössischen Kunst*, Kunsthalle
Göppingen, Germany
Where the Wild Things Are, Dundee
Contemporary Arts, Dundee, Scotland

2005
Guardami: Percezione del video, Palazzo
delle Papesse, Siena, Italy
Lichtkunst aus Kunstlicht, ZKM Museum
für Neue Kunst, Karlsruhe, Germany
The Suspended Moment, Centre Rhénan
d'Art Contemporain, Altkirch, France;
Museo de Arte Contemporánea, Vigo,
Spain
Water, Air, Earth, Fire, Palazzo della Borsa,
Genoa

2004
Animals, Haunch of Venison, London
Ein-leuchten, Museum der Moderne
Salzburg, Austria
Hypermedia, Orange County Museum of
Art, Newport Beach, California
Kurzdavordanach, Photographische
Sammlung/SK Stiftung Kultur, Cologne
NOT DONE!, Museum van Hedendaagse
Kunst, Antwerp, Belgium
Die Ordnung der Natur, OK Centrum für
Gegenwartskunst, Linz, Austria

2003
Fast Forward, Zentrum für Kunst und
Medientechnologie, Karlsruhe, Germany
Moving Pictures, Guggenheim Museum
Bilbao
Imperfect Marriages, Galleria Emi Fontana,
Milan
Of Earth and Sky: Elements in Abstraction,
San Diego Museum of Art
Sitings: Installation Art 1969–2002, Museum
of Contemporary Art, Los Angeles

2002
*Claude Monet ... bis zum digitalen
Impressionismus*, Fondation Beyeler,
Riehen, Switzerland
Kleine Kleinigkeit, Kunsthalle Basel
Making Nature, Atelier Augarten—
Zentrum für Zeitgenössische Kunst der
Österreichischen Galerie, Vienna
*Parallels and Intersections:
Art/Women/California, 1950–2000*, San
Jose Museum of Art
Time/Frame, Jack S. Blanton Museum of
Art, Austin, Texas

2001
BitStreams, Whitney Museum of American
Art, New York
Devices of Wonder, J. Paul Getty Museum,
Los Angeles
Elusive Paradise, Musée des Beaux-Arts
du Canada, Ottawa [
I Love NY Benefit, David Zwirner, New York
*Post-Landscape: Between Nature and
Culture*, Pomona College Museum of Art,
Claremont, California
Public Offerings, Museum of
Contemporary Art, Los Angeles

2000
Making Time, Palm Beach Institute of
Contemporary Art, Lake Worth, Florida
Sites Around the City, Arizona State
University Art Museum, Tempe

Selected Publications
Engelbach, Barbara, and Wulf

Herzogenrath, eds. *Diana Thater: Keep the Faith*. Cologne: Salon-Verlag, 2004.
"Stan Douglas/Diana Thater." In *pressPLAY: Contemporary Artists in Conversation*. London: Phaidon, 2005.
Thater, Diana. *The best animals are the flat animals—The best space is the deep space*. Los Angeles: MAK, 1998.
_____. *Knots + Surfaces*. Texts by Italo Calvino, Umberto Eco, and others. New York: Dia Center for the Arts, 2002.
_____. *Transcendence is expansion and contraction at the same time*. London: Haunch of Venison, 2003.

wang qingsong

Born Heilongjiang Province, China, 1966
Lives in Beijing

Education
1991
Sichuan Academy of Fine Arts, Sichuan Province, China

Selected Solo Exhibitions
2006
Yesterday, Today, Tomorrow, ART Strelka, Moscow

2005
Wang Qingsong in Arras, Exposition OFF des Transphotographiques 2005, Galerie Patrick Veret and other venues, Arras, France
Wang Qingsong, Guangzhou Photo Biennial, Guangdong Museum of Art

2004
Present-Day Epics, Cambridge Galleries, Cambridge, Ontario; Prefix Photo Institute of Contemporary Art, Toronto; Southern Alberta Art Gallery, Lethbridge
Romantique, CourtYard Gallery, Beijing; Salon 94, New York
Wang Qingsong, Galerie LOFT, Paris

2003
Bath House, P.S.1 MoMA, Long Island City, New York

2002
Golden Future, Galerie LOFT, Paris
Night Junket of Lao Li, Photobiennale 2003, Moscow House of Photography
Wang Qingsong, Fundação Oriente, Macau
Wang Qingsong, Marella Arte Contemporanea, Milan

2000
Glorious Life, Wan Fung Art Gallery, Beijing

Selected Group Exhibitions
2006
Beyond Delirious, Cisneros Fontanals Art Foundation, Miami
Chaos: The Age of Confusion, Bucharest Biennale 2
Great Performance, Max Protetch Gallery, New York
Made in China, Museum of Contemporary Photography, Chicago
Photobiennale 2006, Moscow House of Photography

2005
Baroque and Neobaroque, Domus Artium 2002, Salamanca, Spain
Competition, CourtYard Gallery, Beijing
Expo.05—Photo Chinois, Galerie LOFT, Paris
Follow Me! Contemporary Chinese Art at the Threshold of the Millennium, Mori Art Museum, Tokyo
Mahjong, Kunstmuseum Bern; Kunsthalle, Hamburg
Out of the Red, Marella Arte Contemporanea, Milan
PAAF 2005—The 1st Pocheon Asian Art Festival, Pocheon Banwol Art Hall, Pocheon, South Korea
Ruins' Flowers, Old Ladies House Art Space, Macau
A Utopia of the Visible, Beijing New Art Projects, Dashanzi Art District, Beijing

2004
*Between Past and Future: New

Photography and Video from China, International Center of Photography, New York and other venues through 2006
China 04—La nuova fotografia cinese, Metropolis Photogallery, Bologna
Die Chinesen: Fotografie und Video aus China, Kunstmuseum Wolfsburg, Germany
Hereford Photography Festival, Courtyard Arts Centre, Hereford, UK
Images of History, PhotoEspaña 2004, Museo Colecciones ICO, Madrid
Monument Recall: Public Memory and Public Spaces, SF Camerawork, San Francisco
Over One Billion Served: Conceptual Photography from the People's Republic of China, Museum of Contemporary Art, Denver; Asian Civilisations Museum of Singapore
Past in Reverse: Contemporary Art of East Asia, San Diego Museum of Art
Young Artists from China, Japan, and Korea, National Museum of Contemporary Art, Seoul

2003
Chinese Art Today, Prague Biennale, Národní Galerie, Prague
Global Detail, 10th Noorderlicht Photofestival, Groningen, The Netherlands
Images Against War: A Visual Statement by 402 Artists, Galerie Lichtblick, Cologne
The Little Red Book, Chinese Contemporary Art Gallery, London
Now—Images of Present Time, Mois de la Photo 2003, Montréal
Representación y realidad: Fotografía China contemporánea, Loft BCN, Barcelona
A Strange Heaven: Contemporary Chinese Photography, Galerie Rudolfinum, Prague; Galerie Enrico Navarra, Paris; Helsinki City Art Museum

2002
China: a Arte Imperial, a Arte do Cotidiano,

a *Arte Contemporânea*, Fundação Armando Álvares Penteado, São Paulo
Daydream, Nanjing Museum, Nanjing, China
Dream 02, The Red Mansion Foundation, London
Let's Go!, China Millennium Monument Art Museum, Beijing
Money and Value: The Last Taboo, Arteplage, Biel, Switzerland
2nd Pinyao International Photography Festival, Shanxi Province, China

2001
La Chine, Septembre de la Photographie, Musée d'Art Moderne et d'Art Contemporain, Nice, France
Constructed Reality: Conceptual

Photography from Beijing, Hong Kong Arts Centre
Cross Pressures, Finnish Museum of Photography, Helsinki
Promenade in Asia—CUTE, Mito Contemporary Art Center, Mito, Japan

2000
Big Torino 2000—Biennale Arte Emergente, Turin
Man + Space, 3rd Gwangju Biennale, Gwangju, South Korea
Unusual and Usual, Yuangong Art Museum, Shanghai

Selected Collections
Fundação Armando Álvares Penteado, São Paulo
Fundação Oriente, Macau
Guy and Myriam Ullens Foundation, Antwerp, Belgium
International Center of Photography, New York
JGM Foundation, New York
Maison Européenne de la Photographie, Paris
Moscow House of Photography
Queensland Art Gallery, South Brisbane

Selected Publications
Wang Qingsong: Ruo man di ke/Romantique. Beijing: Se He yuan, 2004.
Wang Qingsong in Arras: Rétrospective. Transphotographiques 5. Beijing, 2005.

Curators' Acknowledgments

The realization of *Ecotopia: The Second ICP Triennial of Photography and Video* has depended on the talent, good will, and unceasing toil of many people. The curators would first like to acknowledge the artists and photographers who have contributed to this exhibition. The variously subtle, amusing, enticing, frightening, and intelligent works they have produced forced us to expand our ideas about the natural world both as an entity in crisis and as a subject of art. As always, their visions challenged and shaped our conception of what we do.

The curators are also indebted to the unstinting support of the Board of Trustees of the International Center of Photography, led by Gayle G. Greenhill, Chair, and Jeffrey A. Rosen, President, and former President Raymond J. McGuire. The encouragement of our Exhibitions Committee, led by Artur Walther and Meryl Meltzer, and the continued support of our Acquisitions Committee, led by Anne Ehrenkranz, have been crucial. And we have benefited greatly from the vision and leadership of Ehrenkranz Director Willis E. Hartshorn, as well as Deputy Director for Programs Phillip S. Block, Deputy Director for External Affairs Evan Kingsley, and Deputy Director for Finance/Administration Steve Rooney.

It was a genuine pleasure to work with our contributing writers, Ingrid Dudek, Jean Dykstra, Matthew Guy Nichols, Nola Tully, and Gregory Volk; we thank them all for their thoughtful contributions to our catalogue. We also had the pleasure of wonderful creative collaborations with Harris Dew, Director of Programs and Promotions at the IFC Center, whom we thank for our first theatrical screening of Triennial works; and Katherine Minton, producer of "Selected Shorts" at Symphony Space, for the first-ever evening of readings based on the Triennial. We always enjoy working with Blanche Tannery from the Cultural Services of the French Embassy in New York.

The graphic design for the exhibition was ably executed by the ever-creative mgmt design, with Alicia Cheng at the helm. Rachel Griffin at mgmt. also brought originality and energy to her graphic design contribution. The exhibition design was a rewarding first-time collaboration with the architectural firm Matter Practice, whom we thank for the innovative concepts that enriched our presentation.

In New York, we are grateful to Bonni Benrubi and Thom Vogel at Bonni Benrubi Gallery; Sabrina Buell at Matthew Marks Gallery; Chana Budgazad and Joanna Kleinberg at Casey Kaplan; Angela Choon and Cameron Shaw at David Zwirner; Daniel Cooney at Daniel Cooney Fine Art; Alexis Dean of Zabriskie Gallery; Brian Doyle at 303 Gallery; Janice Guy at Murray Guy; Natalia Mager of Luhring Augustine; Claire Oliver at Claire Oliver Fine Art; Jasmine Jopling at Redux; Alissa Schoenfeld and Yossi Milo at Yossi Milo Gallery; Teka Selman, Erin O'Rourke, and Brent Sikkema at Sikkema Jenkins & Co.; Jeanne Greenberg Rohatyn and Nicolas Rohatyn at Salon 94; John Tevis of Von Lintel Gallery; Carly Sacher at the Clifford Ross Studio; and David Ratzlow.

We also appreciated the efforts of Jonathan Baldock and Diana Baldon of Max Wigram Gallery, London; Frish Brandt and Dawn Troy at Fraenkel Gallery, San Francisco; Meg Maggio at Pékin Fine Arts, Beijing; A. C. Van Der Have at Torch Gallery, Amsterdam; Andrew Hamilton and Toby Webster at The Modern Institute, Glasgow; Jurriaan Van Kranendonk of Galerie Van Kranendonk, The Hague; Pippy Houldsworth of Houldsworth Gallery, London; and Sabina Sabolouie and Natasa Ilic, Zagreb.

For graciously loaning artwork to the exhibition, we are indepted to Katie and Esme Brown, the Fabric Workshop and Museum, Philadelphia; The New York Public Library; and the Los Angeles County Museum of Art.

The staff of the International Center of Photography relies on the hard work of many talented interns. For their time and effort, we thank Dana Meilijson, Maria-Laura Steverlynck, Jennifer Taylor, and Ka-Man Tse. And we especially thank Ryerson student Jennifer Roger, who worked full-time on the exhibition with incredible dedication and professionalism.

For photojournalistic recommendations, research, and advice, we are grateful to *Newsweek* photo editors Paul Moakley and James Price; *PDN* Editor-in-Chief Holly Stuart Hughes; Chloe Sherman, Photo Editor, *Mother Jones*; and Allison Morley, Chair of ICP's Documentary and Photojournalism Program. Technical expertise was provided by Kirsten Springer.

Finally, we extend our thanks to our colleagues at the International Center of Photography. The privilege of presenting the world's most interesting photography is second only to the privilege of having our work facilitated by the most committed and hard-working staff imaginable. We continue to benefit from the toil of Director of Development Marie Spiller and Director of Communications Phyllis Levine. We rely on the years of experience and dedication reflected in the excellent work of Registrar Barbara Woytowicz and Production Manager Karlos Carcamo and his crew. We thank Assistant Curator Erin Barnett for early research on *Ecotopia,* and Assistant Curator Kristen Lubben whose experience is an invaluable resource during every exhibition. For this catalogue, we thank Gerhard Steidl and his wonderful staff at Steidlville; the world's best editor Philomena Mariani; and our talented Director of Publications Karen Hansgen.

Edward Earle, Joanna Lehan, Christopher Phillips, Carol Squiers, Brian Wallis

Credits

Courtesy Fraenkel Gallery, San Francisco: 31-35; Courtesy 303 Gallery, New York: 37-41; © Patrick Brown/Panos Pictures: 61-65; © Lou Dematteis: 79-83; © Mitch Epstein/Black River Productions, Ltd:109-113; ©The Metropolitan Museum of Art: 115 (bottom); © 2006 Man Ray Trust / Artists Rights Society (ARS), New York / ADAGP, Paris and © 2006 Artists Rights Society (ARS), New York / ADAGP, Paris / Succession Marcel Duchamp: 117 (bottom); © Bill Brandt / Bill Brandt Archive Ltd: 119 (bottom); ©Vincent Laforet/*The New York Times*:145-149; © Christopher LaMarca/Redux: 151-157; © Gilles Mingasson/Getty Images: pp. 175-179; Courtesy The Modern Institute/Toby Webster, Ltd,Glasgow: 229; Courtesy Casey Kaplan Gallery, New York: 230-233; Courtesy Hennessey Communications: 236; Photo by Keith Davey, Prudence Cuming Associates: 241

Texts by Ingid Dudek: p. 34, p. 76, p. 94, p. 172, p. 184, p. 244, p. 248

Texts by Jean Dykstra: p. 58, p. 106, p. 142, p. 148, p. 178, p. 190, p. 208, p. 214

Texts by Joanna Lehan: p. 166, p. 244

Texts by Matthew Guy Nichols: p. 28, p. 40, p. 46, p. 52, p. 64, p. 70, p. 82, p. 88, p. 100, p. 118, p. 136, p. 160, p. 220, p. 226, p. 232, p. 238

Texts by Nola Tully: p. 130, p. 196

Texts by Gregory Volk: p. 112, p. 124, p. 154, p. 202